Bought at Maryhill July 9
on Road Trip with Summer & Ryan ♡♥

New England - coast

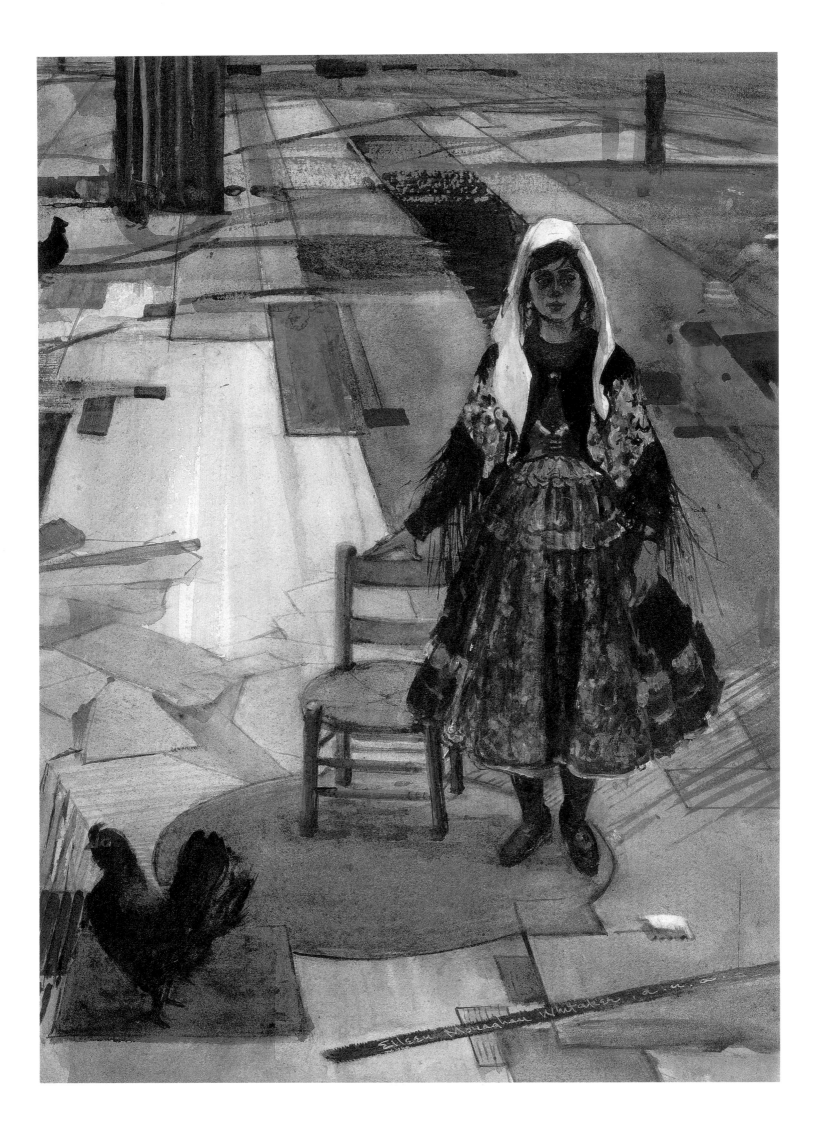

Contrasts That Complement

Eileen Monaghan Whitaker & Frederic Whitaker

by Jan Noreus Jennings

Essays by
Donelson Hoopes
Robert L. Pincus
Theodore F. Wolff

Marquand Books, Seattle

to Frederic Whitaker,

a man who paid heed to the lessons of his own life and was unstinting in
his encouragement of others; a man most gracious, caring, and charismatic;
a man whom it was a privilege and a delight to have known

Contents

Foreword

Contrasts That Complement: Eileen Monaghan Whitaker – Frederic Whitaker is an overdue volume celebrating the work of two well-respected American watercolorists. The most comprehensive survey of the Whitakers' watercolor production to date, this book includes a representative selection of watercolors, an extensive biography, and perceptive essays by nationally recognized art writers.

Donelson Hoopes, the museum professional and historian of American watercolor, expounds upon the Whitakers' steadfast allegiance to realism during the mid-twentieth century – years when American art was besieged by abstraction. Contextualizing them, Hoopes casts the Whitakers as an extension of the great American watercolor tradition established in the nineteenth century. Theodore F. Wolff, who has written extensively on twentieth-century American art, offers a keen perspective into the integrity of Frederic Whitaker's working method and artistic vision. The art critic Robert L. Pincus conveys the imaginative spirit found in Eileen Monaghan Whitaker's watercolor style. Underscoring these astute commentaries is the insightful biography prepared by Jan Noreus Jennings, a journalist, art writer, and longtime friend of the painters. Through her words, readers will come to know the Whitakers as both artists and individuals.

This survey must serve two audiences. The first comprises those collectors, artists, curators, and scholars who are already familiar with the Whitakers. The second comprises the numerous practitioners and admirers of the medium who, by way of this publication, are now encountering the Whitakers' artistic legacy for the first time. It was my pleasure to select watercolors by each artist that would satisfy both the expectations of the initiated and the passion of the recently acquainted. From a vast pool of images, all worthy of publication, I made many difficult choices in arriving at a list that I feel accurately exhibits the artists' respective strengths.

Frederic Whitaker had an innate sense of composition, which he expressed with a sure hand. He painted a wide variety of subjects but delighted in rendering those that offered compositional solidity and a variety of textured surfaces. I mention two wonderful examples. *Sundown at Big Bend* (p. 148) is a panoramic view of the geological layers of a sheared bluff, framed in the foreground by gracefully twisting trees. The other is *Slow – Snails at Work* (p. 157), a striking design filling the sheet from edge to edge with the variegated, nautilus-shaped shells of three snails feeding on long green leaves. These watercolors, among many others, impressed

me in their demonstration of Fred's talent for seeing the infinite compositional possibilities to be found in nature – be they grand or intimate.

Eileen Monaghan Whitaker's ability to capture the character of the person or subject she depicted informed my selection of her watercolors. For instance, one senses the stoic dignity of the women in *Harvest Time, Estremadura* (p. 140), as they labor in the field under the hot sun. Her marvelous way of evoking a sense of discovery in representations of everyday objects is also engaging. This is best exemplified in *Ancient Design* (p. 78), which employs the bold, colorful pattern of a handwoven Guatemalan shawl draped over a blossoming tree branch, juxtaposing the beauty of design – both natural and man-made.

Contrasts That Complement stands as a splendid tribute to the quality and rich diversity of this remarkable couple's combined artistic production.

D. Scott Atkinson
Chief Curator and Curator of American Art
San Diego Museum of Art

Acknowledgments

No one deserves more thanks and appreciation for the words and pictures in this book than Eileen Monaghan Whitaker. She has been available every step of the way, meeting with me week after week, and providing full access to the meticulous records that she and Fred kept of their artwork, their lives as professional artists, and their personal lives. Working with Eileen has been pure pleasure, a privilege, and a most enjoyable experience. My heartfelt thank you to Eileen – with deep affection.

I wish to acknowledge the members of the board of the Frederic Whitaker and Eileen Monaghan Whitaker Foundation, in addition to Eileen, who have supported and guided this project from its beginning. My thanks to board members Frank Beiser, the secretary/treasurer, Jane Beiser, and Tom Bush, and also to the foundation director, Barbara Cox, who has helped with numerous details and has provided valuable insight on the artists from her perspective.

Always ready to lend a helping hand, from research to calls to museums and collectors to providing lists of paintings and whatever else I requested, the staff of the Whitaker Foundation has been most helpful. I wish to thank Lynne Walker, a professional always on top of things; Kathleen Onofrio, who assisted with information about collectors and museums; and Kristy Wulbers, who brings energetic enthusiasm to her work, as well as a can-do attitude. Tom Henry, attorney for the foundation, also has added his considerable expertise.

I am grateful to D. Scott Atkinson, the chief curator and curator of American Art at the San Diego Museum of Art, for his thoughtful foreword. It also was his task to make the final selection of paintings for the book, arriving at a well-rounded, representative survey of the Whitakers' work.

My hat is certainly off to the three essayists. Theodore F. Wolff has written a most insightful, solid piece on Fred, and did so with great charm and charisma. Robert L. Pincus's essay on Eileen shows deep understanding and appreciation of both the artist and her art. Donelson Hoopes has provided his expertise and skillfully placed the Whitakers in the context of the history of American watercolor.

Most of the paintings photographed for this book have been taken by Michael Campos, Campos Photography. My sincere appreciation to Michael for his skill as a photographer and his unwavering dedication to Eileen and to producing the finest quality of images. My thanks also go to his wife and partner, Peg, who has carefully seen to all the behind-the-scenes details of the photography. I also wish to acknowledge the photographers Aaron Lee Fineman, Ric Helstrom, Ken Howie, James Labrenz, and David Revette, as well as the Campus Center

Art Collection at the University of Massachusetts, Amherst, for the contribution of fine digital images of the Whitakers' paintings.

I am most appreciative of the art museums who have allowed the works in their collections to be photographed: the Metropolitan Museum of Art, New York; the Frye Art Museum, Seattle, Washington; the National Academy of Design, New York; the Museum of Fine Arts, Boston; the Hickory Museum, Hickory, North Carolina; the Museum of Fine Arts, Springfield, Massachusetts; the San Diego Museum of Art; the University of San Diego; Syracuse University, and the University of Massachusetts, Amherst. Also I must thank the collectors of the Whitakers' paintings, Tom and Bruni Bush, Wayne and Lauralee Bennett, Joan Schlossman, Charles, Jennifer and John Usher Sands, Steve and Beverly Berg-Hansen, Thompson and Jane Fetter, James and Jerel West, The Buck Collection, J. K. Kery, and the many collectors who wish to remain anonymous.

Many people have contributed, in a most encouraging and helpful way, with their knowledge of the Whitakers, of writing, of museums, and of art books. My deep thanks to Janice Lovoos, whose biography on Fred and whose friendship and correspondence with Eileen have been invaluable. The artist and writer Donald Holden has helped immeasurably in direction and guidance, and Kay Sloan, the president of the Massachusetts College of Art, and Annette Blaugrund, the director of the National Academy of Design, have been eager sounding boards as the project has progressed. Fred's granddaughter Linda Whitaker Martin transcribed Fred's unpublished autobiography, "I Marched in the Parade," for the computer and onto a CD and has been eager to help throughout the book's development, for which I am most grateful.

A hearty thank-you to Richard Reilly, the former curator of the Copley Library and art critic for the *San Diego Union*. His background information on Eileen and Fred has been most helpful and his continued interest and support is a treasure. Similarly, Jon Kery, a researcher, collector, and one of Fred's and Eileen's most ardent followers, has been available to provide detailed information on their paintings. It has been a pleasure to have his input and interest.

Always expressing great interest in this project and support for both Eileen and me, have been the members of our art group, the Circle of Ten. My thanks for encouragement, art savvy, and friendship to the artist Stan Sowinski and his wife, Jackie, the artists Kwan Jung and Yee Wah Jung, and the artists Barbara Madsen and Roy Madsen. A special thank-you to Roy Madsen, who sculpted the bust of Fred and edited Fred's third book, *The Artist and the Real World*, for providing delicious, quotable copy and for his expert consultation.

At Marquand Books, I am most grateful to Ed Marquand, Marie Weiler, John Hubbard, John Trombold, Linda McDougall, Larissa Berry, and Jennifer Sugden, who have been as determined as we have been to see that this is an outstanding art publication. I appreciate their patience, attention to detail, talent in design, and diligence in production.

Never least, but invariably last, I wish to thank the editor, Frances Bowles, who has shown great empathy for the subject and the writer while maintaining a clear eye for detail, a grasp of all ingredients in the book, and the necessary objectivity. She has pruned with patience and a bit of humor, sensitive to the writing – and perhaps even more important, obviously desiring, as do I, to present a most readable, informative, accurate, and interesting account of two exceptional individuals.

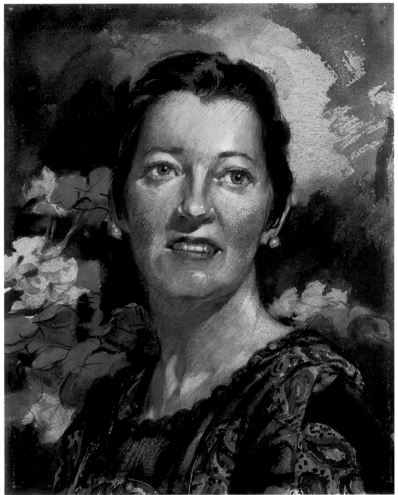

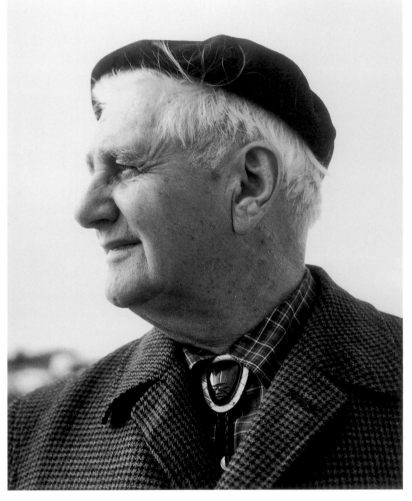

Frederic Whitaker, *Portrait of Eileen Monaghan Whitaker,* 1958
Watercolor on paper, 19⅜ × 15¹³/₁₆ in.
National Academy of Design, New York, 56-W

A photograph of Frederic Whitaker taken by Eileen Monaghan Whitaker, 1964.

Contrasts That Complement
A Biography

> No form of art can have enduring success
> unless it appeals to the generality of people.
>
> – Frederic Whitaker

> I'm not concerned with the average person.
> I must please myself.
>
> – Eileen Monaghan Whitaker

As artists who made their lives and their careers together and worked in the same style and medium – representational watercolor – Frederic Whitaker (1891–1980) and Eileen Monaghan Whitaker (b. 1911) might be expected to mirror each other. Yet they are a study in contrasts: differing in background, upbringing, education, religion, aspiration, and temperament, not to mention their motivation as painters.

Fred painted to convey his thoughts, to communicate, to take his viewers into his confidence, and to create paintings that might be enjoyed and understood by everyone. "That the artist simply 'expresses' himself is not enough," said Fred. "Messages are for the receiver – always." Eileen, in contrast, does paint to express herself, "a painting has to be right for me. I must please myself.... I have to be charmed or excited by something," and then, "my imagination takes over."

Of their thirty-seven-year-long partnership, Eileen says, "Fred was the intellectual and I the emotional one." Fred reflected: "I did not begin to live until I was fifty. This I attribute to our perfect relationship, understanding, respect, admiration and affection, for while our personalities differ, there is and never has been a semblance of conflict."

"Fred and I lived exactly the way each of us wanted to.... We worked together in every way, as equal partners, with great mutual respect.... It was a charmed life, as full and happy as any fairy tale."

Frederic Whitaker

Into the Well

When Fred Whitaker was a boy of fifteen, adventure, athletics, curiosity, and a love of the outdoors filled every available minute. The family lived in Cranston, a suburb of Providence, Rhode Island, and Fred and his friend Herb Scott spent all their free time in the fields and woods and on Blackamore Pond. They caught five-foot-long water snakes and would allow them to coil around their bodies for warmth. They explored the shafts of an abandoned coal mine. They slogged through swamps to find nests of red-winged blackbirds. On one occasion, they almost outdid themselves.

At the edge of a brook, Fred and Herb found the mouth of a drain lined with heavy planks. Intrigued, the two decided to climb in and seek its source. Crawling on their elbows, with no light, they reached the top of a pit surrounded by what appeared to be a stone rim. Still in darkness, they circled the rim, feeling their way to where the tunnel resumed on the other side. On they plodded in the dark, elbow after elbow, grunt after grunt. After "a long spell," they saw a glimmer of light ahead. They emerged triumphantly into the light only to find themselves at the bottom of a twenty-foot-deep well with no way up. "There was nothing to do but retrace our steps," Fred said, "if one can call elbow walking a series of steps." The well, which was 150 feet from the brook, was used as a catch basin for rainwater gushing down the hillside, and the mouth was covered with an iron grating. "This, I am convinced, was the silliest act of bravado in which I had ever participated. Had anything gone wrong, we would never have been found. I shudder when I think of some of the witless undertakings we essayed."

But the boy Fred Whitaker, shy and growing up in considerably less than affluent circumstances, was just like other youths of his age, curious. This curiosity and desire to do, learn, and experience new things encompassed every facet of his young life, from exploring drains to learning to box, from delighting in reading to learning algebra, from drawing flags meticulously to experimenting with smoking, from gathering and selling watercress to help with family expenses to being constantly wary of the self-serving and vicious nature of his older brother Dick.

From England to Rhode Island

Frederic Whitaker was born on January 9, 1891, in Providence, Rhode Island. His mother and father, Ada Hands and Edward Reginald Whitaker, had been childhood sweethearts in Birmingham, England, where their life was filled with the amenities that their successful parents could afford. Fred's paternal grandfather, Richard Whitaker, manufactured metal products including silverware, and his maternal grandfather, Thomas Hands, was a cabinetmaker.

Ada and Edward, who was known as Ted, courted, but by the time Ted was twenty-one, he was more restless than love-struck. He yearned for adventure. To the surprise and dismay of his family and of Ada, Ted joined the army as a common soldier to serve under Lord Roberts, who commanded British forces in Burma and in India. In the army, Ted was a bandsman, playing the French horn, and served as the band's custodian of instruments.

Ted spent nine years in the army and for nine years he and Ada corresponded. "As a child I read many of Pop's letters, which Mom had retained," Fred said. "They were factual descriptions of my father's activities, signed with the brief complimentary close, 'Love – Ted.'"

When Ted mustered out of the service and returned home to Birmingham, Ada was gone. She had sailed with her mother to join her mother's older sister, Kate, and Kate's husband, Bill, in America. Ada's father had died after a lengthy illness, paralyzed and bedridden after a stroke. For six years, Ada had cared for him. She and her mother sought a new life, settling in Providence.

On learning of Ada's whereabouts, Ted, too, sailed for America and tracked her down, assuming that they could pick up right where they had left off nine years earlier. "He called on her one Sunday," said Fred, recalling his mother's story. "They were married the following Wednesday. And that brought together, for life, as mismated a couple as one could imagine." Of course, Ted and Ada had no inkling of this, as they began their married life, if not as strangers, certainly as two who had been maturing under very different circumstances. Yet there was reason for high expectations.

Ted was a skilled craftsman – with the potential to be an excellent provider. He had picked up a knowledge of silversmithing and general metalworking at his father's factory. He was capable and a hard worker. When he arrived in Providence, he quickly got a job as a silversmith with the Gorham Company, where an unskilled laborer earned only nine dollars a week for a sixty-hour week. A skilled silversmith, Ted earned eighteen and then twenty-one dollars a week.

Within the first year of marriage, Richard, known as Dick, was born. Then came Roland, who died a few days after birth, Frederic, Harry, and Victor Herbert. Dick was three years older than Fred, Harry, two years younger and Victor five years younger. As the family grew, it did not prosper. During his roustabout days in the army, Ted had acquired a taste for beer, a thirst that depleted the family finances, not to mention its harmony. Ada was an abstainer, never so much as touching a drop of any intoxicant.

"It is easy to see that Ted was not the same man she had known in her teens," said Fred, "and that there could never be a meeting of the minds between them – and there never was." The marriage became one of constant quarrels, which the sons came to accept as the norm in family life. "On literally hundreds of occasions, I heard Mom exclaim: 'Oh, I wish I were dead!'" said Fred. Perhaps because of the family's continual financial struggle, Ada suffered severe headaches. "I can't recall a time when she was free of the trouble."

Fred's mother, Ada Hands Whitaker, n.d.

Quite naturally, the boys went their own way; there was "little rapport between us boys and our parents. We just didn't speak a common language." Fred's older brother Dick was mischievous and calculating. "With a mentor like Dick, who kept me up to his level of deviltry, I was always three years ahead of my time," said Fred. "Dick taught truancy, 'bad' things. I can't remember his ever having suggested anything uplifting." Harry was an easygoing, amicable, dependable boy, but younger than Fred, and Victor was the youngest, the baby. Thus it was Fred, who, perhaps by temperament, was the stable force in the family. He became his mother's confidant, the one she relied on and whom she expected to be responsible.

Naught but Bread and Tea

Home life for the Whitaker family was a matter of survival; of pinching pennies and wearing secondhand, makeshift clothes; of considering calf's head a treat but often settling for tea and bread; of always getting by on the barest necessities. It also involved continual moves, most a result of their ever-dire financial straits. "Between the time I was born and the time I was married, at twenty-one, we lived in no fewer than fourteen houses," Fred said.

Ted Whitaker, as a skilled metalworker, earned wages that should have been easily adequate for the family of six. He also earned a small amount of money doing odd jobs at home, such as repairing musical instruments. But it was the beertender, rather than his family, who flourished. When Ted was making

twenty-one dollars a week, Ada pleaded with him to allot her fifteen dollars to run the house, buy the family clothes, medicine, and so on. That would have left Ted six dollars for his chief vice, beer. "At five cents per 'schooner' (a very large glass with a handle), that would provide him with 120 beers per week," Fred figured, over and above the rack of twelve bottles delivered to the house weekly and paid for from Ada's household allowance.

But it was never enough. And the promise of fifteen dollars a week for family expenses was seldom kept. Lost work time spent nursing hangovers and assorted beer-induced incidents, ranging from the mildly serious to the silly, reduced Ted's income, and his increasing thirst whittled it down even further. Beer-drinking and saloon companionship became his overriding interests. "They were also the ruling influence in the lives of our whole family," said Fred. "It seems odd that one man's habits should affect the lives of so many others. I won't say the influence was detrimental to us, for we gained valuable knowledge, patience, understanding, and adaptability from it that more pampered surroundings would not have provided."

The biggest day of the week in the Whitaker household was Wednesday, payday. The family was often out of food by Tuesday, "and we all went through such days with nothing to eat," said Fred, "except we nearly always had tea." Often on Wednesday, Fred's mother sent him to the factory – "for I was always Mom's confidant, even as a little child, the one, and the only one, to whom she told her troubles and aspirations" – to meet his father the minute he got paid. "Pop would pass a few bills out to me through the window, and presto, we were in business again."

In order to make do on the tightest of budgets, Ada Whitaker often made knee pants and caps for the boys from their uncle's hand-me-down trousers or bought odd lots, sizes, and colors of goods at bargain prices. On one occasion she bought four pairs of ladies' dress gloves of calf, one green pair and three lavender. Three were for Dick, Fred, and Harry. "Mind you, these were to be our winter gloves for warmth," said Fred. On another occasion she took an old pair of ladies'

stockings, marked them around the outlines of Fred's hands, stitched around the marked line with her sewing machine, cut off the excess material, turned the creation inside out, and there were his mittens. And shoes? "It was up to us to adjust to them," said Fred. "We were never fitted for shoes in a store."

Out of necessity Ada Whitaker was a bargain hunter for food as well as for clothes, and no edible matter was wasted. "No food in our house lasted very long anyway," Fred said. Whatever the family had, it all "had to be eaten somehow, as when Mom tossed a pot of surplus porridge into a beef stew. She reasoned that barley is good in soup, so why not porridge in stew?"

His mother, said Fred, "abhorred things culinary, never looked at a cookbook, cooked everything by guess, and turned out concoctions that no one else had ever imagined. She baked our bread, for reasons of economy, and it was terrible, heavy and damp." Often bread, cut into pieces, soaked in milk, and sprinkled with sugar, was the evening meal. Calf's head, which cost twenty-five cents, was purchased whenever it and household funds were simultaneously available. Ada boiled the brains, held together with a piece of cotton cloth, and the family ate them with salt and pepper. The remaining parts were also boiled, poured into a mold to become headcheese, and served in slices. "But one thing Mom could cook well – and only one – was roast beef and Yorkshire pudding," said Fred. "That was a treat for Sundays" – an aitchbone cut, hard to carve and cheap!

Growing up in circumstances that today would be considered underprivileged, Fred assumed that that was the way everyone lived. Parents quarrel – often violently. Clothes never fit. One is always cold in winter. Payday is revered. Nothing should be wasted. Everything should be appreciated. "We children had no places of our own where personal properties, if any, might be deposited. . . . In judging life," he said (philosophically, years later), "I think of the norm as that followed by primitive man, so I am more than happy about any improvement over that condition . . . a little deprivation is a small price to pay for an understanding of values."

Conscious of the struggles of his parents as individuals, as a couple, and as parents, Fred was aware of their good qualities as well as of their limitations and was never judgmental. "Mom was affectionate, but not in a demonstrative way. We had great affection for our mother. My father contributed nothing other than the necessities of life: food, shelter, clothing," yet, he added, "I always had great admiration for my father, who was an unusually intelligent person, bold as a lion, and one of the strongest men, physically, I have ever known. He had only one weakness – drink."

Free-Range Children

Economic restrictions do not preclude fun. In a limited way, the Whitaker family did play together and enjoy their individual pursuits. In the children's younger days, they made a game of catching flies – often in their home. As the boys grew older, Ada would occasionally, as a treat, buy a quart of peanuts for ten cents and the family made a big night of playing cards for the proverbial peanuts, often staying up into the wee hours, long after the cookstove fire, the only source of heat, had died.

Sundays during the summers of the late 1890s found the family at the German picnic by Molter's Brewery in Cranston, just over the line from Providence. Tables and benches filled a large open area near the brewery and were available to picnickers for the beer they bought. The families brought lunch baskets, pitched in for a keg of beer, and when that went dry, the men anted up for another. Meanwhile, the men played baseball and quoits, a game similar to horseshoes, the women gossiped, and the children diverted themselves in whatever way their imaginations seduced them. Fred's imagination lured him to the brewery engine room to watch the engine at work. "With its enormous flywheel, and especially the two revolving balls that acted as a governor," Fred said, "I never tired of that spectacle."

Except in picnic season, Ted spent Sundays at a local speakeasy, drinking, smoking, and talking. Thursdays were Ada's days. She met without fail every Thursday for tea with a group of women, all formerly from Birmingham, England, to gossip, commiserate, and indulge in whatever treats they could reasonably afford.

Fred played baseball, kick the wicket, hide-and-seek. He made his own toys with spools from his mother's thread, once building a scooter to propel himself about, using a three- by ten-inch board to which he attached spools for wheels. He played with marbles, recycling the five-eighths-inch glass balls that were used as beer bottle stoppers into agates. He became skilled with tops, kites, and even bean blowers. "At a cent apiece, every child had a bean blower," he recalled. "I wonder that the guardians of public safety ever allowed such dangerous toys to be sold." Through his tenth year, before the family moved to Philadelphia, Fred swam, ice skated, fished, used paddle boats, and sailed small boats, all at Mashapaug Pond, a haven of diversion for kids in Providence.

For the most part in all these youthful diversions, Fred and his brothers and friends were left to their own devices. "Our play was never directed," he said. "We youngsters were left entirely alone to seek our amusement from morning to night, which often led to bizarre results – but of these we never informed our parents, voluntarily."

What about girls? "I can't remember that we, or at least I, ever played with girls – any girls. But on one occasion, Olive, a classmate of ours, invaded our elevated sanctuary (overlooking Mashapaug Pond) and insisted upon raising her clothes for a moment to show us the difference between the sexes. This, of course, was a revelation to me, and it started a train of thought which I am still pursuing."

Unrequited Love

"I was always bashful," said Fred. "In my whole school career, I never had the courage to ask help of a teacher or to converse with one in any way" – with one exception, Miss Dix, Fred's third-grade teacher, "with whom I really fell in love . . . the only teacher who ever showed me any individual attention."

Left to right: Fred, his cousin Maude Bellamy, and Fred's older brother Richard (Dick), mid-1890s.

The shy Fred had a few other crushes and bouts with unrequited love. There was Dolly Regester, who lived across the street from him in Providence. Fred was seven "or so," playing with kids on the unpaved road. "It was during these games that I was able to perceive the translucent, unmatchable beauty of this lovely young lady, Dolly. Unfortunately, it never occurred to me to declare or even suggest my passion, so she may go to the grave never having known of my ardor.

"It seems that I had always had an eye for female beauty – that of Ida Ziegler in the first grade, Statia Quigley and Edna Joyce in the third, to say nothing of the radiant Eva Seibel. But, alas, I had never even spoken to any one of these targets of my admiring glances."

The shy one was also the target of affection, that of Louise Thornton, in third grade. "She sat at my left, just across the table, and virtually every day she would reach over and place one or two chocolates into the open back of my desk," Fred said. "I accepted them with relish, but Louise, of dark and olive complexion, was of a type that did not thrill me. I am afraid I was a cad, playing the part of a kept lover without reciprocating. Frankly, I couldn't figure how any child could honestly come by a bag of chocolates every day, and, when she explained that her parents gave her ten cents on each departure for school, my skepticism was not diminished."

Fully occupied with a rigorous schedule of school, athletics, and then work, Fred was not distracted again by the fair sex until years later. When he was not quite twenty-one, he met

Marie Tiedge – and "promptly fell in love. She was my first girl, and I was her first beau."

A Young and Skinny Student

In 1901 the Whitaker family was uprooted. Ted had gotten into an argument with his boss at the Gorham Company, told him where to go, and walked out. Fortunately, he quickly learned through a newspaper advertisement that Hero Works, a glassmaking firm in Philadelphia, was entering the silverware business. Ted answered the advertisement, accepted a job as a metalworker, and the entire family moved from Providence to Philadelphia.

Fred enrolled in the sixth grade in Philadelphia's York Street Public School, where the scholastic standard proved to be far above that of the schools in Providence. If shy and bashful in school, Fred was nevertheless an attentive and obedient student, a natural resource waiting to be tapped. His teacher, Miss Ihrweiler, "was fat – or perhaps muscular –" recalled Fred, and "resembled a Prussian drillmaster." She insisted that students memorize their lessons. "This parrotlike method would elicit little enthusiasm from today's educators, but I have yet to encounter a routine that imports so much knowledge and fixes it in the mind in so short a time," said Fred. "This was remarkable training."

At the end of the year, Fred finished third in his class and received an affectionate and laudatory note of recommendation from Miss Ihrweiler. Dick, who was no scholar, was set back from seventh to fifth grade.

"Presumably everyone, going through life, meets a few individuals who impart a new insight into things and change one's course radically," said Fred. "Miss Ihrweiler was such an influence for me. Much as I learned from her while in school, I thought, during that time, that she was a complete misanthrope. I followed her orders through fear rather than admiration, but her final note revealed possession of the tenderest emotions." Because of Miss Ihrweiler's teaching that one year

in Philadelphia, Fred was able to complete the seventh, eighth, and ninth grades the following year when the family moved to Wallingford in Connecticut.

Though Philadelphia was a boon to Fred's education, Hero Works had not turned out to be as propitious for his father. Working conditions were poor and the management appeared half-hearted in its new commitment to the silverware business. So Ted quit and took a job in Wallingford with the R. Wallace and Sons Company, also metalworkers.

In Wallingford, Fred's eighth-grade teacher was Miss Seymour, whom he describes as "a tall young woman with extremely wide jaw bones" and whom he credits with introducing him to reading. "Each morning, she would begin the session by reading aloud to the class from a Horatio Alger book," said Fred. "A new world was opened up to me." Fred got a card for the Wallingford Public Library, "and from that date onward I was an avid reader, never sitting down at a meal or elsewhere without a book before me." He went through the Alger books and on, to Captain Mayne Reid, Edward S. Ellis, Edward Eggleston, G. A. Henty, Lew Wallace, and Rider Haggard, and then on again to more sophisticated works. "Reading has not only entertained me – it has set up high moral standards before me; it has contributed greatly to the modest fund of information which I possess, but, best of all, it has taught me how to learn, which, in my opinion, is the fundamental purpose of education."

At the age of twelve, Fred entered high school, the youngest student there. He was also skinny, weighing no more than ninety pounds, and, not surprisingly, bashful –"and I mean bashful," he said. "This business of jumping from sixth to tenth grade in one year had its disadvantages . . . I was conscious of my inferior dress, with ragamuffin knee pants and jacket and my twelve-and-a-half-cent shirt with detachable starched collar, which had to be worn a full five days each week." Then there were his classmates, most of whom had advanced physically to adolescence or even into adulthood: the boys were stout and muscular, the girls "all seemed fully developed."

Fred studied English, Latin, algebra, geometry, ancient history, English history, and drawing from casts. Not once did he ask a question or even have a conversation with a teacher. "The idea of becoming so intimate with the teacher as to ask a question of her privately would never have entered my mind."

In the four years while the Whitaker family was living in Wallingford, from 1902 to 1906, Fred went from schoolboy to factory worker, but during all that time, and after, his out-of-school or out-of-work hours were filled with athletic activities – despite his liking for books. He played football with a group of classmates, becoming an "efficient kicker, both in punting and in drop-kicking," and baseball, or went skating and swimming, or roamed the fields, often with his younger brother Harry and always with their fox terrier, Jack.

On one outing Fred and Harry discovered a place where watercress grew. They gathered it on Saturday mornings and sold it for five cents a bunch in the afternoons to shoppers on Main Street. They also came upon a place where skeet shooters practiced and collected "empty shotgun shells by the thousands," burned out the paper casings from the metal bases, and sold the scrap brass to a junk dealer. Along a railroad near their home, they gathered coal that had fallen from coal cars. "When a matter of saving material was involved, we youngsters needed no prompting. The understanding that nothing should be wasted had been well impressed on our minds." Fred and Harry also caddied at a Wallingford country club for ten cents an hour. For a brief time, they delivered the *Wallingford Weekly News* to every house in Wallingford for forty cents each per week and even helped with its printing.

Like his young friends, Fred learned to smoke. He graduated from smoking cane that had a "harsh, acrid taste," at the age of five, to smoking sweet corn silk, tea leaves, sweet fern, cubeb medicinal cigarettes, and finally, tobacco. By the time he was twelve, he was smoking Between-the-Acts tobacco-wrapped cigarettes and Old Virginia Cheroots, small cigars that came three in a pack for a nickel. Then, he said, "I got religion, like a

revival convert, and swore off smoking, swearing, and other vile habits." The religious fervor soon disappeared, he was quick to add, but he never again smoked.

Within a week after Fred's fourteenth birthday, the principal of Wallingford High School, after many attempts to dissuade Fred, granted him a discharge certificate. "It had never occurred to anyone in our family that a boy should remain in school after age fourteen," Fred said.

In the years that followed, Fred continued his passion for exercise and athletics, a pastime that was to last throughout his life.

After the family had returned to Providence in 1906, Fred and Harry, along with the sons of a neighbor who had an old barn in the yard, outfitted a gymnasium with horizontal bars, trapeze, flying rings, punching bag, hanging rope, overhead horizontal ladder, and the like. On Sunday mornings, "Pop would drop in to show us a few stunts," said Fred. Soon Fred bought a set of boxing gloves, and then "Pop would drop in" and critique Fred's skills, saying: "I'll put the gloves on with you."

"This, mind you," said Fred, "after his having rolled into bed the night before with a full load of beer aboard." And, not incidentally, "Pop didn't box. He went in for the kill. But one lesson I did learn was how to parry, block, roll, and side-step, so that Pop was seldom able to connect with one of his crushers." After a summer of practice, however, Fred seized the moment during a Sunday morning bout and landed a right-hand blow to Ted's head, blackening his eye and knocking him off his feet. "He was then forty-nine and I sixteen. That bout signified Pop's retirement from the ring, but not from other muscular activities." Fred continued to box, sparring with many partners over the years, including a navy heavyweight boxer. "He had no defense," Fred said. "He wasted no time with it. His motto was Attack!" From him, as he did from most people and situations in his life, Fred learned a lesson: "If we take time to answer or defend ourselves against unreasonable objections raised by others, we'll never have time to achieve our worthy objectives."

To Work at Fourteen

Fred's first job, shortly after he turned fourteen, at the M. Backes Company fireworks plant in Wallingford, was to run a machine that made giant firecrackers. One of his tasks was to make a paste, cooking the mixture until it became very thick and the rising bubbles burst languidly. The paste, an explosive, was used to fill cylinder rockets. On one occasion, when he had failed to boil the paste sufficiently before filling the cylinders, he heard a whirring sound. Then a red cannon cylinder blew apart like a released steel spring. "This was followed by another, and another," said Fred, "until the whole heap was hopping and popping like corn over a flame." The exploding cylinders were firecrackers performing prematurely, exploding randomly until all were spent – some ten thousand of them. "From that first, unsupervised step of my first steady job, I learned two valuable lessons," said Fred: "how to make paste properly and not to make the same mistake twice."

At the time, Fred, who was always slight as a youth and did not really begin to grow much until he was sixteen, weighed ninety-seven pounds "and eagerly looked forward to reaching a hundred." His second job, secured for him by his father, followed quickly on the heels of the first. At R. Wallace and Sons Company, where Ted worked, Fred became an errand boy and did odd jobs in the metal-spinning department. As an errand boy, frequenting all departments of the factory, Fred had the opportunity to meet artisans in all disciplines, to watch them work, and to ask questions. "By the time of my sixteenth birthday, I could describe in minute detail every operation of silverware manufacture."

Fred took on a series of jobs within the company, each one paying a bit more than the last. When the Whitaker family moved back to Providence, where Ted took a job at the W. J. Feeley Company, Fred began working as a chaser's apprentice for the William J. Braitsch Company, manufacturers of ornamental umbrella and cane handles of gold, rolled-gold plate, and silver. His take-home pay turned out to be a disappointing

and paltry $1.75 per week. After a few weeks, Ted determined such pay was far too little and ordered Fred to quit. Fred "left Braitsch to let them get along as best they could without me." Next, for Elmwood Mills in Providence, manufacturer of shoelaces, Fred applied metal tips to the laces. "This paid me good wages, six dollars weekly, so I remained there until Pop got me a job in which I really found myself." The job was with Ted's own employers, the W. J. Feeley Company, manufacturers of ecclesiastical metalware in gold, silver, bronze, and brass. Ted persuaded the company designer, John Gabriel Hardy, to take Fred on as an apprentice.

On the strength of the flags that Fred drew, copying them from color pictures that came with each pack of Sweet Caporal cigarettes, which dominated the smoking market then, Ted considered Fred a "born artist." The color pictures of flags, and later of Spanish-American war heroes and political figures, were an advertising gimmick. "I copied the flag pictures with colored crayons, and I soon knew the designs of virtually all [the] national flags," said Fred. "When guests came, Pop would say: 'Fred, draw a flag.' I was careful to reproduce only those requiring little ingenuity. I realized my shortcomings even if Pop did not."

The position with Feeley ended his series of machine operating jobs and introduced Fred "to the manufacture of religious articles," which he pursued until his retirement from business. Fred began his apprenticeship with the London-born Hardy in 1907. Fred was sixteen; Hardy was thirty-six. "He was the first gentleman I had met," said Fred, and "he had more to do with the crystallizing of my outlook than anyone else – even my own father. I learned by observation and emulation."

Fred's first assignment was to make an accurate, detailed, pen-and-ink drawing, in actual size, of a thirty-inch-high, elaborately decorated ostensorium, or monstrance (a receptacle used in the Roman Catholic church to display the Host after it has been consecrated). "Naturally I hadn't the faintest idea of how to proceed . . . and struggled along for several days." Hardy, watching Fred attempting to draw an acanthus leaf cusp, nudged

him to get up, then sat down in his chair and picked up his pen, saying, "This is really a very beautiful leaf. Notice that it goes like this" – and with a natural flowing movement of his pen, drew a perfect acanthus leaf. "I could have cried from mortification and frustration," said Fred, but "once I had grasped the fundamentals, I knew that art was my métier." That was the beginning of Fred's meticulously drawn and careful renderings in watercolor of a wide variety of highly detailed objects.

In addition to designing for the company, Fred learned mechanical drafting and became the factory paymaster and estimating accountant. To further his education and practical knowledge, he obtained a state scholarship for night classes at the Rhode Island School of Design, where he studied charcoal drawing from life for four years. These classes met three times a week, from 7:30 to 9:30 at night. He also took a "cheap correspondence course in pen-and-ink drawing" and allotted to its study two hours a night for the four remaining nights of the week.

This routine left Fred's weekly time tally at fifty-five hours for work, six hours for school, and eight hours of self-imposed drawing at home. Between factory closing and the opening of night school classes, he had an hour and a half for another activity of his choosing: poring through art books in the Providence Public Library. He followed this routine religiously. "It was good training, which gave me an understanding of the value of time." In this tight schedule he allotted Saturday afternoons and the Sunday daylight hours to athletics: boxing, running, pole-vaulting, shot put, and the like.

Though now a working man, the young artisan turned his wages over to his mother to help with household expenses and in return he received an allowance. From that, in addition to his necessities, he indulged in two weaknesses: for fifteen cents, a quarter pound of chocolate-covered almonds to last him from payday to payday, and for ten cents, a copy of *Life*, a humor magazine that published pen-and-ink drawings by some of his favorite artists, Orson Lowell, Charles Dana Gibson, and Gordon Grant.

The W. J. Feeley Company, which was established in 1870, was the first factory in the United States to manufacture metalware religious articles for the Catholic church. Previously, such articles were imported from Europe. During Fred's first seven years there, "W. J." was his employer, but he worked directly with Hardy, the head designer. When ownership transferred from the Feeley family to the McElroy family, who had been investing in the company, Robert McElroy, the son of the primary investor, was given complete charge. Bob McElroy had been working in the company for a number of years to gain experience and to watch over his family's interests, though, as Fred pointed out, "no one ever discovered just what his duties were." McElroy was, Fred reported, a friendly, enthusiastic person, but his interests were often frivolous, often fleeting, often expensive, and rarely productive. His most notable contribution to the company was to establish an English afternoon tea hour in the designing room. "The tea parties were designed for Bob, his luscious young secretary who never had anything to do, a few guests, and members of the designing staff," said Fred. When word spread about the afternoon parties, so did the number of employees attending. As McElroy moved on to other diversions, spending less time in the office, the tea parties petered out, much to the designers' delight, not only for the prized leftovers they inherited – fancy biscuits, Bar le Duc jams, cream cheese, and other dainty treats – but also for the restoration of peace and quiet.

"Despite his reputation as a light-headed ne'er-do-well," observed Fred, "Bob had an active and discerning mind, did his own thinking, was generous and warmhearted, always a perfect gentleman, and was extremely well-informed." A good businessman, he was not. Nor was his ear tuned to his senior employees. When Hardy, the head designer, had a disagreement with a customer, McElroy ordered Hardy to apologize. Convinced he was in the right, Hardy refused, and resigned his position. McElroy then named Fred head of the design department, entrusting him with a fairly free rein. For Fred, the incident was a boon. He was twenty-three, with a huge opportunity

before him. For the company, the incident heralded McElroy's growing lack of interest in its business operations and in its lasting success.

During the next six years, Fred designed and supervised the production of hundreds of articles in gold, silver, brass, and bronze for priests and other dignitaries of the church, and even some that were presented to Pope Pius X and Pope Benedict XV. "Unfortunately, I kept no personal record of them, and the factory records disappeared with its dissolution," said Fred. "But throughout my life I have realized the value of having been a designer, an inventor of sorts, and a mechanical draftsman, for in these lines one is compelled to calculate and to know how things are done – not in a general way, but down to the finest detail."

Fred worked for the Feeley company for thirteen years, until it closed "for reasons that can easily be imagined," he said. "McElroy absented himself more and more from the plant, the financial condition of the firm worsened, and eventually orders were given to liquidate the business gradually." But not before McElroy, wanting to do something for "key figures in the establishment," offered Fred and Bob Mangan, the office manager, the opportunity to buy rosaries from the company's inventory to resell for themselves and retain the profit. The two formed a partnership, the Esmond Company. Fred took orders in his own name from Feeley's regular customers and scouted for new ones in Boston and New York. The rosaries were shipped from the Feeley plant and billed by Esmond, which paid Feeley the wholesale price after the rosaries had been sold. Fred and Bob Mangan each made four thousand dollars before Feeley closed its doors.

Marriage in a Heartbeat
Completely wrapped up in his education and his work and blowing off steam in rigorous athletics, Fred had little time to hone any social skills. "I knew absolutely nothing of social life," he said. "The first girl I went out with, when I was close to

twenty-one, was the girl I married. I couldn't dance – in fact, I was a complete ignoramus in all teenage interests."

Fred met Marie Tiedge one Sunday afternoon when he and his boyhood friend Herb Scott were exercising on their horizontal bar. Herb's father had asked the boys to show a house he had just finished building to a widow and her two daughters. The younger was Marie. "Before [I was] twenty-one we were engaged and before [I was] twenty-two we were married," said Fred.

The marriage marked the second in a short list of two occasions on which Fred's father gave him a gift. The first had been when Fred was six years old and Dick, nine. Father and sons were out for a walk and passed by a pastry shop that had a tray of cream puffs in the window. Dick and Fred implored their father, but to no avail. Ted walked right by the shop. Then, stopping with some fanfare, he handed Dick a nickel and told him to go back and get a cream puff for each of them. The second gift to Fred was a ten-dollar bill – his wedding present in 1912.

Fred was making eighteen dollars a week as a designer at the W. J. Feeley Company. A year after Fred and Marie married, a son, Frederic Herman, was born. Another son, Teddy, was born two years later but died of diarrhea before his second birthday. Their only daughter, Marion, was born in 1918. "On being married, neither of us knew anything about life," said Fred, "about sex, about social contacts, or about anything else so necessary to domestic success. We fumbled along and learned by trial and error."

To compound the problems of two naive youngsters struggling with the unknowns of a life together and with a family, Fred developed what doctors called nervous indigestion. "Each doctor restricted my diet slightly more than his predecessor until eventually I was eating little more than canned spinach," Fred recalled. "My regular weight should be about one hundred and seventy-five pounds, but I was reduced to near one hundred and twenty-five." This condition continued for nearly nine years. Eventually, tired of the advice of his doctors and of other people, "I decided," Fred said, "that, if I were about to die, I could die

without further attention from doctors. I began eating what I wanted to eat and within a year or so was back to normal. I am convinced that my only real trouble at that time was starvation."

For many reasons, starvation included, Fred describes those first ten years of married life as "truly . . . a nightmare." His interests and Marie's were vastly different and rapidly diverging. While Fred was progressing in his design career, painting watercolors on the side, joining local art societies and longing for companionship and friends who shared his interests, Marie was wholly immersed in her family.

"Marie was a wonderful housekeeper," said Fred. "She was a devoted mother, an excellent cook, a willing and hard worker. Through her diligence, the house and our two wardrobes were always kept in perfect order." But there was a catch. Not only did Marie feel that the family came first, but also "she wanted to carry the principle so far that it excluded contact with virtually everyone else who might desire a status closer than that of acquaintance," said Fred. "She resented our acquiring any interests that failed to apply directly to the home." For Fred, this became stifling.

One particular situation spotlights the frustration of their marriage. During the 1930s Marie had inherited from an uncle a fourteen-room house on a three-acre site on the outskirts of Providence. Fred thought it would be grand to have it become a gathering spot for artists, writers, educators, and the like, a place for sharing and developing myriad interests. In Providence at that time, College Hill was the center of cultural activities. Through the Rhode Island School of Design, Brown University, and the Providence Art Club, all located there, Fred met many of the city's most outgoing citizens and those specifically interested in and talented in the arts. Fred envisioned the spacious house that Marie had inherited as yet another cultural hub for the city. Marie, however, would have none of it. "She had a fixed suspicion of artists per se," said Fred, "charging that they were intrinsically parasitical." Over and over again Fred was made to realize that "Marie would do anything under the sun for me

that she thought would help me, but she would never raise a finger to give me anything I asked."

Evelyn Lincourt, who had been Fred's secretary at the G. H. Seffert Company, recalled that "Mr. Whitaker's daughter Marion said her mother would do whatever pleased her children but refused to even meet any of her husband's friends and associates. She was a simple German hausfrau who wanted a 6 a.m.- to 6 p.m.-husband, who would come home to supper and schnapps every night. She remained that, but he kept growing and expanding his world."

In time Fred set up a studio behind his office at the plant, where he could paint and on occasion entertain others who shared his interests in the arts. Eventually he only slept at home and the only meals he ate with the family were Sunday lunch and dinner. "Naturally such a schedule could have only one ending," said Fred. "The divorce was granted in 1950, after twelve or fifteen years of virtual separation. It should have been sought long before."

In addition to dealing with his own immediate family life with wife and children while he was still in his twenties, Fred had to deal with the infirmities of his parents and the preoccupations of his brothers. Fred's father was stricken with cancer and bedridden for nine months before he died in November 1918. He was sixty years old. Ted was buried on November 20, the day that Fred and Marie's daughter Marion was born. During his father's final months in bed, Fred constantly heard stories about Ted's cavalier escapades and experiences in the army. They seemed to roll freshly and vividly from his father's memory – or perhaps imagination. "Rudyard Kipling's stay in India corresponded almost exactly with that of my father," said Fred. "And my father's stories corresponded perfectly with those of the characters in the great author's books."

Upon his father's death, Fred's mother was left destitute, what little they had always going to the bartender and then to the doctor. Marie's mother was living with Fred and Marie, so Fred suggested that his mother join them. "This," said Fred, "was rejected flatly by Marie, who counseled, 'Let your three brothers

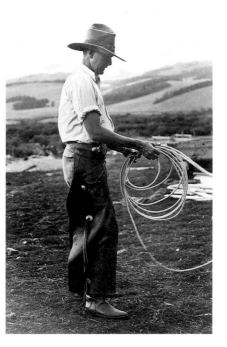

Fred Whitaker working as a cowboy during an extended vacation at a dude ranch in Colorado, 1930.

do something.'" By nature easygoing, Fred conceded that he "was provoked to observe that Marie judged her own mother by one rule and mine by another."

At the time of their father's death, both Dick and Harry were married and Victor was in the navy. The brothers met and decided that each would contribute a fixed amount weekly so that their mother could remain in her home. In reality, because of some hardship or another, Harry and Victor contributed little. "Dick, still working full-time, never paid one cent to Mom," said Fred. "But, knowing that I delivered to her each Wednesday what was now a contribution several times that agreed upon, Dick called on her each Thursday morning before going to work and actually 'borrowed' money from her. The galling aspect of my situation can be imagined." Marie felt that the situation proved that Fred was "gullible," and, if his brothers didn't help their mother, why should Fred? "Our unenviable condition was compounded," Fred said, by the fact that Marie had a point: she "and I had no more than our own brood needed."

Fred's mother, also stricken with cancer, died in 1922, four years after his father. She was sixty-two.

The Designer and Entrepreneur

When the Feeley Company closed, Fred went to work for the Gorham Company in Providence, designing special ecclesiastical metalware, bronze tablets, and memorials. He worked under Lionel Moses, who had begun his career with the architect

Stanford White. Fred was given the unusual or special jobs, but all his show drawings were signed: The Gorham Co. – Lionel Moses, A.I.A. "My own name never appeared on the designs," he said, "but on sculptured memorials and the like, the bronzes carried my name as designer along with that of the sculptor."

At Gorham, Fred had moonlighted. He, Bob Mangan, the sculptor Aristide Cianfarani, and Charlie Williams, a specialist in plaster casting, started a business making objets d'art out of a mixture of plaster of Paris and glue (Fred called it "campo"), which sets extremely hard. They made candlesticks, plaques in the style of Andrea Della Robbia, and comparable novelties, finished in subdued colors and gold with a fine patina.

Working at night, Fred designed the articles. Cianfarani made the models. Williams did the casting. Mangan was the salesman. "Our products were sold to the best stores in New York," Fred said. "I am still impressed with their artistic excellence. But we made no money, so we closed the place. We learned the great truth that all businessmen know and that others will not believe, namely that it costs more to sell an article than to make it."

During this time, Lionel Moses left Gorham to become the head of Stanford White's own firm, McKim, Mead, and White, in New York, and was replaced by "Young Billie" Codman, the son of "Old Billie" Codman, under whose artistic direction, Fred recalled, "the Gorham plant had grown to become the largest silversmithing factory in the world." Most of the designers and modelers there, whose experience had been only at Gorham, felt that the younger Codman was a "tyrant" and "they were morbidly afraid of losing their jobs."

Fred took the change of command more casually. "I found Young Billie reasonable enough," said Fred, "although, a few weeks after his arrival I received notification that I was discharged." That was in 1921. At Gorham at the time, Fred was among the elite, making $250 a month, paid twice a month, by check, which was considered quite impressive then. From Gorham, Fred went to the Tiffany Company in New York City, again as a designer and as understudy to the head designer, Arthur Barney.

Marie did not move to New York when Fred joined Tiffany and, after a short and difficult period of weekend commutes to Providence, struggling to pay for an apartment in New York and the family's expenses in Providence, spending his evenings "planning the designs for the following day" because he "was anxious to show Barney that his faith . . . was not misplaced," and taking time off for daily treatments for an infected cheek, Fred decided that the logistics, economics, and physical and emotional drain were not worth the "grind." At the suggestion of a former colleague, Bill Peck, who had been the factory manager for the Feeley Company, Fred returned to Providence in 1922 to sell church furniture and small religious articles for Peck's business, the Cathedral Art Metal Company. Fred also designed and sold some of his own pieces. He met up with Bob Mangan again in Providence and the two of them set up another religious goods business, the Mangan Company, and would take turns in making sales trips on the road. For the first year, living on their savings, they took neither wages nor expenses. "From the time I was eighteen, I had made it a rule to save something," said Fred, "little though it might be, from my earnings, and at that time my nest egg amounted to three thousand dollars." Fred was thirty-one.

After the first year, with a large inventory on hand, Fred borrowed a thousand dollars from the Union Trust Company to expand the contacts and sales efforts; within three or four years, the Mangan Company was worth a hundred thousand dollars. In 1933 Fred sold his interest to Mangan. "Of my eleven years in the Mangan Company, I spent probably one-third of the time on the road, selling to Catholic priests and nuns in the various convents," said Fred. "At one time or another, I made calls on virtually every convent and Catholic institution east of the Mississippi."

In 1934, Fred purchased the bankrupt religious goods firm of Foley and Dugan in Providence and began building it up. The merchandise consisted mainly of small, personal religious articles such as rosaries, medals, crucifixes, prayer books, and

religious picture cards. In addition to overseeing design and manufacturing, Fred was a salesman. "I can think of no training that will teach one more about human nature, about business, about what makes our economy function, and about getting along with others than that of selling – and by selling I do not mean the taking of orders brought to one, but traveling about and rooting out business."

In June 1941, while successfully running Foley and Dugan in Providence, Fred purchased another religious goods firm, the run-down G. H. Seffert Company in New York City, for the value of its inventory. Foley and Dugan sold its merchandise directly to priests and nuns; the Seffert Company sold to church goods retail stores throughout the country, giving Fred an entry into the wholesale market.

"Within a few years," recalled Evelyn Lincourt, Fred's secretary at the plant, he "turned the G. H. Seffert Company from a limper to a sprinter. Fred was multi-gifted: an excellent business-man, a super salesman, a superb organizer, and a considerate boss. He ran a tight ship with a light hand." During the first six months alone, the company's sales increased by 600 percent.

Then came Pearl Harbor. Fred's son Fred, who was to take over the Seffert operation, volunteered to serve in the navy, but was rejected because of his height, being six feet four inches tall. So he signed on as an enlisted man in the coast guard, and then took officer training at the Coast Guard Academy. Fred's daughter Marion, who had just graduated from the Rhode Island School of Design, took charge of Foley and Dugan in Providence. His son-in-law, Donald Thurston, who had also become one of Fred's key assistants, signed up for service in the Army Air Corps. Fred shuttled between New York and Providence, spending the weekdays at Seffert and the weekends in Providence consulting with Marion at Foley and Dugan. Because of the war, workers in both places were primarily women. Almost all of the metals out of which most religious items are made were rationed and "procurement be-came difficult indeed. . . . Despite the difficulties," said Fred,

"business boomed and we made good money selling all sorts of religious articles." Much of this was due to Fred's ingenuity.

In great demand were necklaces of sterling silver for the miraculous and scapular medals worn by women and nickel silver for the same kinds of medals in larger sizes and simpler designs for men. Fred had originated the idea of using nickel silver bead chain – the kind used by electricians and plumbers for light pulls and other practical purposes – to make men's neck chains to be worn under the clothes. "When the utilitarian qual-ity and really attractive appearance were recognized by the mili-tary, everyone demanded bead chains," he said.

Fred also improvised a rosary made entirely of bead chain, with beads in three different sizes. "We had them made in nickel silver by the Bead Chain Company of Bridgeport, Connecticut, then we plated them with silver or chromium and added our own crucifixes and centers." The chains did not become tangled, as link-chain rosaries do. Because of their pleasing appearance, strength, low price, and resistance to wear, they quickly became popular throughout the country.

Other rosaries came from farther afield. Most of the reli-gious goods sold in America at that time traditionally came from Europe, but during the war, that supply was shut off. In 1942 Fred set up a rosary-making establishment in Mexico, and be-fore long every American religious goods distributor was using Mexican-made rosaries. These dealings in Mexico and with Mexicans introduced Fred to a country that, later, as an artist, he was to explore thoroughly.

Books of instruction for Catholic children were another staple for Fred's enterprises. This aspect of the business involved Father Lord of Saint Louis, Missouri, who was the author; Sam-uel Lowe of Kenosha, Wisconsin, the printer; and Fred and his companies, the publishers and distributors. "I used to think," said Fred, "that American tolerance and understanding was well illustrated when we three, Father Lord, the Jesuit, Samuel Lowe, the Jew, and I, the Protestant, would confer at luncheon on what next to offer to the Catholic youth."

One day, while running both Foley and Dugan and G. H. Seffert, Fred received a call from John Locke, an artists' agent, who said that John Pike, one of *Colliers* magazine's best illustrators, was in Egypt with the army and that *Colliers* would like Fred to replace him. "No offer could have pleased me more," Fred said, "but nearly frantic from running two establishments in separate cities, I was forced to acknowledge that the end was unattainable."

By the end of the war, the Seffert Company, installed in more spacious quarters, was doing several times the business of Foley and Dugan. When the younger Fred was discharged from the coast guard, he took charge of Foley and Dugan and, when Donald Thurston was discharged from the army air corps, he joined Fred in New York as general manager of the Seffert Company. In 1947, Fred purchased a small jewelry factory in Pawtucket, Rhode Island, to help with manufacturing. "Soon after, realizing the disadvantage of so spread out a set-up," Fred said, "we decided to regroup the three outfits under one roof." The younger men, who loved boating and the other attractions of living near the seaside, as well as a slower pace, voted for a base in Providence, and the enlarged plant was established there in 1949. Shortly after, Fred retired from business. He was fifty-eight years old. He sold the plant to Fred and Don at book value, to be paid for through promissory notes extending over twenty-five years. "Naturally I knew there was a fair chance of my time running out before that of the notes," Fred said, "but as Fred and Marion were to be my heirs anyway, that did not matter." In retiring from business, Fred planned to devote himself to painting, writing, involvement in art societies and with friends in the arts – and a new domestic life.

The Ostensorium

In 1938, the Roman Catholic Archdiocese of New Orleans sponsored a competition for the design and production of an ostensorium to be used for benediction by His Eminence Cardinal Mundelein of Chicago at the Eighth Eucharistic Congress in New Orleans. The design of church metalware requires knowledge of religious ceremony and custom and of historic styles of architecture and ornament. The ostensorium was to be of solid 14-karat gold and platinum, designed in the Italian Renaissance style, and rich in symbolism. It was to weigh no more than twenty-five pounds, so that it could be elevated easily by the cardinal.

In this field, Fred was among the best known. He had been approached by the Gorham Company of Providence and the Watson Company of Attleboro, Massachusetts, to prepare designs for them on a freelance basis. Fred declined them both. "If I were to enter the competition at all, I should want to make the ostensorium itself as well as the design," he said. Furthermore, he said he had retired from that type of work and was not interested. Then, in March that year, just ten days before the competition deadline, one of the principals of the New Orleans jewelry firm of Bernard and Grunning visited Fred in his office in Providence to ask him to design and make the ostensorium. "In view of his eloquence and the special trip he had made, I agreed to handle the job," Fred said. The two resolved verbally that, in all publicity announcements about the work, the name of the firm of Bernard and Grunning and the name of Frederic Whitaker, as designer and maker, would be mentioned together.

"I went home to work and within a week a full-size colored design of the forty-two-inch monstrance had been worked out," said Fred, "together with detailed drawings of the individual parts, from which the sculptor and the many workmen – silversmiths, chasers, metal spinners, engravers, enamelers, stone setters, metal molders, jewelers, and others – could estimate the time required for their services." The finished piece included innumerable emblems, coats-of-arms, figures, precious stones, and allegorical representations. Over a field of twenty-four competitors, including two from Europe, Fred's design won.

The archbishop, His Excellency Joseph Francis Rummel, described the ostensorium, which is now one of the treasures of the Cathedral of Saint Louis in New Orleans, as "the most beautiful and most expensive piece of religious goldsmithing

ever executed in this country." The vessel was set with a hundred thousand dollars worth of diamonds and other precious stones, which had come from parishioners in churches throughout Louisiana, who donated everything from extravagant diamond brooches and earrings to gold dentures and eyeglass rims to old gold, precious stones, and jewelry of all kinds.

Before being sent to New Orleans, the ostensorium was displayed in the window of the Tilden Thurber Company, the leading dealer of objets d'art in Providence, under police guard. "The viewing throng was so great that the main thoroughfare of the shopping district was packed from one side to the other and traffic had to be rerouted," said Fred. Then the Railway Express Company's armed guard accompanied the ostensorium, by air, to New Orleans.

In Providence, Fred adhered to the publicity agreement with Bernard and Grunning. In New Orleans, Bernard and Grunning did not. "For at least ten years they boasted the work, in print, naming themselves as the designers and makers," said Fred. "Aside from handling standard jewelry, I imagine the development of the monstrance was the only special commission of importance with which they had ever been associated."

Eileen Monaghan

Celebrations and Vacations

The Fourth of July was a special day both for the Monaghan family and for the immediate neighborhood. "My father would buy several large brown paper bags of fireworks," Eileen says. "He'd hide them from us kids until early evening of the Fourth. As it got dark, we'd gather around the streetlight, and he'd bring them out, one at a time. There were brilliant sparklers. All kinds of firecrackers. And he'd shoot off missile-like fireworks that burst into showers of blazing colors – of course, nothing like we see today, but thrilling. We'd hear the crackling and popping of the firecrackers, an occasional loud boom, and our eyes were glued to the sky to catch the next burst of color and light. What excitement!"

Then came the letdown. The show was over. "But after a spell of disappointment at what we thought was the 'end,'" Eileen says, "Papa would come out with another bag of fireworks, then more after that. All the kids in our immediate neighborhood gathered at the Monaghans' for the real holiday celebration."

The Monaghan household was a center of neighborhood attention for another reason. "We had a telephone for as long as I can remember," Eileen says. "Our number was 2326. We were among the few families in the neighborhood with a phone." Because of this, the Monaghans received telephone calls for families throughout the neighborhood. "Each of us kids was called upon to deliver messages or to call neighbors to the phone."

Music also played a big part in their family life. Eileen's father played the piano, drums, and harmonica. As a boy he had played in a drum corps that toured the New England states and he encouraged his children to learn to play an instrument. Most chose the piano; Eileen chose the violin. "My father was always singing," she says. "After dinner we would frequently all gather around the piano. My father would play and lead us in singing – I know all of the old songs, even real old ones."

Another treat for the family was Sunday afternoon rides. Eileen's father loved cars, trying new models as they came out.

"He had touring cars long before I was born," says Eileen. "We went for a ride almost every Sunday afternoon – usually all eight of us. And we had wonderful, carefree vacations." Each summer the family would go to a farmhouse in the Berkshire Hills, to a village near a lake, or to a summer beach resort in Connecticut.

The Charm of the Irish

Eileen Monaghan was born on November 22, 1911, in Holyoke, Massachusetts. She is the fifth daughter of Thomas Francis Monaghan, a Holyoke native, and Mary Doona of County Kerry, Ireland. Mary had come from Ireland to the United States with two sisters to live with an aunt and uncle in Northampton, Massachusetts. "The aunt and uncle were people of means," Eileen recalls. "They had a beautiful, large home and my mother became a favorite." As it was related to Eileen, her parents met at Skinner's Silk Mill in Holyoke. The owner, Bill Skinner, was a friend of Mary Doona's uncle and he offered the young girl a job. "One day my father, who was doing some electrical work for the owner, spotted 'a lovely young girl outside, at the water pump,'" says Eileen. "He asked Bill Skinner who she was – was advised that she was very special – and was introduced to Mary Doona." Or as Tom Monaghan was soon to call her, Molly. Molly Doona and Thomas Francis Mcnaghan were married shortly after – on June 22, 1900.

Tom Monaghan was born on August 2, 1874, and grew up in South Hadley across the Connecticut River from Holyoke. His father had been born in Ireland and Tom cherished his Irish heritage. From the beginning, Tom Monaghan was a success. Even as a youth, he was talented and sharp. At the age of fourteen, he had been given the opportunity to work with an electrician, who had learned his trade, during the embryonic period of electrical research, under the direction of Charles Proteus Steinmetz, a master electrical engineer who is best known for his research into alternating current, commonly known as household current.

Always curious, Tom Monaghan let nothing get by him without learning something from it. Early in his career, he worked for a few electrical factories and wired many businesses, buildings, and some residences for electricity. Before Eileen was born, he had wired for electricity homes where the Irish-American sculptor Augustus Saint-Gaudens (1848–1907) and the English writer Rudyard Kipling (1865–1936) were staying.

During Eileen's childhood and well into her adult life, her father served as superintendent of Fire and Police Alarm Systems for the city of Holyoke. "Actually, he was called the city electrician," Eileen says. "He could invent or improvise mechanical and electrical devices for whatever purpose was needed. He was capable of solving mechanical and functional problems through his imagination and with his own hands."

Monaghan's interests were boundless, as were his friends and business associates. Generous to a fault, he was blessed with an easygoing affability, attracting the goodwill of all. He and Molly were the children's greatest boosters, encouraging them all to develop their individual talents.

In contrast to her naturally gregarious husband, Molly Doona Monaghan, a devoutly religious person, was gentle and loving, yet reserved; sociable and giving to all, yet not the type of homemaker likely to take time out for ladies' afternoon teas. Eileen's mother could be counted on for genuine friendly conversation, neighborly interest, and a helping hand when needed, but the focus of her life was raising her family.

"It was Mama who encouraged us in the everyday details of our lives," Eileen says. And it was Mrs. Monaghan who was the disciplinarian in the family. "I was often scared of her," says Eileen. "We all were. That is, when we figured that maybe we had done something we deserved to be scared of her about! She was strict." Perhaps both because of and in spite of this strictness, Eileen's affection and respect for her mother are unrivaled. As Eileen was growing up, instead of expecting a birthday present on her birthday, she gave her mother a present.

Molly Doona Monaghan was born on July 16, 1873, in Killorglin, a village in County Kerry, Ireland. One of seven children, she was a particular delight to her grandparents. Through

their generosity and encouragement, she was able to attend a convent school in Killarney.

To Molly Monaghan fell the "responsibility of bringing up us children." Organized and dependable, Molly was a good cook and an excellent seamstress. "I now realize she was an early health nut, very nutrition conscious," says Eileen. "Mother baked everything, bread, cookies." The Monaghan children never had white bread, only whole wheat, and very rarely bought cookies or candy at the grocer's as the other kids in the neighborhood did. Molly also knew the merits of being miserly with salt. "Mama was very creative in her cooking," Eileen says, "trying different things. My favorites were her lamb stew and gingerbread."

When it came to their wardrobes, the Monaghan children were quite posh. "Mama made many of our clothes as we grew up and would do so from sketches we'd make – never using commercial patterns, but often cutting rough ones of her own from newspaper. I had some stunning outfits," says Eileen. "I always wanted to be different."

Eileen picked up this flair for sewing. Throughout high school and college, and during her commercial career, which included fashion design, she loved and wore fashionable clothes. She would often design, make a pattern, cut out, and sew up an outfit all in a day.

As well as being the disciplinarian, chief cook, and family seamstress, Molly Monaghan managed the household finances. "My father was generous and a soft touch," says Eileen, "He realized his lack of discipline and left those matters to Mama." Tom Monaghan gave his regular salary to his wife. "But he made loads of money at extra jobs," Eileen says. "He was always busy with some new project and had all kinds of patents on things he invented."

Ireland held a particular fascination for him. "When my eldest sister was about two years old, my father decided he must see Ireland," Eileen says. "He took about a year off and the three of them visited the 'old country.' He fell in love with the country and the people, and for the rest of his life he told countless stories of his 'adventures' in Ireland." Tom Monaghan enhanced the stories with a fine grasp of the Irish brogue and a bit of showmanship. "He made everything he told us seem alive," Eileen says, "no matter how many times we heard the stories, over and over again, throughout our growing up." This gift of "telling stories" was part of Tom Monaghan's everyday life. "Papa could entertain us just telling about events of his day," Eileen says. "It didn't have to be Ireland. He could take something that happened at work or with someone he just met, and make it fun to hear about."

Comfortable and generally happy, the Monaghan family experienced but one inhibiting ingredient in their lives: Mrs. Monaghan's staunch religious beliefs and the strict rules that spilled over into every part of their lives. "We all grew up in the Catholic faith and we were all good Catholics," says Eileen. "Mama was unwavering. One of the things we never talked about at home was sex. Even when we were all grown up, and some of us married, sex was not freely discussed. My father was a healthy, warm-blooded man, very much in love with my mother, and he never gave up courting her, even in their last years."

A Close-Knit Family

"If anyone didn't worship all of us," Eileen says about her siblings and parents, "we'd think, what's wrong with you?" Yet, theirs was a house full of individuals with different interests, talents, and temperaments; of individuals who remained loyal and supportive throughout their lives. The Monaghan children all grew up in the same house at 54 Gates Street, a comfortable residential section of Holyoke called Elmwood. Though discipline was strict, theirs was a life of considerable comfort and privileges.

Ten years Eileen's senior and the first-born of the Monaghan children was Mary, a vivacious, outgoing girl and the intellectual of the brood. "I idolized her," Eileen says. "She was the one who started everything and we all followed her" – even in drawing on the walls. "The stairway to our attic was pure white delicious plaster, and my mother, who was such a strict disciplinarian,

Left to right: Eileen's brother Kevin, Eileen Monaghan, and her sister Frances (Franny) in Holyoke. Massachusetts, c. 1917.

allowed us to draw on these walls to our hearts' content. We all loved to draw!"

Mary paved the way to art school and, as the younger sister, Eileen remembers "drinking in all the things she had to say and reading all the taboo books she read." In addition to this commitment to art, Mary was a fashion devotee, "way ahead of the 'provincials' in our town," says Eileen.

Next came Kathy. "She was so smart, exceptional in music, a genius at the piano," Eileen says, "but very high-strung." Both Mary and Kathy were stricken during epidemics of diphtheria and scarlet fever. Mary recovered completely, but Kathy developed an ear infection, necessitating a number of surgeries. Throughout her life, the ear problem was a source of constant irritation.

Connie was the fun-loving daughter, an attractive girl who loved dating and outings and had no interest in pursuing the life of an intellectual.

The fourth Monaghan daughter was Claire, who died in early childhood during the diphtheria and scarlet fever epidemics, and Eileen remembers little about her.

Then came Eileen, who later took Claire as her middle name when she was confirmed. A quiet, easygoing child, Eileen was enthralled with whatever she experienced. People fascinated her – a fascination that was to continue throughout her life. "I get all involved with individuals," she says. "My mind just whirls around them, their appearance, their manners, their lives, what

we talk about. I can sketch a face, a shirt, or maybe a shawl or dress that excites me. A casual visit, and I will go on building up images and 'creations' for hours, or days." Fortunately, Eileen and Connie were not affected by childhood epidemics, and neither were the two youngest Monaghans, another daughter, Franny, who came after Eileen, and, finally, a boy, Kevin. "My father called them the tinkers," Eileen says. "They were always into mischief. Kevin was a precocious little guy, a real rascal – and Franny was in cahoots with him."

Mary was ten years older than Eileen; Kathy, seven years older; Connie, five years older; Franny, two and a half years younger; and Kevin, five years younger. "I was happy to be in the middle," Eileen says. "The three older ones probably had a lot going on between them. So did Franny and Kevin. I just sailed along and did my thing, involved as much as I wanted to be, whenever and wherever I wanted to be.

"There was never any real dissension between us. As a matter of fact, I remember we were always laughing when we came to the dinner table." About the only time Eileen recalls her father admonishing the kids, to use the term loosely, was when he cautioned them to stop laughing when they were eating. "You'll choke," he warned. "But with my father, we could get away with anything."

Another important family member for Eileen as she was growing up was Aunt Kitty, her mother's eldest sister. "Aunt Kitty had an unhappy marriage, left her husband, and became bitter about men," Eileen says. "But she was wonderful to us kids. Her interests centered around our family." Aunt Kitty lived downtown in Holyoke and frequently spent Sundays or weekends with the Monaghans and occasionally invited one or other of the children to spend a night with her in her apartment. "She had beautiful, artistic things," Eileen says, "and she loved to cook special dishes. She also had a charge account at B. Altman in New York, and we kids used to wear some of the most stylish clothes – far more sophisticated than our friends. One year we were the only kids in Holyoke to have bright

yellow slickers with sou'wester hats. I loved being different from the other kids."

From Aunt Kitty, as well as from their parents, the Monaghan children learned of their Irish heritage. Kitty taught them the Irish brogue and introduced them to classical Irish music and folk ballads. For each of the children, she had high goals, her encouragement echoing that given by their parents, who were both avid readers. "Our home was filled with books and magazines," Eileen says. "There was always something we could be reading and someone in the family was always reading."

Tom Monaghan reveled in doing special things on certain occasions for each of his children, encouraging them to follow their interests and talents. "When I was in the ninth grade, Papa promised me a string of pearls if I made the honor roll," Eileen recalls. "I made it. I got my string of pearls – and I stayed on the honor roll." While the other Monaghan children were learning the piano, Eileen studied the violin, walking the mile and a half every week for lessons, beginning in the sixth grade. She was first violin in her junior high school orchestra and in the Holyoke High School Orchestra.

Languages were a particular source of enjoyment for her in high school, and she studied Latin for four years and French for two. Mrs. Monaghan thought perhaps Eileen should go to Mount Holyoke College to major in languages with the goal of teaching. "But I also loved to draw," Eileen says. "I was drawing all the time. Everything that excited me. Our art classes in high school were pretty primitive, but my art teacher, Miss Linn, encouraged me. She persuaded my mother and father to let me go to art school in Boston, then the Massachusetts School of Art, now the Massachusetts College of Art or MassArt, a state-run art school." That was no small feat of persuasion.

Mary had studied art in college, at Boston University, at the Boston School of Practical Art, and at Yale, but had had no luck whatsoever in finding a job in the field. After an aggressive search that yielded only sporadic work, she gave up on art and took a job as the secretary to the Society of Professional Engineers

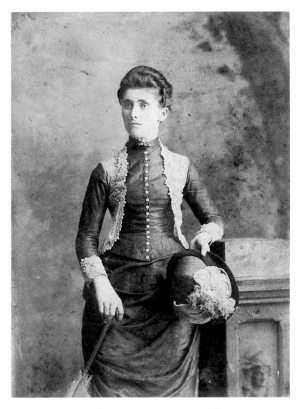

Eileen's Aunt Kitty (Catherine Doona Ormond).

in New York City. As far as Mr. and Mrs. Monaghan could see, there seemed no point, therefore, in sending Eileen to art school.

Somehow, the persuasive Miss Linn convinced Eileen's parents that Eileen had talent, that it should not be wasted, and that she definitely should go to art school – that, indeed, she *must* go to art school. The point that won them over was that Eileen could get a degree, not simply in art, but in teaching art. "And off I went to Boston, thrilled with the opportunity – and scared. Weren't our parents unusual? To let each of us go our own way?"

The *Holyoke Transcript* noted her departure in the fall of 1929:

> Miss Eileen Monaghan of Gates Street, daughter of Supt. of Fire Alarms and Mrs. Thomas F. Monaghan, entered the Massachusetts School of Art this week. She graduated from Holyoke High School last June and won the prize offered the high school student by the Holyoke League of Arts and Crafts for the greatest skill shown in art classes. Miss Monaghan made quite a reputation at high school for her clever drawings.

Wider Horizons

Eileen, who knew no one in Boston and had never lived away from home, entered the Massachusetts School of Art when she was only seventeen. "And boy! Was I lonesome," she says.

After living alone in one rented room, she moved in with Anna Harris of Utica, New York. A few years older than Eileen, Anna was studying at the School of Practical Arts in Boston in the evenings and worked during the day. "We exchanged hours of conversation and thoughts on art and religion," Eileen says. "She was a terrific influence on me. During the four years at MassArt, I learned about life as well as art. It was exciting to meet new people after growing up in a sheltered small town. Boston was an ideal place for a young person starting a new life. It was a cultured, cosmopolitan city.

"For two years I lived within a couple of blocks of Symphony Hall and attended performances of the Boston Symphony Pops. One year I lived next to the Boston Museum of Fine Arts. My last year in college, I lived in Cambridge, adjacent to Harvard Yard."

Eileen's course of study during the first two years of the prescribed schedule for all art students included drawing from casts in charcoal and drawing from the nude model, and classes in composition, design, watercolor, oil, modeling in clay, and casting works in plaster. There also were courses in architecture, city planning, jewelry making, and art history.

The instructor in art history was Miss Ella Munsterberg, who, for one of their assignments, asked the class to make drawings of masterpieces, each student selecting a different era and artist. Eileen has no recollection of what she chose to draw, but does remember that a classmate, Catherine Sherman, decided to work with Leonardo da Vinci's *Virgin and Child with Saint Anne.* Unbeknownst to Eileen, Catherine used Eileen as the model, and the result was a drawing that Catherine titled *Eileen Monaghan in the Style of St. Ann.* Catherine did the drawing in 1931. More than fifty years later, in 1984, she gave it to Eileen.

In Eileen's junior year at MassArt, she began taking the courses in teacher training that would lead to a bachelor's degree and allow her to teach art. The courses included sociology, psychology, crafts, and practice teaching. "It didn't take me long to see that, for me, the idea of teaching was a mistake," Eileen says. "I was not cut out to be a teacher – I realized that the minute I walked into a practice teaching class. Furthermore, I was learning methods of teaching, but nothing about being an artist. So, at the end of my junior year, I switched back to Costume Design and spent my fourth year in that division."

College years also were a time of broadening social experiences. "In high school I had a couple of crushes on boys, but I was so bashful," says Eileen. "I had a few dates, but nothing romantic." During summer vacations in college, Eileen worked as a waitress in a small summer hotel in Branford, Connecticut, where the Monaghan family used to vacation. The waitresses were college girls, the bellhops college boys, and each group had its own dormitory. "We were one big happy family," says Eileen. "It was one of the most thrilling experiences of my life. We earned twenty-five dollars a month, paid in full at the end of the summer, plus modest tips. We ate all we wanted from the same menu as the guests."

Then there was John "Mickie" McDonald, a student at Georgetown University, who lived in Stony Creek, not far from

Eileen's graduation picture from Holyoke High School, 1929.

Eileen Monaghan, right, with her friend Catherine Sherman in Fenway Park, Boston, 1929.

Branford. "He courted me in his sailboat," Eileen recalls. "I remember he looked terrific in a white suit and white calf shoes." Eileen and Mickie corresponded throughout the school year and dated during the summer. "We had great fun. It was fresh, exciting, carefree. But we were too young to be serious."

Meanwhile, Eileen was getting serious about where her studies might take her and eager to get out of school and into her chosen field – fashion illustration. "At the end of my fourth year, I decided to quit college, instead of continuing for another year just to graduate." (The credits she had earned in the teacher training curriculum did not count toward a degree in fashion illustration, so she would have had to continue for another year in order to receive the diploma.)

"I decided to go to New York City – to seek my fortune! I had so much enthusiasm and ambition, it was impossible for me to realize that it was 1933 and the country was in a depression."

Art as a Paying Proposition

"Everywhere I went [in New York] people were being laid off – rather than hired," Eileen says. "It was a terrible time to find a job. But somehow, I hadn't a clue that the Depression had anything to do with me." But at least she had a place to live. "Mary's apartment was in Tudor City on the east side of Manhattan, overlooking the East River.... A wonderful place to live. Boy, did we live high on the hog. Filet mignon every night! Well, almost."

Mary was still working for the Society of Professional Engineers in the Grand Central Station Building. She supported them both and Eileen found her first job – "to use the term loosely," Eileen qualifies. "It was with Percy Toff in a miserable loft on East Thirty-eighth Street. I designed ladies' neckwear. Since I had no experience, I was to work on designs, and I would be paid for any that were sold – forget any regular pay!" Eileen produced dozens of samples every day, working diligently for weeks with not even a hint of compensation. After nearly three months, Mary insisted that she and Eileen check the neckwear departments of various stores to see if, perhaps, Eileen recognized any of her designs. She did, and they found several. Eileen confronted Mr. Toff, who said that they must have slipped his mind and gave her a check for twenty-five dollars. "Mary's first reaction was 'Tear it up,'" Eileen says. "Then 'No, cash it,' but that was the end of Mr. Toff's job."

This episode was followed by months of freelancing on-the-spot drawings and visits to her parents' home in Holyoke and to New Haven, Connecticut, where she stayed with her sister Franny, who was expecting her first child. Franny had eloped in her teens with Gilly Bush, a young man she had met while she and Eileen were working during the summers in the Branford resort. While staying with Franny, Eileen found work designing box covers for a laundry and producing fashion illustrations for a department store. But this was definitely not New York.

Soon Eileen returned to the convenience of Mary's Tudor City apartment and found her first real job as an assistant stylist at the Syndicate Trading Company, a buying office on Madison Avenue that represented numerous department stores throughout the country. Eileen's salary was fifteen dollars a week for a five-and-a-half-day week. "I spent most of the mornings in whole-sale districts sketching new items," Eileen says. "In the afternoons in the office, I did finished illustrations for bulletins which were sent to buyers to acquaint them with what was 'in' and available to them. Most of my work was in women's fashions, sketching

the latest vogues, but I was also called upon to sketch just about anything and everything a department store handles.

"Almost anything I reported on I could buy at wholesale prices, a 40 percent discount. That included furniture, electrical appliances, kitchenware, and gift items in addition to fashion items. It spoiled me for life!"

Eileen's immediate boss was Marion Wright, a woman ten years her senior and very knowledgeable about fashion. She trusted Eileen's talent and judgment, allowing her considerable leeway to work at her own pace. When possible, that pace

Eileen, left, and her sister Franny in 1932 at Montowese House in Branford, Connecticut, a small resort hotel where both worked as waitresses during the summer.

turned out to include the luxury of later morning starts, for which she compensated by working well into the evenings.

The real excitement of the job came with the large fashion shows at New York hotels, the conventions for buyers who came to town, and the exhibitions at the opening of each season, the most important being those in the fall. "At fashion shows, I sketched all the fashions, including how things were made. I sketched quickly as the models walked down the runway, and by the [time I had finished] my sketches, I could have made any of the outfits." Her skill as a seamstress and her flair for fashion design enhanced her ability to capture the fashions in her drawings. "I have never confused commercial art with fine art, but my experience in commercial art has been invaluable," Eileen says. "I gained a facility in making quick, sharp observations and sketching them quickly. At the Syndicate and with Marion, I picked up a tremendous knowledge of the fashion industry."

After living with Mary during her first year at the Syndicate, and after having stayed with Franny and husband Gilly when their baby, Thomas, was born, Eileen lived with her sister Kathy and Kathy's husband Norman Jamieson in Pelham Bay for two years while still at the Syndicate. "I commuted on the Pelham Bay Subway into Manhattan," Eileen says. "It took three-quarters of an hour and I was able to read the *New York Times* in the morning and either the *Sun* or *World Telegram* in the evening – even in the clamor of rush hour."

During these years, Eileen quite matter-of-factly enjoyed her sisters' hospitality. "In retrospect, I wonder how my sisters and brothers-in-law were so kind and generous to invite me to live with them. I didn't fully appreciate it at the time. I was never allowed to contribute anything." Then, as if seeing a lightbulb flash, Eileen said, "I have just realized that I have never really supported myself."

Throughout those early years, while she was working as a commercial artist, the family was her most important social involvement. "I had no intimate friends of my age – and this

was a disappointment," Eileen says. "I dated some. Nothing serious. I worked with agreeable, friendly people, but we had nothing in common. Basically, I was wrapped up in my career, learning all the time."

Then in December of 1936, family concerns took on even greater importance, severing Eileen temporarily from her career. Her mother was suffering from bronchitis and was advised by her doctor to go to Florida for the winter. Eileen took a five-month leave of absence to accompany her parents, and the three of them went to Hollywood, Florida, for a winter of sunning, swimming, and trips to Fort Lauderdale and Miami. When they returned home in May 1937, Mrs. Monaghan was in good health. But, says Eileen, "it was a difficult time for me, not working, not accomplishing anything, and living with my parents after having been away from my mother's strict rules."

For one thing, Eileen, who was then twenty-five, had been smoking cigarettes since high school, a fact she concealed from her parents, knowing they would disapprove. By this time, she was smoking a pack a day. "I realized I'd be with them for five months, so I went ahead and smoked," Eileen says, "inwardly scared stiff. They had a few things to say about it, but accepted what they realized as the inevitable." (Eileen quit smoking in 1952.)

After returning to the Syndicate, Eileen received a raise to eighteen dollars a week. Within a year, she was itching to work on a more advanced level, to find another job where she could continue learning and growing. She left the Syndicate in the summer of 1938, but before doing so, had to take another unexpected leave.

"I had a ravenous appetite, but kept getting thinner all the time," says Eileen. "I was running around with boundless energy – couldn't sit still. And I would often have nervous spells." After several metabolism tests, it was determined that she needed an operation to correct a hyperthyroid condition. As it turned out, most of her thyroid was removed. Gradually she regained her strength, and her voice, which she had lost for some time, and once again was eager to seek new challenges.

Eileen with her mother at her sister Mary's home in Pleasantville, New York, 1939.

"I was determined to follow my earlier goal of being a fashion illustrator . . . in a department store, an advertising agency, or a studio in that field." What immediately followed was a freelance job at a local paper in White Plains, producing advertisements for a women's specialty shop. Then, on the recommendation of John Boetel, whom Eileen had met while interviewing for another job, came work as a fashion illustrator and layout artist for Genung's Department Store, which was also in White Plains. "Boetel said I should develop what he thought was my natural tendency toward design," Eileen says. "I became art director of Genung's, which was a small chain of stores in Connecticut and Westchester County, New York." But Eileen really wanted to work in New York City – and soon Boetel himself had a job for her in his new art studio on West Fortieth Street in Manhattan.

"These art studios and services were common in New York City then," Eileen says. "A group of specialists in commercial art worked together to supply stores, advertising agencies, and other clients with complete artwork for their advertisements." Boetel specialized in women's and children's fashions and Eileen was hired to do layouts and illustrations.

There Eileen met Isabel Bosserman, who worked for Boetel periodically as an illustrator. Eileen and Isabel became friends, went to art exhibitions together, and to the ballet and

Members of the Monaghan family at the home of Eileen's sister Mary and her husband Lou Kent in Hartsdale, New York, c. 1942. Left to right: Eileen's mother, Mary, Mary's toddler son Joe, Eileen's father, her sister Connie, and Eileen.

opera, and vacationed one summer in Nantucket, bicycling, sketching, and sunbathing. "She was a stunning girl, intelligent, well dressed, a good friend," Eileen says. "But she was a misanthrope. She had an unfortunate love affair years earlier, which left her embittered toward men. I was just the opposite, full of enthusiasm, optimism, in love with almost everyone."

During the short time she worked for Boetel, Eileen learned a great deal, but after several months, he left his studio to accept a job as advertising manager for W. T. Grant, a nationwide chain of department stores with headquarters in New York City at 1440 Broadway. In 1941 Eileen became the layout artist for Alexanders, a department store in the Bronx. In a short time, she was made art director and given her own office – which "I had painted in reds and pinks. I loved this job," Eileen says. "I had a good friend here, Adelaide Watson, the fashion illustrator. The advertising manager said he had great plans for me, that the store had a great future, that there were exciting plans for expansion, and that I would be part of the future success."

But as the year 1943 wore on, Eileen found that she wanted to work on a larger scale. "I felt I could learn nothing more at Alexanders, with no one except myself for competition. So, when John Boetel offered me a job at Grant's as assistant art director, at a much higher salary, I accepted." Eileen started at sixty dollars a week.

W. T. Grant was a large operation. All the advertising for the chain was produced in its New York offices. As assistant art director in charge of layouts for fashion, accessories, children's clothing, and shoes, Eileen was responsible for the appearance

of the advertisements from start to finish. She also handled the monthly promotional material for fashions and the artwork for fashion openings.

"I loved working there," she says. "The work was stimulating. I was constantly on my toes, since the standards were high, and I was constantly learning. For the first time since leaving college, I had an interesting, lively, intelligent group of co-workers and friends. There was a lot of talent in this office." Yet, much as she loved Grant's, that restlessness to move on, to learn more, to seek challenges, struck again. She sent letters, including references, to art directors at several advertising agencies.

Shortly thereafter, Eileen, then thirty-two, was interviewed and offered a job as the assistant to the art director at Chernov Advertising Agency in the Empire State Building. The art director was Beverly Gussow, a redhead "who had the temperament of a redhead," Eileen says. "Though I liked her in many ways and learned quite a bit about design from her, she wasn't my ideal. And I had very little in common with any of the people there. So I decided to seek work elsewhere."

Eileen's next job offered a slight change of pace: she became assistant to the art director for *Boys' Outfitter*, a trade magazine for the boys' clothing industry. The offices were in the old Flatiron Building on Fifth Avenue at Broadway and Twenty-third Street, at the southwest end of Madison Square, and fairly close to Greenwich Village. When she began, in 1945, her salary was eighty-five dollars a week. Her main job was to do layouts for advertisements. In 1946, she was promoted to art director. This was another job she enjoyed, working continually, setting her

own hours and schedule, staying late in the evening if she felt like it. "I remember often cutting out a dress from a piece of material – on my drawing table – and putting it together, pinning, and sewing it," Eileen says. "In a day or so I'd have a new dress!"

By 1947, she decided she deserved a raise. After surveying the advertisements produced by the art department, she found that she was doing 80 percent of them. With tangible proof in hand, she pointed out this lopsided statistic to her boss. Promptly, her salary jumped to the hundred dollars a week that she had requested. A sponge for work she enjoyed, she also found time to squeeze in freelance work.

In 1949 Eileen retired from a full-time career in commercial art to devote herself to painting, other freelance projects – and a new domestic life.

More Contrasts

Learning from One Another

Just as the family circumstances for Fred and Eileen were different, so were their siblings. For instance, once, in 1904, when Fred and his younger brother Harry were roaming the meadows and woods near their home in Wallingford, they spotted a crow's nest in a tall tree near the Quinnipiac River. In it was a brood of young birds. "We took one and carried it home to make a pet of it," said Fred. They mixed cereal with milk and spooned it into the tiny bird's "eager, gaping, and noisy mouth" and cared for it as their pet, watching over it as it grew to adult size. The bird became very attached to both Fred and Harry, following them about and often alighting on their heads or shoulders. "His favorite perch," Fred said, "was the peak of the house from which he could spy us at a distance and fly down to greet us."

One afternoon, when Ted and their older brother Dick were leaving Wallingford for a new job in Providence, Dick caught the crow, the cherished pet of his brothers, and beheaded it with an ax.

"I could recount tales of Dick's aberrations indefinitely," said Fred. Once "he threw the hatchet at me as I ran, after I had refused to help chop down a neighbor's tree. The whirling hatchet struck my shoulder, fortunately with the back end rather than the edge of the blade." On another occasion, "he threw Harry to the ground and rubbed a cut lemon into his eyes, threatening to ruin his one sound eye." The other eye had already been blinded in an incident masterminded by Dick – an explosion of dynamite caps in the Whitaker kitchen when Harry was only seven. "And," in an incident that still rankled, "to demonstrate his own generosity, he presented a fellow worker with my postage stamp collection, on which I had worked for ten years."

Dick had begun work at the age of thirteen for a glass manufacturing firm and, at the age of fourteen, became a silversmith apprentice with R. Wallace & Sons, where Ted worked. Like his father, Dick continued as a silversmith.

"No one could complain of Dick's industry," Fred said. "He was always a hard worker. . . . When times were bad, he didn't hesitate to seek substitute work. . . . Industrious though he was, Dick could put more effort into trying to beat the system than it would cost to play it straight. He never learned what Robert Frost epitomized so effectively: 'The best way around is through.'"

A far different person was Fred's younger brother Harry, his companion in many outdoor adventures. "Harry could rightfully be called a gem of the first order," remembers Fred, "always complaisant, anxious to help, and as honest as they come. . . . No one ever asked Harry for cooperation without receiving it." He, too, left school early and, at the age of fourteen, began work in the bronze factory of the Gorham Company; he became a builder and installer of architectural bronze.

During the Depression in the 1930s, when the silver and bronze business collapsed, but Fred's business was doing well, Fred offered jobs to both Dick and Harry. Harry was put in charge of the packing and shipping department and then of the die, tool, and stamping department, running both efficiently and staying with the firm until he retired. Dick began work in the assembling department. Soon he was borrowing money from other employees, collecting money from the bookkeeper, money that, he said, Fred had authorized, and in his characteristically malevolent way, was spreading tales among Fred's workers that "had them at each other's throats. Finally, I had to tell him that, brother or no brother, I could not afford to have the place disorganized and that he would have to leave," Fred said.

Fred's youngest brother Victor was "handsome, courageous, alert, and intelligent, and when more mature, the kind of pal you'd feel secure in having at your side," Fred recalled. Because Victor was considerably younger, he played with friends of his own age while growing up. An outdoorsman, he loved to hunt and spent much of his teen years roaming the woods with his rifle and their dog, Jack. After service in the navy in World War I, he worked at a number of jobs in Shapleigh in Maine, where he met and married Louise, a girl who was visiting from Marblehead, Massachusetts. The two moved to Rhode Island and Vic worked briefly for Fred as a salesman, but quickly realized he was not cut out for that kind of work. Vic tried a number of other ventures, all unsuccessfully. "Louise was a good sport," Fred said, "and carried on until 1940, when they separated. The two were deeply in love with each other, but their living patterns were incompatible." Never really finding his niche, Victor died of pneumonia when he was just forty-two years old.

Whereas Fred and his siblings grew up in an atmosphere colored by Dick's ill will and the family's misfortunes, Eileen, all four of her sisters, and their young brother Kevin, grew up in a comfortable world and were encouraged to pursue their talents. Yet, only Eileen, and to an extent Kevin, stuck with a commitment to art.

Mary, who went to art school first, and then cheered Eileen on as she studied at MassArt, and even supported Eileen in her early career, was her idol. Mary worked as a secretary and married Louis J. Kent, the founder of Kent-Bragaline, a firm that sold high-quality fabrics to interior decorators in New York. They lived, with their son, Joe, in a beautifully designed home filled with antiques and objets d'art.

Kathy, like all her siblings, grew up drawing on the walls of the stairway to the attic, but she took her art no further. She married Norman Jamieson, who was in the construction business with his father. Norman loved the outdoors, especially hunting and fly-fishing. Kathy and Norman had two sons, Kevin and Norman, who also became enamored of fly-fishing as they grew older. Kevin was three years old and Norman just an infant when their father died of lung cancer, leaving Kathy to raise the children alone. She became a school nurse.

Connie, too, became a nurse. She also painted. "Con was terrific from the very beginning," Eileen says. "She had her own style, but she never took herself seriously." Though she had many beaus, Connie never married and she moved with the Whitakers to California in 1965.

Franny, who had been very bright in school, had no interest in art. She eloped right out of high school with Gilbert "Gilly" Bush, who worked initially for a meat packer, then later for a steel company. "Franny was a natural homemaker," said Eileen, and "a marvelous mother." She and Gilly had three children, Tom, Mary Ann, and Dorothy. Franny was one to get the most out of every minute; sadly, she died of breast cancer at the age of fifty-eight.

The Monaghan sisters also had a brother, Kevin, the youngest. "My father was ecstatic when Kevin was born," Eileen says, "but they never really got along, as Kevin was so independent." As a youth, Kevin was brilliant and likable, if an intellectual snob. "He never could conform," Eileen says. "He was a character, clever, witty, doing exactly what he wanted." Fortunately, he was good at what he did: he played the piano professionally in Connecticut, being billed as the "Prince of the Piano" and reviewed as the "bearded Liberace of Westnor Restaurant"; he painted and exhibited his work in competitive exhibitions; and he loved to travel and meet interesting people, intellectuals for the most part. But he always kept in touch with his siblings. Writing to Eileen from Bologna, Italy, in a letter dated May 10, 1949, Kevin said: "Delighted to hear that you've done a picture that you like – the sketch and description sound really like something very good – suppose it's another of your prize-winners."

In another letter to Eileen, written from Dublin, Ireland, in 1965, after Fred and Eileen had moved to La Jolla, California, Kevin remarked: "I remember your life watercolor drawings at Mrs. ? life sketch class and being amazed at what emerged from the simple directness of your brush – a gift from God. . . . Darling, your pleasure and happiness delight me and I now await news of your new world."

Of all of Fred's and Eileen's siblings, Kevin was undoubtedly the most colorful, multitalented, and memorable person. "Fred and Kevin hit it off right away," says Eileen. Even so, said Fred, remembering Dick, "Virtue makes no headlines. Violators of the code naturally provide the most arresting, if not the most inspiring, incidents."

A Life Together

Saint Valentine's Day, 1943

Given Fred and Eileen's long and happy marriage and a life, as Eileen says, "as full and happy as any fairy tale," their meeting, the overture, aptly took place in an art gallery in New York – on Valentine's Day. With a week's vacation from Alexanders, Eileen decided to visit Kevin at Fort Benning in Georgia, where he was stationed, having enlisted in the army a few months before Pearl Harbor. At the last moment, Kevin sent a telegram: "Don't come. On maneuvers in Louisiana."

So, with a week free and no plans, she scanned the Sunday art sections of several New York papers and noted a few exhibitions of interest in galleries on Fifty-seventh Street, the art gallery center of Manhattan. One was advertised as Whitaker – Watercolors at the Ferargil Galleries. Not only was watercolor her favorite medium, but also the show had received good reviews. Emily Genauer, the art critic for the *New York World Telegram*, observed that "Whitaker, for a practicing silversmith, for anyone in fact, is singularly free and spontaneous in his work. . . . Perhaps this is because of the clarity of his tone. Maybe it derives from the strong rhythms of his designs. Possibly it is due to their atmospheric quality. At any rate, [the paintings] speak eloquently of his technical skill, of his imagination, and of his poetic, romantic feeling toward nature." The reviewer for the *New York Sun* commented that "Mr. Whitaker has a smooth and controlled technique in watercolor. His pictures ought to soothe and beguile picture-lovers who wish to keep their poise."

"What a revelation," says Eileen, "walking into that room full of the most stunning, incredible watercolors I had ever seen." A young gallery attendant asked if she would like to meet the artist. "Naturally, I said yes."

After a brief introduction, "Mr. Whitaker and I went through the exhibition," Eileen recalls. "He discussed several of his paintings and we talked about watercolor in general. I was

impressed and inspired by the way he used the medium. I had never seen such vigorous, fresh, and yet solid watercolors before. I also thought Mr. Whitaker was a very nice man."

Fred Price, the owner of the gallery, suggested that the two go across the street to see an exhibit by Marsden Hartley, "whose work didn't thrill either of us," Eileen says. Miss Monaghan and Mr. Whitaker continued their discussion on watercolor in particular and art in general over a cocktail at Schrafft's, nearby on Fifth Avenue.

The Fairy-Tale Ending

That was Sunday, February 14, 1943. Before leaving, Mr. Whitaker made a date with Miss Monaghan to meet again. The next meeting almost never happened. "The day we were to meet, I had a terrible sinus attack," Eileen says. "I called Mr. Whitaker's office. He wasn't there, so I left a message for him," which he did not receive. He went to the meeting at the appointed time; she did not.

Fred was miffed, says Eileen, today readily laughing at the miscommunication. "Much later Fred told me he first thought, 'How thoughtless of her!'" But, from what he had gathered at their first meeting, he decided that "this doesn't sound like the young lady I met. There must be some explanation." After a few days, he called the number Eileen had given him and found out that, indeed, there was a simple explanation for the undelivered message. Another date was arranged, this time at the Russian Tea Room.

"I was really impressed with this man," Eileen says. 'After that first date came several more dinner dates. We went to art exhibits and other functions in the arts. There was nothing romantic about my feelings for him in the beginning. He was interesting to talk with – different from any man I had ever met. He was also fun!"

In the months that followed, Eileen and Fred – or, as she referred to him at the time, "Whitaker" – went on frequent sketching outings and dinner dates, explored new restaurants,

and shared mutual interests. A favorite place was El Chico, a Spanish nightclub and restaurant in Greenwich Village just around the corner from Fred's apartment. "This is where I first heard Mexican music, and I'll never forget the impact it had on me," Eileen says. "Fred loved this Mexican-Spanish atmosphere, too, and I guess this was part of the inspiration for our later trips to Mexico and Spain."

One night at dinner at the Biltmore Hotel, Frederic Whitaker told Eileen more about his marital situation, his wife, Marie, and their two children, Fred and Marion. "Of course, I knew he was married," Eileen says. "He had been very open about it. That night he said that he and his wife hadn't lived together for years, though they occupied the same house with their two children. He didn't give me a line about being misunderstood. Just the facts. That was all. From then on, in our closer relationship, he rarely spoke of his wife and, when he did so, it was always with respect – no criticism or gossip."

For Fred, Eileen was a breath of fresh air, enthusiastic and talented, a person who welcomed new experiences and who was enthralled by people and the arts. For Eileen, something unexpected happened. One weekend Eileen and "Whitaker" went on a sketching trip in Westchester County, near the Saw Mill River. "We sketched for a long time, then had a picnic lunch," Eileen recalls. "Then, walking together in the woods, . . . I realized I was falling in love! It came suddenly. I somehow didn't believe I would fall in love with a man twenty years older than I."

The feeling was, it transpired, mutual. "But I couldn't call Fred 'Fred' for the longest time," Eileen says, still amused. "I called him 'Whitaker' to others, but addressing him I couldn't say 'Whitaker' and I couldn't say 'Fred.' I had built up this respect for this wonderful man!"

What did she call him?

"Oh, . . . sweetheart, you know. . . ."

When Fred and Eileen met, he was living in his apartment at 1 Sheridan Square in Greenwich Village, running the G. H. Seffert Company, and making frequent trips to

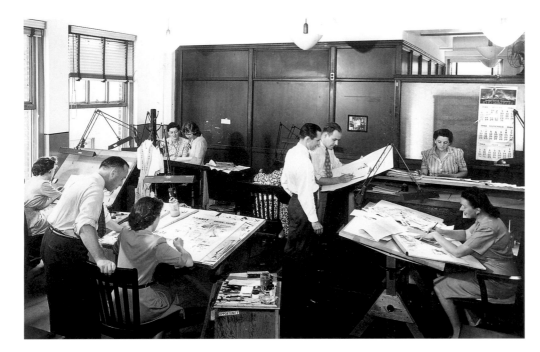

Eileen in the advertising and art department of W. T. Grant in New York, 1944. Eileen is in the far, upper-left corner.

Providence to check on the Foley and Dugan Company; Eileen was living with her parents, who had moved to Hartsdale, next to her sister Mary's home, in Westchester County. She was working at Alexanders, and later at W. T. Grant. (It was for this position that Fred, using the Seffert Company letterhead, provided one of Eileen's references: "Behind [Eileen Monaghan's] quiet and unassuming manner, she carries a great store of ability, determination and dependability. . . . You may depend upon it that whatever she says, is so, and whatever she states she can do, she can do. . . . I gladly recommend her for any position she herself decides she can handle.") About a year after their first meeting, Fred decided to look for an apartment in the Village for Eileen, so that she would not have the long commute, would be closer to work, and, not incidentally, closer to him.

"Fred found a furnished apartment on Jones Street," Eileen says. "Bedroom, living room, kitchen, and bath. It was comfortable for me and practical for us." Fred and Eileen slept sometimes in Eileen's apartment, sometimes in Fred's, whatever was convenient for their plans. There, a tradition, or perhaps it started as a game, a blend of romance and amusement, began. "As an early riser who makes his own breakfast," Fred related, "I am greeted in the morning, more often than not, with a little mash note left at my place the night before." Eileen, in turn, would receive amorous and humorous notes from Fred. "They were so original," she says. "They might start off kind of passionate, 'I'm crazy about you, I love you, la la la la la,' then end up with ' – and a punch on the nose,' or some such offbeat, off-the-wall punch line. And Fred would sign them 'Pancho,' or 'Butch,' or whatever amused him."

For their first Christmas together, Eileen bought Fred a painting. "It was a little casein painting by Henry Gasser," Eileen recalls. "I purchased it at the Salmagundi Sketch Sale. It was twenty-five dollars at auction!"

For the most part, their relationship was a delight, right from the beginning, except for a personal struggle for Eileen. "For a while, . . . I was a wreck," Eileen says. "I had panic attacks in the middle of the day. I went to the doctor, who said, physically, I was fine. I told him I was in love with a wonderful man, who was married, so I don't know where it's going and I'm scared stiff to tell anyone, especially my mother because he's married and not Catholic."

The doctor said: "Slow down. This is your problem. You are disturbed because you don't know how to handle this, but you've got to handle it."

Marie would not consent to a divorce. Even if she had, Eileen discovered that she could not marry Fred, a divorced Protestant, and remain in the Catholic Church. And, no matter what happened, such a marriage would be unacceptable to her mother.

"I remember walking after work along Fourteenth Street at Union Square, having one of these nervous feelings," Eileen says. "I remember thinking: How is it that you can go through life, learn so many things, but no one ever tells you how to handle something like this? How do you cope with situations so foreign to your background? I haven't one clue as to what to do."

Eileen suggested to Fred that perhaps she should stop seeing him. "I was hoping Fred would have the answer," Eileen says. "As he always seemed to. He offered nothing. He kept

quiet. I knew I had to figure it out." Eileen did not see Fred for two weeks.

"At the end of two weeks, I said to myself, Fred means too much to me. This is my life. I have to work this out because I choose to stay with Fred." With that realization, a weight was lifted, and even though the two had to continue "hiding, sneaking around . . . when we went to Mexico I told my parents I went with a girl I worked with, etc., etc.," her personal demons had been confronted and conquered.

By 1950, Fred, wearied by Marie's refusal to agree to a divorce, sought one in Juarez, Mexico. Early in December, the divorce became final and Fred and Eileen drove to Arlington, Virginia, to be married by a judge in his office near the courthouse.

Perhaps something of a disappointment in light of their romantic relationship, the marriage took place on December 11, 1950. "I remember getting the license in the courthouse, then taking a Wasserman test and being told the tests are negative," Eileen says. "I gasped in horror. I have always reacted to the word *negative* in the same way: negative means bad. (I still ponder this one.) What a relief when it was explained."

A recording of "I Love You Truly" was playing softly in the background and, after a brief ceremony, the judge turned his back so that the newlyweds could embrace. "It was so corny and funny I could hardly keep from bursting out laughing," Eileen recalls. "Inwardly, I had been shaking with anxiety. We went outside to find the streets covered with snow."

Then, Eileen and Fred had to break the news to Eileen's parents. Her sisters, Mary, with her husband Lou, and Connie, with her friend, the illustrator Arthur Fuller, were drafted to go with Eileen and Fred. "It was awful," Eileen says. "My mother was so upset. Even my father, an easygoing guy, was shook up. Mother could think only from the standpoint of the Catholic Church. I could not be married to a divorced man, and therefore I was living in sin. Fred had almost nothing to say. Connie and Mary very little. I was a wreck. Lou and Arthur tried to soften

the blow, telling my parents how lucky Fred and I were to be happy, to have each other, to have so much in common."

It did not take Eileen's parents long to reconcile themselves to the idea of their daughter's marriage. They had always liked and admired Frederic Whitaker as a person. It was just the religious aspect that they found difficult to accept.

Two years after Fred and Eileen married, Marie did file for a divorce and, when it was granted, Fred and Eileen were advised by Fred's attorney to re-marry. The attorney pointed out that Mexican divorces had not been fully tested in U.S. courts; he also suggested that Fred make out a new will, taking into account Eileen as well as his two children. To protect themselves from possible future legal difficulties, the Whitakers married again on April 24, 1953, in New York City.

An Activist in the Arts, 1943–1950

"The minute Fred joined anything, he became involved!" says Eileen. In his fifties, Fred was becoming a moving force in several organizations for the arts, among them the American Watercolor Society (AWS), Allied Artists of America, the Architectural League, and the National Academy of Design, the country's most prestigious art society and a standard-bearer for fine, traditional, representational art in all media. He was also exhibiting his paintings in competitions and one-man shows. "My experiences as a professional painter really began in New York in 1941," said Fred, although his experience as a painter went back much further: all of his designs for ecclesiastical metalwork were done in watercolor.

In 1929, Fred became a member of the Rhode Island Watercolor Society. In filling out the application form, Fred wrote: "Have never received instruction in watercolor" and answered no to the query about whether he had had any public exhibitions to that point. In those early years, he also joined the Providence Art Club and served as president of the Providence Watercolor Club. His first one-man show in New York City was at the American Salon in December 1939. His next

Members of the Salmagundi Club, 1940s. Left to right: Junius Allen, Henry Gasser, Ted Kautzky, Ogden Pleissner, Stow Wengenroth, and Frederic Whitaker.

was at Ferargil Galleries in 1940, there was another in 1942, and a third that opened on Valentine's Day in 1943.

To meet artists in New York, Fred approached the Salmagundi Club in 1941 and was invited to join. The oldest art club in the country, the Salmagundi was founded in 1870. William Merritt Chase, John La Farge, George Innes, Louis Comfort Tiffany, and Anders Zorn had all been members. "Prospective members passed a Cerberus-like membership committee and a similarly minded art committee before earning the final welcoming handclasp," said Fred. For painters at the time, the Salmagundi Club was considered a proving ground for prospective admission to the National Academy of Design.

Through the Salmagundi, Fred "soon knew the artists of New York" and took on various responsibilities in connection with his membership in national art societies. Almost simultaneously, he held official positions in Allied Artists of America, the American Watercolor Society, the Municipal Art Society, the Fine Arts Federation of New York, and Artists for Victory, a group established, shortly after the United States entered World War II, to marshal the artists of the country to assist in the war effort.

"In retrospect," said Fred, "I marvel at my presumptuousness or ingenuousness in taking on" those responsibilities. He logged one leadership position after another, and though it might seem, despite his shyness as a youth, that he was a born public speaker, he credited his apparent ease on the rostrum to his connections with the Masonic Order. He became a Master Mason in 1916 and passed through various levels of the association, rising from office to office. Masonic ritual and lectures are

formalized and must be recited from memory. "This system, arranged in graded steps, is probably the only one that ever could enable me, with my ingrained reticence, to rise in public to speak," Fred said. It provided him a measure of self-assurance although, he is quick to point out, the self-assurance is actually "but a fraction of what it may appear." Nevertheless, it equipped him to take on responsibility, delegate authority, and speak his mind.

In 1943, at the urging of Mike Engel, the publicity director for M. Grumbacher, Inc., manufacturers of artists' supplies, Fred organized Audubon Artists, Inc., a society open to artists working in all media in the visual arts, whose individual styles ranged from the conservative to the avant-garde. "It was [Engel] who brought about my first one-man show at Ferargil Galleries and helped to launch me in the New York art mill," said Fred.

Mary Margaret McBride, center, interviewing, left, Michael Engel (who helped launch Fred's exhibiting career in New York) and Fred Whitaker, right, for Radio WPAT in New York, 1943.

Left to right: Henry Gasser, Fred Whitaker, and Ted Kautzky at their three-man show at Grand Central Galleries, New York City, 1945.

Engel had repeatedly asked Fred to accept the presidency of a small regional society, the Audubon Artists Group, so named because its first meeting was held in a building on what had once been the farm of the ornithologist and painter John James Audubon in the Audubon section of New York City. Eventually, Fred said: "I'll tell you what. If you want to have a first-rate, *national* art society organized, I'll do it. Bring in those you want for key positions, and we'll go to work."

A nucleus of five organizers led by Fred decided to call the new society Audubon Artists, Inc., to distinguish itself from the original, regional Audubon Artists Group, and to invite specific artists to join the new national society. Twenty-four of the country's business and professional leaders agreed to serve on the board of directors. On a letterhead that included the directors' names, membership invitations were sent to 450 highly regarded painters and sculptors; 400 promptly accepted. "Within months after starting from scratch, we had an operating organization whose members together represented the greatest amount of art talent ever assembled," Fred said. "I doubt that any important and national art society had ever been organized in so short a time." The organizational work was done in Fred's business office at his expense and he served as president during Audubon's first three years.

In 1945 Fred was elected an associate of the National Academy of Design. He was nominated by Walter Biggs. Louis Betts painted Fred's portrait for the academy, which requests a portrait of each of its members for its collection. A few years later, Fred was made a full academician, one of only twenty-five members of the watercolor division. He served as vice president of the academy for one year and as a member of the council for six years. Three times he declined invitations to be a candidate for president because of a political conflict within the organization, which, he felt, was crippling any effective leadership.

A position that he did enjoy at the National Academy was that of chairman of the watercolor jury, a job he took over from Andrew Wyeth, who was ailing. In a letter to Fred dated

January 1948, Wyeth wrote: "It is a great relief to know that you are taking over as I well know that you can do a much better job than I." Writing to Fred again in February, Wyeth mentioned the importance of choosing the best watercolorists in the country as associates, those painters "who can prove themselves through the years to be put up as nominations for Academicians. Our field is important enough now to stand out with the oil class."

Fred was also involved in the National Society of Painters in Casein, the American Artists Professional League, the Council of American Artists' Societies, the American Veterans Society of Artists, Knickerbocker Artists, and the National Arts Club, as well as with regional art associations across the country and in England. "I'm just a guy who can't say no," said Fred. "I doubt that any other artist has been guilty of so many involvements, and I am sure that I have sat on more exhibition juries than any other American painter."

In 1949 he was elected president of the American Watercolor Society, a national art organization to which he had been elected in 1938. The society was established in 1866 after the close of the Civil War. Each year it sponsors an annual exhibition that attracts submissions of the highest quality. When Fred took the helm, the society was run, as he described it, "in a very sketchy way" by a small group of men and women who had been taking turns as directors and jurors year after year. "These were all excellent individuals," Fred said, "but the management had become ingrown." Fred's task was to spread the work out. This he did by appointing numerous standing committees and inaugurating new projects. "Within a couple of years, we had at least

a hundred members who knew the ropes and could be depended upon for virtually any emergency," Fred said. The members' interest mushroomed. "If my seven years as president accomplished anything, I feel one contribution was showing members the importance of their own organization and encouraging pride in their membership."

During these years, Fred and Eileen enjoyed a busy social life as well. Sketching outings, dining out, and dancing were everyday occurrences. "Meeting Fred changed the entire course of my life," Eileen says. "Not only in a romantic way. It introduced me to a new world, that of the fine arts. Through Fred's active participation in so many art societies, our colleagues and friends were colorful, creative individuals from the visual arts and celebrities from the theatre as well as the civic and social community." The Salmagundi Club, the National Arts Club, the AWS, the Architectural League, and the National Academy of Design became centers of their lives, offering events that ranged from informal to formal: openings of shows, special celebrations, New Year's Eve parties. "What a stimulating atmosphere for a young woman eager to grow," says Eileen.

Fred was painting at every opportunity, continuing with one-man exhibitions, entering national competitive shows, and winning prizes. Eileen says that she became "involved secondarily" – sketching with Fred – then, "I started painting watercolors again under [his] exciting influence. . . . " He suggested that she show her work, "though," she says, "he really never pushed me to enter competitive exhibitions. It just happened. It didn't enter my mind that I was ready, but there was something about that painting," gesturing toward *The Inlet* (also called *The Cove*; see p. 90), which was the painting that Eileen entered in the Allied Artists of America competitive exhibition in 1949. Not only was it accepted, but also it won a prize. "What an incentive that was to continue painting seriously," says Eileen. With the taste of that first recognition so sweet, Eileen was hooked on competitive exhibitions. She now has more than 80 awards; Fred, more than 150.

"By exhibiting in annual shows, I learned more about painting than I could have otherwise, in a lifetime. It amounts to being in competition with the best the country has to offer. Each time you see your painting hung in a show, it teaches you an awful lot that could never, or hardly ever, be learned in any other way. It stands up, or it doesn't." Eileen speculates that if she had not met Fred, "it's not likely that I ever would have been that involved in fine art."

Professional Art Making, 1950–1965

In 1950, the year that Fred and Eileen married for the first time, they bought their first home, on Murray Street in Norwalk, Connecticut. Both had retired from commercial art and ahead of each lay an empty slate – tempting and just teasing to be filled. "It was wonderful living in a home of our own with a huge studio," Eileen says. "But after so many years working regular hours, I had a hard time adjusting to free time. I'd waste much of it, not knowing how to plan my day." Fred, of course, wasted no time. He was painting every day, exhibiting his work, entering competitive shows, and continuing to be involved in numerous art societies, particularly the American Watercolor Society. He was also writing about art and other artists.

"Few artists are really articulate, and fewer still are able to write concisely," he observed. "When an artist is found who can state his case verbally, even reasonably well, he is put to work as a writer." The artist Ralph Fabri first invited Fred to write about art for *Today's Art*, a periodical based in New York and distributed by art supply stores to their customers. This invitation was followed shortly by a request from the editor of *The Artist* in London that Fred write instructional articles, and the offer of his own page, a "Frederic Whitaker page, in which I might philosophize at will." Within a couple of months, Ernest Watson, the editor of *American Artist* magazine, asked Fred to write editorials, and Watson's partner, Arthur Guptill, persuaded Fred to provide some articles for the magazine's amateur section. "This work for the beginners had no particular appeal for me," said

The Whitaker home and studio on Murray Street in Norwalk, Connecticut, 1950 to 1965.

Fred, "for I have always been more interested in the thought behind art production than its technical aspects. But I did learn a great deal – especially from my association with these two art teachers and publishers."

Accomplished draftsmen and teachers, Watson and Guptill had founded a magazine they called *Pencil Points* in 1918. It featured architectural rendering and pencil drawings. By 1930, *Pencil Points* evolved into *American Artist*, a magazine concentrating on art and artists in the United States and on their technique. Watson and Guptill took pride in the fact that their art magazine was being written for, by, and about practicing artists. When Guptill became ill, Fred not only continued to write the articles for the amateur page, but also took over Guptill's responsibilities for the amateur section for more than a year. When Guptill died in 1955, Watson sold his holdings in the Watson-Guptill Corporation and Norman Kent, who had been the art editor of *Reader's Digest*, took over as editor-in-chief of *American Artist*.

Also a writer, Kent had published several books on art, particularly on watercolorists, books in which he had included the Whitakers' work. Kent himself painted in watercolor and worked in the graphic arts. "He did marvelous woodcuts and was an expert calligrapher," Eileen says. "Norman had a very precise and demanding personality, and was not one to compromise easily."

"Under Kent, I continued as a writer of feature articles on the work, life, and philosophy of distinguished American painters, illustrators, sculptors, and draftsmen in many parts of the country," said Fred, "with an occasional editorial or philosophical outburst." Kent and Fred shared a mutual admiration, having worked together as colleagues both in publishing and in various art societies, and the Whitakers and Norman and his wife Diane became close friends.

Fred's first article for *American Artist* was actually on the Spanish sculptor Enrico Monjo, whose sculpture exhibition in New York City so impressed Kent that he asked Fred to interview the artist and write about him. Fred was only too happy to do so, and the article appeared in *American Artist* in May 1957. Both Fred and Eileen were enamored with Spain, the country and its people. They had become close friends of Luis de Urzaiz, the vice president of the Spanish Institute in New York, and had become acquainted with Urzaiz's brother-in-law, General Manolo de Villejas, who had formerly been chief of staff for the Spanish dictator, Francisco Franco.

Subsequently, Fred wrote about Haddon Sundblom, Bettina Steinke, Barnaby Conrad, Leslie Saalburg, Shinji Ishikawa, Harvey Dinnerstein, Aristide B. Cianfarani, John Koch, Olaf Wieghorst, Marjorie Close, Walt Disney, and Millard Sheets. By the time he died in 1980, Fred had interviewed and written articles about ninety artists. "What little I know about writing," said Fred, "came from two sources: from dictating business letters and from a Sherwin Cody course by mail on English, to which I subscribed when office work was first thrust upon me." In 1961 the Reinhold Publishing Company asked Fred to write a book on watercolor instruction. *Whitaker on Watercolor* covered the fundamentals and continued through pictorial planning, with sections on how to analyze a subject and the many different ways that watercolor can be applied and manipulated. The book was published in 1963.

Meanwhile during those years, Eileen was having more success in managing her time and was painting regularly, exhibiting, entering competitive shows, and winning prizes. In 1953 she was elected to membership in the American Watercolor Society. "This was the greatest thrill of my artistic career at that time," Eileen says. In 1957 she was elected to membership in the National Academy of Design as an associate member (and as a full member – an Academician – in 1978). Hardie Gramatky

Eileen, Norman Kent, and Fred in 1951 at a gathering at the artist Roy Mason's home in Batavia, New York. Kent was the art editor of the Reader's Digest *at the time and later became editor of* American Artist *magazine, working closely with Fred.*

proposed her, and Fred painted her portrait for the academy's collection (see p. 10). She also continued her commercial work as a freelancer, designing greeting cards for the Book of the Month Club in 1954 and for the American Artists Group in 1958, as well as undertaking various other design projects.

Much of the inspiration for the Whitakers' paintings and for subsequent exhibitions during these years came from their travels. "We did a lot of painting in those days on the spot," Eileen says. "We'd sketch and paint on picnics in the country – or in Central Park. Gloucester and Rockport were favorite spots. I remember sitting for long periods on the Gloucester wharf, studying the gulls, then later, I'd try sketching them in flight."

Each year they drove to Philadelphia with entries for the Philadelphia Watercolor Society's annual exhibition, and then would drive north and west to sketch in the steel towns. "Fred was fascinated by the mixture of different-colored smoke that rose from the various smoke stacks of the steel plants," Eileen says. "As the smoke rose and mixed with the clouds, [and] often rain and/ or snow, it was an exciting combination to paint in watercolor."

They also enjoyed sketching and painting in Doylestown, Pennsylvania, "a delightful little old town, where we painted mostly the old houses and little street scenes," she says. An area they found particularly interesting was the "Amish country around Lancaster, which I loved. It was beautiful farmland with immaculate buildings in a cluster."

Fred's business dealings in Mexico City, including the setting up of a rosary-making establishment and the procurement of Mexican silver jewelry, had served to whet his appetite for further exploration. An eager companion, Eileen fell in love

with the Mexican people the minute she crossed the border. "About every other year after we met, we traveled to Mexico," says Eileen. With her affinity for languages, she quickly learned to converse in Spanish "in a sketchy," yet efficient way. Where she had an ear for the language and could understand or "hear" what the natives were saying, Fred could read and write the language and could "speak" or respond verbally when Eileen translated what she heard. Together they had no problem chatting with the natives, finding their way around, and getting to know the Mexican people. And together, they passed "through virtually every one of [Mexico's] states," said Fred. For a long time, Eileen felt that if she were ever reincarnated, she would like to be Mexican – or Spanish.

The Whitakers also made a number of trips to Europe, touring Spain, Portugal, Italy, England, France, and Ireland. During all of their travels, they were constantly sketching and taking photographs. Often they used a stereoscopic camera, which takes three-dimensional pictures.

After a four-month trip abroad in 1956, the Whitakers, smitten by Spain and the Spanish people, had a two-person exhibition, *Fabulous Spain – Artists' Paradise*, at New York's Grand Central Galleries in 1957. The opening reception was attended by visiting Spanish dignitaries and artists, illustrators, designers, and patrons from New York. Grand Central Galleries was renowned for its exhibitions of fine, traditional art and its artists for their conservative, responsible work. Fred had been a member for a number of years during the time when he was leading art societies and exhibiting competitively and on his own, and Edwin Barrie, the director of the gallery, referred to Fred as "Mr. Watercolor."

Soon friends, fellow artists, gallery directors, exhibition organizers, art society members and officers, and writers on the arts in this country and abroad, consciously or unconsciously latched onto the nickname. "Mr. Watercolor" came to honor not only Fred's devotion to, and expertise in, watercolor as a practicing artist, but also his advancement of watercolor as more than

simply a "spontaneous" medium, his leadership activities in watercolor organizations, his encouragement of other artists in aquarelle, and basically, his ethic of hard work, whatever the worthwhile cause. As Boylan Fitz-Gerald wrote in *The Artist* (London) in 1959: "A distinguished practitioner and winner of many awards . . . often called Mr. Watercolor, [Whitaker] has an unremitting dedication and a dominant will to work."

The Whitakers also showed their work at competitive exhibitions in Westchester County, New York, in New Jersey, and in Gloucester, Massachusetts, and had a number of other two-person shows, including exhibits at the Westport Library in 1952, the Providence Art Club in 1957, the Holyoke Museum in 1959, the Darien Library in 1962, and again at Grand Central Galleries in 1965.

Though both were receiving awards for their paintings, a prize that stands out in Eileen's mind – notably because of the time, patience, and perseverance she invested in the work – is the Henry Ward Ranger Purchase Fund Award that she won in 1958 for *Harvest Time, Estremadura* (p. 140) at the annual exhibition of the National Academy of Design. Paintings purchased by the Ranger Fund are destined for exhibition at "nationally recognized museums," and Eileen's painting was shown at the Art Museum at the University of Massachusetts at Amherst, and remains there, in the permanent collection. The painting, which was inspired by the Whitakers' trip to Spain in 1956, depicts women, dressed in colorful attire and wide-brimmed hats, working in the golden wheat fields of Estremadura, Spain.

"I made a design that satisfied me," Eileen says. "Then I enlarged it on a full sheet and painted the picture. It was terrible! I was so distraught. It came nowhere near what I was trying to say. But I knew there was something there. Something good. After some time, I decided to start all over. Another failure! So depressing. I decided I was probably through as an artist.

"Well, when I recovered, I started all over again – for the third time. This time, I made it! Finally, I was pleased. If anything, I am persistent. This was definitely a lesson in perseverance."

The painting also won the Ted Kautzky Award at the annual exhibition of the AWS that same year.

Gregarious people, the Whitakers enjoyed a busy social life in Connecticut – most often with other artists and with friends in the arts. Several artists who worked in the commercial field, primarily as illustrators, lived in Fairfield County and commuted to New York City or worked at home freelancing. Shortly after moving to Norwalk, the Whitakers were invited by Hardie Gramatky, the artist and illustrator, to his home to meet a group of artists and illustrators who gathered each month to review their recent paintings, discuss the arts, and socialize. "Their aim was to spend more time painting watercolors free from the demands of their commercial work," Eileen says. Though Eileen was the only woman in the group who was an artist herself, all of the wives were invited to join the gathering, which was held at the home of a different member each month. Over the years of the Whitakers' participation, artists in the group included the founders Wally Richards and Steve Dohanos, and Alex Ross, Louis Kaep, Harry Anderson, Tom Lovell, Herb Olsen, Joe Arcier, Warren Baumgartner, John Wheat, John Pellew, Bill Strosahl, Tran Mawicke, and Gramatky.

At Fred's urging, the artists decided that, if they wanted to exhibit their works as a group, the group should have a name. After considerable discussion, they deferred to Fred's suggestion: simply, the Fairfield Watercolor Group. "Criticism is invited," Fred wrote in a tongue-in-cheek article describing the group for the *Westporter Herald* in 1953. Each artist took a turn in having a painting spotlighted on an easel. "The others then tear hell, verbally, out of the picture – the extent of the tearing depending somewhat on the quantity and quality consumed of the hosts' spirituous offerings." The ladies join in the barrage, "and frankly," Fred continued, "as critics, they're even better than their spouses. Just demonstrates how little practice it would take to become a big city reviewer."

The Whitakers took their turn as hosts for this group, and they gave many other parties in their large Connecticut country

Left to right: A Persian friend and photographer, David Yonan, Fred, Eileen, Eileen's sister Connie, and Arthur Fuller, at the Whitaker home in Norwalk, Connecticut, 1953. Fuller was an illustrator, primarily of wildlife, and a longtime friend of the Whitakers and of Connie.

home, with its L-shaped living and dining area that was perfect for entertaining. Domesticity was a new venture for Eileen. "Gradually I learned to cook," she says. "Fred was not demanding and certainly a great husband for someone like me. He encouraged me in entertaining our first guests for dinner by reminding me constantly that these friends were coming to see us because they like us – not just to be fed."

One of Eileen's first cookbooks was James Beard's *Fireside Cook Book.* "I bought it from a German man who regularly made the rounds of art studios selling art books," Eileen says. "Actually, the reason I bought the book was the wonderful illustrations by Alice and Martin Provensen. I still admire the illustrations. Oh, and I do use the book in cooking, too."

By chance Eileen took some cooking lessons. Fred and Hardie Gramatky were asked to jury an art show in Bridgeport, Connecticut, that was sponsored by the Junior League there. In appreciation, the league presented the gentlemen with tickets to a series of cooking lessons given by the Cordon Bleu chef and teacher Dione Lucas. As neither of them had any interest in cooking, Eileen and Hardie's wife, Doppy, inherited the tickets.

"I took to these demonstrations," Eileen says. "I became enamored with gourmet cooking, and actually started at the top. Fred said, 'Eileen is burning up all our liquor, flambéing everything in sight!'" When the Whitakers had parties, Eileen eagerly tried the most ambitious dishes and menus. "Fred tried to convince me that I should not experiment with guests – but it never worked with me. It was a challenge to strike out, and almost always, it worked."

Most parties were topped off with music and dancing. "Everyone danced in those days," Eileen says. "The rumba, the samba, the tango, the foxtrot, the waltz. From the first time I attended a dance in high school, bashful and shy and not knowing how to dance, I loved doing all sorts of dances, mostly by following the lead of a good partner. . . . In college, I became so crazy about dancing, I used to say I'd rather dance than eat!"

Fred credits his becoming proficient in "terpsichorean skills" to Arthur Murray's classes in New York. Both he and Eileen took lessons as various dances became popular. And both took lessons from a Cuban dancer who called himself Señor D'Avila and who claimed to have taught Arthur Murray the rumba. "Fred was wonderful at the rumba," Eileen says. "I love the samba."

In 1952, Fred and Eileen were invited by John "Jack" Pellew, a friend and fellow artist, and his wife, Elsie, to join them for tea with the Huntingtons, friends of the Pellews who held a salon regularly on Sunday afternoons, offering their guests tea and discussions in the arts. The Huntingtons – the philanthropist Archer Milton Huntington and his wife, Anna Hyatt Huntington, who was a sculptor – lived on an estate of well over a thousand acres in West Redding, Connecticut, about twenty miles from Norwalk.

"What a place!" says Eileen. "Their home was a simple, almost austere structure of cement blocks with rough mortar showing between the blocks. It was a large building, almost like a fortress, and Anna's studio was part of it." The acreage included high meadows overlooking an expanse of rolling hills, a large

Eileen, 1953.

heavily wooded area, kennels for their deerhounds, and a farm with cows, burros, goats, ducks, and domestic and exotic fowl. Archer Huntington was the son of Collis Potter Huntington, the businessman and financier who, along with Leland Stanford, Charles Crocker, and Mark Hopkins, built the Central Pacific and Southern Pacific railroads. Through a handsome inheritance, Archer was able to pursue his interests as poet, philanthropist, patron of the arts, and founder of art museums, including the Hispanic Society of America in New York City. His consuming interest in life was Spain. The Huntingtons' Sunday afternoon teas attracted distinguished people from all walks of life, many of them South American dignitaries, as well as American artists and art patrons. "Archer has been called 'the last of the Titans,'" Eileen says. "I think that is probably true. What a magnificent man. To visit them and listen to Archer talk for a couple of hours was like taking a condensed course in almost any phase of the humanities. He had affection for both of us and held Fred in high regard. . . ." Huntington and his wife were to become quite influential in the lives of the Whitakers in the early 1950s. "He would have given me anything I might ask to improve the art societies," Fred said, "but I was careful never to exercise that prerogative. We understood each other perfectly, and had I met him many years before, we could have done things together."

Though the Huntingtons could easily afford and enjoy whatever they fancied, they did not – fancy, that is. "They were so down to earth in their tastes and activities," Eileen says. "Archer usually wore an old sweater that was darned over and over at the elbows. Anna wore simple cotton housedresses with thick cotton

or wool knee-length socks and sturdy shoes, often boots. When she walked the estate, she usually carried a gun to shoot squirrels she considered a nuisance. She said they added nothing to the natural balance and only destroyed birds."

Anna Huntington was a sculptor internationally known for her heroic statues, among them, *Joan of Arc, El Cid, Don Quixote,* and *The Torchbearers.* "Always serious and beautiful pieces," Eileen says, "never sentimental or pretty. Even at ninety-four, on our last visit with her in 1970, she was up on a twenty-foot ladder working on a clay model. She was as sharp, warm, and lovely as ever. What a woman! She was a tremendous inspiration." Anna Huntington died in 1971. Archer Huntington, who suffered from crippling arthritis and was confined to a wheelchair for much of the latter part of his life, had died in 1955 at the age of eighty-five.

A few days before Archer's death, he asked to see the Whitakers. "He talked almost incessantly," Eileen says, "so animated and lively and apparently enjoying it all. He even sang some old songs in Arabic. As we started to leave, he pulled Fred down and hugged him, telling him to continue doing what he had started in life, encouraging him. There were tears in the eyes of them both as we left the room.

"Just as we were outside, Archer called in a booming voice: 'Good-bye now. The next time you see me, I'll be dead!' – and he laughed.

"The following week we attended his funeral in New York. We met many interesting, fascinating individuals at their home, but none more than themselves."

In 1955 Eileen also lost her mother, and in the following year, her father. The Whitakers' home in Norwalk was set back from the street, down a long driveway, and in 1952, the Monaghans had moved from Hartsdale to a little house on Murray Street in front of Fred and Eileen's home. Mrs. Monaghan, who was suffering from Parkinson's disease, was confined to a wheelchair and was becoming more dependent. On June 22, 1955, *The Norwalk Hour* reported: "This evening Mr. and Mrs. Thomas F. Monaghan of Murray Street will observe the fifty-fifth anniversary of their

marriage quietly, with members of their family present. They came to Norwalk to reside three years ago, having lived for most of their married life in Holyoke, Mass. The couple have five daughters and one son." Eileen's sister Connie, then a nurse, left her job and came to care for her parents. Kevin, too, returned from years of living, traveling, and studying art abroad, to live with his parents during what turned out to be their last years.

Mrs. Monaghan died in July 1955. Eileen had entered a painting, entitled *Portrait of My Mother*, in the AWS show then on view at the Frye Art Museum in Seattle. Shortly after the exhibition opened, she received a letter from the museum director, W. S. Greathouse, who reported that Mrs. Prentice Bloedel of Winslow, Washington, was interested in buying the painting, which had been marked NFS (Not For Sale). On July 8, 1955, Eileen wrote back to say: "The painting is a portrait of my mother, who died four days ago, so of course, I cannot sell the picture. Returned today from funeral in Massachusetts to find your letter here which explains delay in reply." Though Eileen had painted the portrait in 1955, it was inspired by a photograph she had taken of her mother in 1940, in which Mrs. Monaghan was threading a needle – something that Eileen had seen her mother do over and over again throughout her life.

Mr. Monaghan, who "was still very active," Eileen says, died slightly more than six months later, in January 1956. "Papa suddenly complained of not feeling well," Eileen recalls. "A young doctor came to the house, examined him, and insisted he be taken to the hospital immediately." Mr. Monaghan was operated on for colon cancer, but within two weeks, he died in the hospital. "He was kidding around and telling stories till the end," Eileen says. "The nurses and other patients loved him. It was so typical of my father."

Teachers and Scholars

Enjoying their life together, their social circle, and their vocations, the Whitakers were, in the 1950s, financially carefree. In addition to his multiple investments, Fred expected to have a source of income from the religious goods business he had sold at book value in 1949 to his son Fred and his son-in-law Don. Initially, Marie was reaping the benefits of the promissory notes for a fixed period of time, as part of the financial settlement after the divorce. As these promissory notes were scheduled to extend over twenty-five years, Fred assumed that his turn would come in due time.

"Unfortunately, the [company] began to run downhill," Fred said. "In 1958 it was placed in receivership and a year later liquidated." His son and son-in-law were given partnerships in a new firm established by the buyers of the old. Fred received nothing in the settlement.

"After the collapse of the plant in Providence, Eileen and I felt it advisable to expand our earned income," Fred said. He looked into the possibility of buying a business to build up, but then decided upon something that, though certainly not lucrative, was far more suited to their lifestyle at that time: They would teach drawing and painting. "That is, we decided that Fred should teach, and I would assist!" says Eileen. "I'd learned long ago that I was not cut out for teaching."

The Whitakers rented the top floor of a large brick building in downtown Norwalk, overlooking the Norwalk River. Fred built "horses" of wood designed to be both seat and easel for painting watercolors. They rounded up dozens of folding stools, cut boards in appropriate sizes to hold tins of water, paint boxes, and trays, and opened classes in drawing and painting in watercolor. Quickly attracted to the classes were the wives of wealthy industrialists, lawyers, doctors, legislators, and other citizens of affluent Fairfield County – most of whom had studied art earlier, but who then married and had children.

"We had loads of material to work from," Eileen says, "views of houses with varied colored doors, porches, and windows, old, weathered buildings, little boats tied up to the wharf, a little stream trickling through a deep gully, a neighbor's grapevines." In warm weather the class scouted out interesting places in Norwalk or nearby. Fred first sketched and painted a scene in front of the

class, then the students followed his lead or chose a subject of their own. Occasionally the class field trip was to the Whitakers' Norwalk home, where the sizable lawn was peppered with trees, including maples and walnuts, several types of evergreens, and flowering bushes. They also had a vegetable garden and a flower garden.

"Nothing was really expected of me," Eileen says, but nevertheless, she was present and available. On one occasion, some students were attempting to paint the evergreens on the Whitakers' lawn and asked Eileen for suggestions. "Well, I have never painted an evergreen either," Eileen told them. "All I would do is do with the brush what the evergreen is doing. It's going like this," with a swish of her brush. "It's doing like this," with another swish, and with careful strokes or unfettered swishes, she captured the form and suggested the movement of the evergreens.

Though the classes added minimally to their income, Fred and Eileen say that they enjoyed them and learned from the teaching experience – but in different ways. "I certainly learned a lot, . . ." Eileen says. "We met interesting people, a few who became cherished friends. However, when the classes were over and nothing particularly good resulted from the three hours, I would be so depressed! I felt like giving up painting! I soon learned that I need to be stimulated by something way beyond me; the helpless and hopeless had no place in my life!"

Fred is quick to point out that "as in the case of our other activities, we ourselves learned a great deal more than any of our students." Fred dedicated his second book, *Guide to Painting Better Pictures*, which was published in 1965, to "My gracious students, who taught me all I know about teaching."

The Whitakers taught for six years, stopping in 1964 only to devote more time to travel in Mexico, the American Southwest, Europe, and Canada. But first, they made a relatively lateral transition, becoming scholars, rather than teachers. Just home from travels in the West, Ernest Watson, the co-founder of *American Artist* magazine, told the Whitakers about the

Huntington Hartford Foundation in Pacific Palisades, California, which awarded grants to artists to work on a project of their choice at the foundation. Painters, sculptors, composers, and writers were eligible. The Whitakers applied, and each was granted a three-month residency: Fred to write his second book, *Guide to Painting Better Pictures* for Reinhold Publishing Company, and Eileen to explore the possibilities of acrylic paints, which were new and had been introduced to her by their friend, the artist John Pellew. Her specific project was to explore the use of acrylics on Masonite to resemble egg tempera.

"Living conditions were idyllic," Eileen says of the Huntington Hartford experience. The foundation complex was situated in a canyon in the Santa Monica Mountains just a few miles from the Pacific Ocean. Fellows lived and worked in studio cottages scattered about the 154 heavily wooded acres. Each cottage was different – the Whitakers' had been designed by Frank Lloyd Wright's son. All the fellows had breakfast and dinner at the Community House. Lunches were left at the doorstep of each cottage so as not to disturb the work. A limousine with a driver was available for trips. "It was an unexpected, never-to-be-dreamed-of experience for me!" Eileen says. "I couldn't get over the fact that, with all of this wonderful opportunity given free to me, I should create masterpieces every other day, at least!"

What Eileen did accomplish was a return to the ways she had used in art school, working slowly on a theme, doing much research if necessary, and just studying and working constantly, without the interruptions of the everyday, real-life world. "Serious painting had always been my goal," Eileen says, "but time allotted was often on a hit-or-miss tempo." At the foundation, she did work with acrylics, which she found "exciting for an experiment," but decided "that the transparent technique on paper is my medium."

Meanwhile, Fred completed his book, and both enjoyed socializing with other fellows at the foundation, who at the time included Mark Van Doren, the writer, editor, professor, and (as he preferred to be known) poet; Will Durant, the author

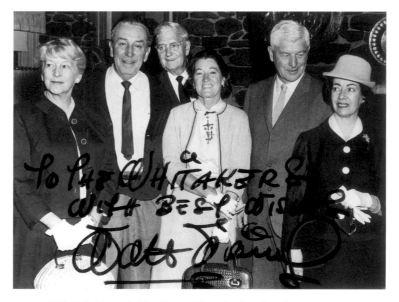

With Walt Disney in his office at Disneyland, 1965. Left to right: Carol Dempster Larsen, Disney, Fred, Eileen, Ted Larsen, and the coloratura soprano Lily Pons.

of a number of books on the story of civilization; and the controversial Max Eastman, the author of *Great Companions*, a copy of which he inscribed to Fred and Eileen. "Max took a shine to me and was very sweet and attentive," Eileen says. "He told us his earlier convictions, when he was considered one of the most outspoken Bolshevists in this country, had mellowed by the time we met him, but I was never convinced."

The Whitakers also had the opportunity to explore more of California on frequent visits with friends from Connecticut, who had a winter home in Palm Springs. Edwin "Ted" Larsen, one of the legendary Wall Street wonder boys of the 1920s, made a fortune in the stock market and sold his stocks before the crash in 1929. He retired before he reached the age of thirty. "Ted was a brilliant man," Eileen says, "well read, erudite, with an inquiring mind that continually sought to know more. He and Fred had so much in common." Ted's wife Carol, as Carol Dempster before her marriage, had been a star of silent films and one of D. W. Griffith's protégées on the East Coast. The Whitakers and the Larsens had become close friends in Connecticut, a friendship that they continued at the Larsens' retreat in Palm Springs.

During one weekend, the Larsens' longtime friend Walt Disney called from Burbank and invited the Larsens to tour his studio. Learning that the Whitakers were visiting, Disney invited them, too, "and bring Lily," he said, referring to Lily Pons, whom Fred described as "the great coloratura soprano" and who was the Larsens' neighbor and friend. Retired from the Metropolitan Opera in New York City in 1960, she had moved to the more agreeable climate of Southern California.

At 9:30 sharp the next morning, Disney's private plane, a twelve-passenger Grumman Gulfstream staffed by the pilot, a copilot, and a hostess, picked up the eager tourists and flew them to Burbank. "Walt spent the entire day showing us all of his studios and projects," Eileen says. "What impressed us most were what he called the 'Imagineers,' a group of creative individuals in diverse fields who were developing ideas and working on models

for future displays at Disneyland." Fred called the "Imagineers" simply "the idea-men," the ones who worked out original gags, characters, scenery, and situations.

Always receptive to the creative mind, Fred was impressed with Disney, the original "Imagineer," whose creations and operations so intrigued him that he asked if he could write an article on Disney for *American Artist*. The article, published in September 1965, was a consideration of Walt Disney as the contemporary American artist who had contributed the most to the advancement of the visual arts.

"Well, our artist friends were scandalized," says Eileen. "They said: 'Disney?' 'Mickey Mouse?' 'Snow White?' 'Art?' 'What?'"

Actually, Fred had explained his reasoning concisely in the article: "The real 'greats' in art were so called principally because they had brought a new quality to the art of painting. Da Vinci [*sic*], for instance, showed us the possibilities of chiaroscuro . . . Turner showed us how to paint light, and so on. . . . Disney's contribution – animation – was an entirely new factor, probably more revolutionary than that effected by any other single artist. . . . He has taken art production out of the one-man studio and made of it an industrial and co-operative effort of gigantic proportions . . . the extent of the possibilities has not even yet been fully explored." In the fifteen years that Fred lived following publication of this article, he was able to witness the exploration of at least a few of the possibilities opened up by the vision of Walt Disney.

The Whitakers' fellowship at the Huntington Hartford Foundation in Pacific Palisades and visits to the Larsens in Palm

Springs occurred during the first three months of 1954. In the previous December, they had taken a leisurely drive across the country, with numerous stops along the way, including Scottsdale in Arizona and La Jolla and Santa Monica in California.

The Scottsdale stop was a particularly sad one for Eileen. There she picked up a telegram from Connie, who said that their oldest sister Mary, whom Eileen idolized, had had a stroke and had died in a hospital in Pleasantville, New York. She was just sixty-three. "This was the worst blow of my entire life," Eileen says. "I cried my heart out. I was devastated."

There was nothing Fred and Eileen could do. Mary was gone, so they continued on to California and to their commitment in Pacific Palisades. They stopped first in La Jolla, where they visited the artist Roy Mason and his wife Lena who gave them an enticing introduction to this affluent coastal village community. In Santa Monica, they visited other friends the artists Emil Kosa and George Gibson. "Living in this delightful part of the country was lovely," Eileen says. "We'd been to California in 1951, but just touring for a couple of weeks, so we had no idea of the wondrous climate of Southern California. But after this sample, we decided that, if not Mexico, California would soon be our new home."

Painting in California, 1965–1975

With their abiding love and fascination for Mexico and its people, the Whitakers almost made Alamos, in the province of Sonora in Mexico, rather than California their new home. Early in 1965 Fred and Eileen took one of their regular trips to Mexico, this one, however, especially to check out Alamos as a possible residence because of its climate and opportunities for painting. "We loved it," Eileen says. "We stayed a month, mingled with the natives, did lots of sketching and painting. We met many wealthy Americans, who had bought and rebuilt old mansions there and lived in them for part of the year, as well as artists who made frequent trips. I remember talking at length with one of the artists, who regularly visited. 'No,' he told us

with great animation. 'You must not live here year-around. No. In May there are the bugs, then there is' the this and the that and the this and the that, and on and on." This admonishment, as well as similar comments from other acquaintances who had been there, made the Whitakers realize that Alamos, glorious as it was to visit, was, perhaps, not the place to live. "It is really isolated," Eileen says, "a wonderful experience for a short-term hideaway, but impractical for year-around living."

So they extended their trip west to another favored place, La Jolla, in California, which they had explored the previous winter, with Roy and Lena Mason. After pulling in to a small motel on La Jolla Boulevard, in mid-February, Fred and Eileen began scouting for homes – initially out of curiosity, just to see what was available. "We looked for two days at homes in Mission Hills, Point Loma, and La Jolla," Eileen says. Then, on a Sunday morning, a real estate representative took them to a home in the Muirlands area of La Jolla, situated thirty-two steps up from a long, angled driveway on El Camino del Teatro. "Before noon, we had bought the house," said Fred.

The Whitakers moved in on June 1, 1965. Fred was seventy-four; Eileen was fifty-three. "The movers were bringing our things up," Eileen says, "and Fred was already sitting on the patio painting." In no time, the Whitakers became acquainted with people interested in the arts in La Jolla and San Diego, at that time a relatively small and elite group. The Masons were already dear friends whom the Whitakers had met in New York in the 1940s. "It was natural to fall in love with Roy the instant you met him – everyone did," Eileen says. "Roy was a bright man with broad interests, and a fine painter as well. There was never a more attractive couple than Roy and Lena. It was wonderful for us to have the Masons, such good friends and stimulating people, so close."

On moving to La Jolla, the Masons had become friends with Jerry and Inez Parker, patrons of the Fine Arts Gallery of San Diego (now the San Diego Museum of Art). The Parkers were also friends of Ted and Carol Larsen, the Whitakers'

Fred and Eileen in their La Jolla home, 1966.

friends from Connecticut and Palm Springs. The Masons and Parkers knew Reed Barrett, the president of the Fine Arts Society, and his wife, Anne, and everyone knew Warren Beach, the director of the Fine Arts Gallery, and Philip Gildred, a longtime patron of the arts and a civic leader in San Diego. Most of these friends, together with the military elite of San Diego, active and retired officers in the navy and the marines, gathered regularly at galas.

Shortly after they moved to La Jolla, the Whitakers' social circle fell into place. "Lena Mason called and invited us to a party to be given by the Parkers, whom she said were also friends of the Larsens," Eileen says. "Naturally, Fred and I said we would love to go. It was a wonderful party. The Parkers were charming and we met many interesting individuals" – the Barretts, the Beaches, the Gildreds, and so on. "After a couple of hours, Fred said he thought it was time for us to leave, so we politely said our good-byes, thank yous, and left. Days later, we found out, much to our shock, that the Parkers' party was given for us! We were the guests of honor!"

The Whitakers' new home, which was built on a steep hill, had a large cellar under the front area. They decided to use half of the cellar as their studio, fitting it out with sufficient fluorescent lighting. Within the first year, however, they had built a freestanding studio adjacent to the house. It was paced and laid out by Fred and Reed Barrett, who was also a semiretired architect and contractor, during one of the brash but amiable Barrett's frequent, and unannounced, visits to the Whitakers. Designed with amenities for artists – handy sinks and good lighting – the addition was practical in that it could eventually be used as a guesthouse. It was then built, under Barrett's supervision, by Barrett's son-in-law, Dick Hibbard, who was a contractor. Eileen staked out her territory, where she could take advantage of the natural light. "It didn't matter to Fred," Eileen says. "He could paint under any conditions – well, almost." The Whitakers sent out invitations to their "New Studio-Warming Open House" to all their new friends,

the celebration occurring on June 5, 1966, just one year and a few days after they had first moved in at 6453 El Camino del Teatro.

The addition of this studio was a boon to the artists, but long before it was built or even planned, the Whitakers were competing in local and regional art shows, in addition to their annual national competitions, and Fred had his hands once again in art society organization. In August 1965, Eileen won first prize for *Cabritos* at the Carnation Festival Art Exhibition at the San Diego Civic Center. Among the paintings she had worked on in their cellar studio was *Cuenca Cathedral* (p. 108), for which she won an award at a competitive exhibition at the M. H. de Young Memorial Museum in San Francisco and also at an AWS annual exhibition. Watercolor was starting to take wing in San Diego, and local artists were forming the group that was to be called the San Diego Watercolor Society. Founding members asked Fred to advise, and "of course, Fred loved doing that," Eileen says. The Whitakers became honorary members of the society, exhibiting in shows and occasionally jurying.

In addition to showing their paintings in competitive national exhibitions, the Whitakers regularly exhibited their work in galleries and other art venues in La Jolla and San Diego, and elsewhere in the West. In La Jolla, they exhibited with the Jones Gallery, directed by Doug Jones, in the Green Dragon Colony on Prospect Street. In San Diego's Old Town, their work was shown by Old Town Galleries, a quaint assemblage of art shepherded by Maybelle Smith; in 1973 the business was taken over by Circle Galleries and became Old Town Circle Galleries. In Balboa Park in San Diego, they exhibited at the Art Institute and at the Sales and Rental Gallery of the Fine Arts Society. They also exhibited at the A. Huney Gallery, which was run by Arvilla Huney, in San Diego, and at the Art Centre of Rancho Santa Fe, which was directed by Carol Hard.

Special exhibitions also lured them, such as the Fiftieth Anniversary Exhibition of the La Jolla Art Association in 1968, at which they exhibited their work with that of their fellow

Eileen and Fred in their studio on El Camino del Teatro, 1972.

watercolorists Roy Mason and Rex Brandt, as well as the oil painters Olaf Wieghorst, who concentrated on Western themes, and Jean Swiggett, who was known for his realistic figures, particularly nudes. Also in 1968, the Whitakers exhibited in the San Diego Art Institute's Fifteenth Annual Exhibition. Fred won the Best-in-Show Award and the First Prize in Watercolor for *Baroque Facade* (p. 82), a detailed depiction of the Food and Beverage Building that had been built in 1915 on the Balboa Park Prado. A gem of baroque architecture, the building was razed shortly after that, leaving Fred's watercolor painting as a legacy to a bygone era in San Diego architectural history and as a superb example of Fred's rich, masterful handling of intricate architecture.

Fred painted another gem of architectural and ornamental subject matter that same year: *Museum Piece* (location unknown), the depiction of an intricately designed religious piece discovered in a dark corner of a small room in the old San Fernando Mission in San Fernando, California. The painting won the Herb Olsen Award at the 1968 AWS Annual Exhibition. "I think *Museum Piece* is one of Fred's most stunning paintings," Eileen says. "I've never seen any watercolorist do dark interiors with [such] life and vitality. . . ."

Fred, it seems likely, agreed. In a note on a card about the painting he kept in his files, he had written: "*Museum Piece*, 1968, 21½" by 29" – Probably the best painting F. W. has ever made."

Outside San Diego, the Whitakers exhibited in San Francisco, Los Angeles, and Palm Desert, California; Scottsdale and Tucson in Arizona; Jackson, Wyoming; and Santa Fe, New Mexico. In San Francisco, they showed with the Society of Western Artists. "We drove up twice a year with our paintings," Eileen says. "We were crazy about San Francisco, a combination of Boston and New York, and the society members were a terrific group of artists and individuals."

They showed with Dalzell Hatfield Galleries in the Ambassador Hotel in Los Angeles, Desert Southwest Art Gallery in Palm Desert, O'Brien's Art Emporium in Scottsdale, Rosequist Galleries in Tucson, Trailside Galleries in both Scottsdale and Jackson, and Blair Gallery in Santa Fe.

In 1974, both Whitakers showed their paintings at the Frye Art Museum in Seattle. Also that year, Fred was among eleven people to receive the Horatio Alger Award, which was presented by the American Schools and Colleges Association, a nonprofit corporation dedicated to recognizing "achievements which inspire in American youth an appreciation of their equal opportunities under American free enterprise." The award honors individuals for their rise from humble beginnings to make exceptional contributions to society through "initiative, hard work, honesty, and adherence to traditional ideals." Fred was one of only two artists ever to have received the award.

"Happiness is largely a matter of adjustment," Fred said. "Of adjusting ourselves to our environment rather than expecting the rest of the world to adjust itself to our wishes or our way of thinking."

Fred credited his happiness to his ability to accept life's circumstances and experiences – good, bad, and indifferent – realistically. "How many go unhappily through life, upset by petty disturbances, because they never learn the simple truth that a switch of a single constituent of one's outlook can adjust that individual to a thousand vexing conditions, and that this is much easier than trying to change a thousand conditions to his liking. Adjusted to his environment, one has all he needs, and such a one is rich indeed."

Fred's success clearly came through adversity, challenge, action, and adjustment. In July 1972, a biography, *Frederic Whitaker*, written by Janice Lovoos, an artist as well as an author, was published by Northland Press, the publication coinciding with a

one-man show at Old Town Circle Galleries in San Diego. The opening reception provided standing room only, and almost every one of the paintings he exhibited was sold.

Adjusting to His Environment, 1975–1980

On September 5, 1975, Fred wrote in an addendum to his autobiography: "The painting that I finished today is number 994. I am wondering if I will be able to finish the series to number 1,000." His eyesight had been failing for some time and though the decline was slow, it was noticeable. "On many occasions I have said to myself: 'This painting will be my last,'" he wrote. "But somehow we manage to continue . . . the goal is number one thousand. Just now that figure seems unobtainable, but I am encouraged by the fact that twenty-five numbers back my feeling was about the same." Two months later, in November, Fred completed *By the Beautiful Sea*, which was his last. Its number: 1,000.

In fact, Frederic Whitaker had painted far more than a thousand pictures and, though it was indeed hard for him

Fred, the artist and writer Janice Lovoos, and the writer and editor Norman Kent collaborating in California, 1967. Lovoos wrote the biography, Frederic Whitaker, *which was published in 1972.*

to give up painting, his last work did not mark the end of an influential, productive life. During the next five years, Fred continued to add to his manuscript collection at Syracuse University. He updated his autobiography. He sat for a bronze bust and a watercolor portrait. He oversaw the compilation of his third book. He and Eileen began another art group, the Circle of Ten, that, like the Fairfield Watercolor Group they had belonged to in Connecticut, involved monthly gatherings and artists' critiques. He was active in social events with others interested in the arts and, in a voluminous correspondence, telephone conversations, and personal meetings, continued to encourage those who would follow in his footsteps in painting and the work of art societies.

Since 1964, Fred had been contributing to the Frederic Whitaker Manuscript Collection at Syracuse University. Martin Bush of the Syracuse University Manuscript Collections had persuaded Fred that Syracuse would be the appropriate steward of his papers. Bush, along with Frank P. Piskor and Lawrence Schmeckabier at Syracuse, established the collection.

"We would like to preserve everything you have ever produced in written, typed, or printed form," Bush told Fred. "This would include all fan mail, photographs, newspaper clippings, notes, lectures, reviews, catalogs, speeches, working drawings, copies of outgoing mail, sketches, noncurrent or dead files, or, in other words, we would rather preserve everything related to your life and work than see any of it discarded or destroyed." Thus it is that a vast collection of Fred's writings, many of them intended for publication – and many not – and more than a hundred of his paintings dating over the span of his lifetime are housed at Syracuse University.

Bush encouraged Fred to write his autobiography, a task that he began in 1964 and worked on diligently but sporadically over the next two years, recording thoughts as they came to mind. He titled the work "I Marched in the Parade," a title that hints at an observation made ten years earlier by the artist John Scott Williams.

Fred and Eileen in their El Camino del Teatro studio, 1975.

Fred and the artist Roy Madsen with Madsen's bronze sculpture of Fred, at the A. Huney Gallery in San Diego, 1978.

In September 1954, while Fred was president of the American Watercolor Society, Williams, who was also active in a number of art societies and had served as vice president of Artists for Victory during the war, had written Fred a letter about the modesty of artists, the fleeting nature of the public's interest, and the waywardness of publicity. Williams concluded with what was almost a pep talk, saying: "As a profession, we [artists] are not good showmen. We do not make a noise. But if in your

enthusiasm for the profession you can lead the big band as drum major, I am sure the artists will appreciate and wish to join the parade."

Fred chose to report his life as one who *marched* in the parade, prefacing the book by saying that his contemporaries (he was then in his mid-seventies) had witnessed a dramatic period in history. Crediting Thomas Alva Edison with "inventing a system for inventing" and, thereby, catapulting scientific pursuit into public prominence, Fred maintained that more technological progress and productivity had been compressed into the previous seventy-five or one hundred years than was achieved in all previous eras combined.

"It would seem then that any one of us who has been even a little discerning could offer an interesting and possibly valuable cultural and historical report by simply describing his own life experiences," Fred wrote. "This explains my being presumptuous enough to include my recollections between the covers of a book, writing as a reporter rather than as a man of letters."

The book is not merely a record of his life as it unfolded, but also a description in detail of things he learned to do, observed, or experienced, among them, the shoeing of horses, the harvesting of ice from winter ponds, the creation of tortoise-shell combs, the "sand-bobbing" of a silverware teapot, metal chasing, hand-forging, the making and jury-rigging of special toys and functional tools, the evolution of matches and the production of firecrackers and other explosives, "therapeutic electricity," the all-encompassing amenities of a corner general store, the measuring, packing, and pricing of food items when each process was handled separately for each customer, the distribution of milk, the trapping of flies, the nineteenth century as the cast-iron age, and the peddling of cure-all pills prescribed for every ache.

The year after Fred stopped painting, in 1976, he sat for a bronze bust of himself that was sculpted by the Whitakers' friend Roy Paul Madsen, who was, in addition to being a sculptor and a

member of the Circle of Ten, a university professor, and a writer. In 1977, one of the edition of busts was presented by Reed Barrett to Syracuse University for the Frederic Whitaker collection.

Also that year, Eileen painted a watercolor portrait of Fred, who posed in profile and held a book. "It was so natural to see Fred with a book," Eileen says. "Yes," rejoined Fred, "but not such a big, heavy book." So, the book prop was replaced by a huge empty box, which answered the artist's requirements for her composition and the subject's desire to be comfortable.

In 1978 and 1979, Madsen assisted Fred with his third book, *The Artist and the Real World*, a compilation of essays – Fred described them as "random reflections" – that he had written over the years, on matters artistic and not, collected under two broad headings, Professionalism and Technique and Art in Society. Madsen helped compile, select, and edit for publication work that, for the most part, was never meant for publication, but consisted, rather, of notes written to help Fred crystallize his thoughts and observations.

"Most of these collated essays are an incredible distillation of insight, wisdom and provocative thought about the uphill fight of becoming a figurative artist in an art world dominated by nonobjective art," wrote Madsen in an introduction to the book. "These thoughts about 'making it in art' are like Frederic Whitaker himself: lucid and tough-minded, gentle and humorous, insightful, frequently tongue-in-cheek, usually profound, sometimes acerbic, and refreshingly honest and intelligent." The book was published in 1980, shortly after Fred's death.

Eileen, meanwhile, had been writing or typing correspondence for Fred as well as herself since the mid-1970s. She continued to paint, encouraged, critiqued, and cheered on by Fred. But it was not easy. "When Fred could no longer see to paint, . . . it was like the end of the world for both of us."

"This year has been, for me, a fateful one," Fred wrote in his autobiography. "During 1975 it was definitely impressed upon me that I am an old man. Previously I knew, naturally,

Antony di Gesú's photographic portrait of Eileen, 1982. Eileen is standing in front of the portrait of Fred that she painted in 1977.

Eileen in her studio, 1979.

that eighty-four years was a long life span, but this year the fact was forcibly driven home to me in a flood of reminders." In addition to the failing eyesight, Fred was suffering from Parkinson's disease, arthritis, and loss of hearing. "Along with this slowdown in the physical parts," Fred wrote, "comes a corresponding decline in the mental department. My mind is no longer nimble."

"The last year of Fred's life was particularly rotten for him," Eileen says. "And he was such a good sport. I never really knew

how badly he had been feeling until I read his additions to his autobiography after he died. He never complained."

Frederic Whitaker died peacefully, while just dozing, at 9:30 in the evening of March 9, 1980, in his home in La Jolla, two months after his eighty-ninth birthday.

"And right up to the end," says Eileen, "he was winning prizes." Eileen had entered Fred's *Cottonwoods Country No. 2* in the 1980 annual competitive exhibition of the American Watercolor Society that was to be held in April. The awards jury was meeting and had given Fred's painting the Samuel J. Bloomingdale Award when Mario Cooper, the president of the society, entered the jurying room and announced that he had just received sad news: "Fred Whitaker has died."

Beyond the thousand paintings that Fred numbered, many other paintings of his have surfaced and have been authenticated. "Fred gave so many of his paintings away over the years," Eileen says. "Many of them he never bothered to number. So we have no definite number, but it is well over a thousand" – perhaps closer to two thousand. "Fred liked certain of his paintings more than others," Eileen adds, "but he didn't treasure any of them. He would sell or give them away by the handfuls, happy that he could share them." Fred's former secretary, Evelyn Lincourt, echoed the thought: "He gave his paintings generously, including to his staff. To him, selling a painting to a friend was prostitution."

After Fred died, letters poured in to Eileen. The San Diego watercolorist Ed Wordell wrote: The "love you had for each other was so evident by . . . eye contact with each other and the gentleness with which each of you treated the other." The artist Henry Gasser wrote from New Jersey: "I know that I am not the lone recipient of Fred's generosity – there are many artists today who are indebted to Fred's help during their careers, and he smoothed the path for so many of them." David Gill, a judge in San Diego, wrote: "If a man may be fairly measured by the mark he leaves on the lives of others . . . one of the giants of art has left us. What a marvelous and lasting mark he leaves behind."

Painting Alone

A Darkening Palette

"I was in a fog for at least two years after Fred died," Eileen says. "It was the end of the world. Every aspect of my life was turned upside down. The closer people were to me, the more difficult it was to be with them." She was more comfortable having a light-hearted exchange with the clerk in the grocery store than a chat with a friend. "It was escape," she says. "When I was feeling really rotten, I would just go to the grocery store or somewhere like that and talk with someone who had no idea what I was going through. It was a relief."

For the first couple of years after Fred died, Eileen was occupied with legal matters. "That was my whole existence," she says. "I don't remember anything else. Fred had everything spelled out in his will, but it still took so long."

When asked about her descriptions of "the end of the world" and about the lawyers who were "my whole existence," Eileen pauses, then laughs at what Fred used to say about her. "Fred said, 'You can discount about 80 percent of what Eileen says!' Well, maybe I do exaggerate, sometimes, when I'm excited. I just respond to things. That's my nature. But I really was devastated when Fred died – and it sure felt like the end of the world."

Remembering their early days together, when she was living in her apartment on Jones Street and Fred in his at 1 Sheridan Square in Greenwich Village, she says: "One day I took a nap. I felt I was getting a cold. When I awoke, I felt great – no cold at all! As I lay there, thinking, I suddenly had the most wonderful feeling that being in love, Fred and I together could overcome anything! Nothing could hurt us. Sickness could not touch us. It was like a revelation, and the feeling remained with me, that is, until Fred died."

Three fortuitous opportunities for Eileen came along in the early 1980s; one she fought, another she almost abruptly dismissed. The first was a one-day seminar on her work and a critique of the students' paintings at Crafton Hills College in

Yucalpa in California. A representative of the college, who turned out to be most persuasive, called Eileen and asked her to do a watercolor demonstration. "I told him emphatically I won't do it. I would be no good. I would hate it," Eileen says.

Over the years, she has repeatedly turned down invitations to do demonstrations. Her typical, concise response resembles almost identically the one she wrote to the artist Marie Fillius, who asked Eileen to give a demonstration for the San Diego Watercolor Society in October 1976: "I do not give demonstrations, at all – nor lectures, classes, or critiques."

"I can't think of anything I'd rather not do," says Eileen.

Undaunted, the representative from Crafton Hills persisted, calling her repeatedly. "Finally one day he said, 'Why don't you just talk about slides of your paintings?'" Eileen recalls. "He said it could be very casual, that I wouldn't have to give a demonstration. So I thought, well, I could do that." The coup de grâce came when he said: "Eileen, this is what Fred would want you to do."

Eileen gave the seminar on October 25, 1980, talking briefly about her background, education, and approach to painting, and then giving a slide presentation with a commentary on dozens of paintings. "When I start something like that, something I've never done before, it is exciting," Eileen says. "And I really did enjoy the experience and meeting the students."

In speaking to the students, Eileen said: "We are all individuals and we should not try to act like others. Individuality is the mark of a truly creative person. We can certainly learn from others, but we're on our own when it comes to our own creations." Then she shared advice given to her years earlier by Everett Shinn and Ted Kautzky, artists who were friends of hers and Fred's: "Remember, Eileen, just be yourself."

"The trouble then was," Eileen told the students, "I didn't know who 'myself' was!"

And now, Eileen was asking the same question again. She was suddenly a "me," rather than a "we." She did not really feel like painting. It was becoming hard to find the inspiration she needed and, perhaps as a reflection of that, her palette had been changing.

"Fred told me before he died that my colors were getting too dark," Eileen says. "He rarely made any comments about my paintings, and there was no way Fred would ever give me a bold criticism. He was always supportive. About the only critical thing he ever said about a painting, if asked for his opinion, was, 'Well, it's not the best thing you've ever done.' But, I sensed, when he said my colors were getting too dark, he meant he didn't think it was pleasing."

Eileen's palette had become darker, more somber, during the last couple of years of Fred's life and continued dark for a couple of years after he died. An emotional artist, she was painting what was coming naturally at that time – not her lighthearted, often whimsical and optimistic imagery, but paintings of a more subdued nature, both in subject and in color.

Then in early 1982, Eileen was invited to join a group of doctors and professional men in San Diego who met usually once a week, to paint and socialize. Among them was Dr. Lee Monroe, who was also president of the San Diego Zoological Society at the time, and Charles Faust, who had created the animal environments for the San Diego Zoo and the San Diego Wild Animal Park and who did sand casts as well as watercolors. Eileen was the only professional watercolorist in the group, which numbered between ten and twelve people, the men being the amateur artists and their wives being in charge of the culinary and social pleasantries of the gatherings.

Years earlier, Eileen and Fred had met Dr. Monroe when he was one of the doctors caring for Roy Mason, who had had a stroke that left him bedridden or in a wheelchair for the last several years of his life. An amateur artist with great appreciation for art, Dr. Monroe was co-publishing with Dr. Jim Kelley, another of Mason's doctors, a book on Roy Mason. That the Whitakers were longtime friends of the Masons was a boon. Monroe sought out Fred's observations as an artist and an author and his advice on the book. Naturally, Eileen was included in these tête-à-têtes. These early meetings, however, were primarily

informational: discussions between artist and writer with a specific purpose in mind.

"We didn't know quite what to expect when we invited Eileen to our sketchy painting gatherings after Fred died," says Monroe's wife, Bobbie. "Here she was, a professional, successful, well-known artist. Obviously with her own schedule and way of painting and doing things. Well, she showed up in this Ritz Crackers sweater and was so down-to-earth, friendly, and casual, we loved her. She fit right in." Eileen felt much the same way and continued to paint with the group regularly for years.

For Eileen, painting in the company of other people and painting whatever happened to be presented or on hand was another new experience; all her life she had painted in the privacy of her studio, and painted only subjects that she herself found inspiring. "Charlie Faust had a collection of kachina dolls," Eileen says. "During our meetings, I painted each of the dolls" (see p. 127). She painted other subjects as well, and gradually found herself able to enjoy painting again, and socializing.

The most defining experience for Eileen, as an individual and as a versatile artist during the 1980s, was the publication of the book *Eileen Monaghan Whitaker Paints San Diego*. In 1969 the artist Rex Brandt had painted the pictures for *San Diego: Land of the Sundown Sea*, a book that had been published by the Copley Press. Helen Copley, the head of the press and of Copley Books in San Diego, decided it was time for a new book. Richard Reilly, the director of the Copley Library in La Jolla, was selected to oversee the project. Copley and Reilly both thought that Eileen would be the best artist for the book they had in mind.

Reilly, who knew Eileen from his other occupation, as art critic for the *San Diego Union*, contacted Eileen and told her that Mrs. Copley wished to commission her to paint the illustrations for an updated version of Brandt's book on San Diego. "No," Eileen said instantly. "I'm not interested in painting a bunch of buildings – the gas and electric building and so forth ad nauseam, and places that have been done over and over." Convinced Eileen was the artist for the job, Reilly persisted.

So Eileen reviewed Brandt's book, page by page, with her longtime friend Cay Young, who herself was a part-time artist and whom the Whitakers had known in Connecticut when she took watercolor lessons from them. Cay and her husband Frank had moved to La Jolla in 1970. "Cay said, 'You do it your way; choose what you want to paint,'" Eileen says. "Talking it over with Cay, and considering the idea for a book from her observations and focusing on being able to do it my way, made me look at it differently. That really changed my mind." That, and Reilly's effective, if not original, entreaty: "Eileen, this is what Fred would want you to do."

She was given carte blanche to do whatever she wanted to do in whatever style she chose. There would be no restrictions and she could take as long as she liked. "After I got into it, I really started enjoying it," Eileen says.

The book jacket carried a description of the artist's activities on behalf of the book:

> For the past four years, all of San Diego County has been the studio for the watercolor artist . . . from the Pacific Coast to the Cuyamaca Mountains to the Anza-Borrego Desert, from the Mexican border reaching north through the seaside communities to Oceanside. She toted sketchbooks, pencils, and pens, cameras and rolls of film. . . . As she sketched, she mingled with the wealthy of Rancho Santa Fe and the spirited youths of Chicano Park. She chatted with passersby in Balboa Park, joggers along Mission Bay, scuba divers in La Jolla, shoppers in outdoor markets. She set up her studio in the heart of a bustling downtown San Diego, as well as the pastoral outreaches of Santa Ysabel Valley.

"I chose many places I had never been before," Eileen says. "I went wherever the spirit took me, and I had exciting, wonderful times." A few of her favorites are Julian, Santa Ysabel, Mary Star of the Sea Church in La Jolla, California Tower in Balboa

Park, Horton Plaza, Chicano Park, the Del Mar Races, sailors at a downtown pier, old houses throughout San Diego, and a 1984 World Series game.

"Doing the book forced me to get out and sketch and paint constantly," Eileen says. "It made me focus on specific things and pay more attention to detail than I normally would. My goal was to create as accurate a presentation as possible and still preserve my individual interpretation."

The writer Don Dedera, an editor of *Arizona Highways* magazine and a columnist for the *San Diego Tribune,* was asked, in February 1983, to write the text for the book. Paul Weaver, a former editor and publisher of Northland Press, accepted a position as editor and designer in April 1984. *Eileen Mcnaghan Whitaker Paints San Diego* was published in November 1986 with great fanfare, including an invitation-only reception given by Helen Copley at the Copley Library. The following month an exhibition of original paintings for the book opened at the Old Town Circle Galleries and ran through January 2, 1987. Almost all of the paintings were sold. Eileen also was kept busy through the end of 1986 and into 1987, giving media interviews and participating in book signings.

But the early 1980s, for Eileen, were not entirely upbeat. In March 1982, at the time that Eileen was considering the book, her sister Kathy, who had been suffering from multiple physical problems, died. Kathy had been living with her son Norman and his wife Diann at their home in Youngsville, New York. Closer to home, Eileen's sister Connie, who had moved to La Jolla with Fred and Eileen in 1965 and who had made San Diego her home, was sick throughout the early to mid-1980s, and in and out of hospitals. Eileen was constantly rushing to one hospital or another, responding to an emergency or an almost-emergency and becoming exasperated by being on call and by the many false alarms. She cherished the times when Con was in good spirits. "I took Con sketching with me occasionally," Eileen says. "Once we drove north looking for the flower gardens of Carlsbad for the book (see p. 181). It was a good day for Con, for both of us."

Eileen also took Con to dinner frequently, and when necessary transported her from one doctor to another and back to her apartment. "Generally, though, she was miserable," Eileen says. "So depressed. She was anemic. She would have panic attacks. She would call saying she felt so sick. She didn't know what to do. The doctors had no answers."

Writing to Janice Lovoos, in a letter dated March 20, 1985, Eileen told her friend that Con was in a convalescent home and Eileen was in the process of moving her things into the Whitaker garage. "At this point [life] is a steady routine of dreary work . . . sad, depressing, and hopeless." Connie Monaghan died on April 5, 1985. "The book," Eileen says, "was my salvation."

Guatemala in Color, 1988–1992

"It's like a giant multicolored quilt gone mad," says Eileen, describing the way in which reds, pinks, oranges, and purples collide in a turbulent sea of radiant, fiery colors – almost defiant in their coexistence – the effect of Guatemalan textiles laid out, row upon row, from sidewalk to intersecting sidewalk, over the lush, sun-drenched plaza in Antigua.

If California had been a discovery and Mexico a delight, Guatemala was dazzling. "The colors are so vivid, the experience of them is almost blinding. Never have I been so overwhelmed by the power and energy of color as I am in Guatemala." Eileen was to take three trips to Guatemala, and an exhibition of twenty-one paintings inspired by her adventures there and sixteen paintings derived from previous sojourns in Mexico, *Eileen Monaghan Whitaker: Watercolors of Guatemala and Mexico*, was presented at the Frye Art Museum in Seattle in July and August 1990.

The series of Guatemalan adventures began in October of 1988 when Lauralee Bennett, whom Eileen knew from her work on the Copley book on San Diego, and her husband, Wayne, invited Eileen to join them during their trip there. Wayne went to study the language; Lauralee took lessons in weaving; all three were eager to explore. The Bennetts welcomed Eileen at the airport in Guatemala City and draped a colorful, hand-woven

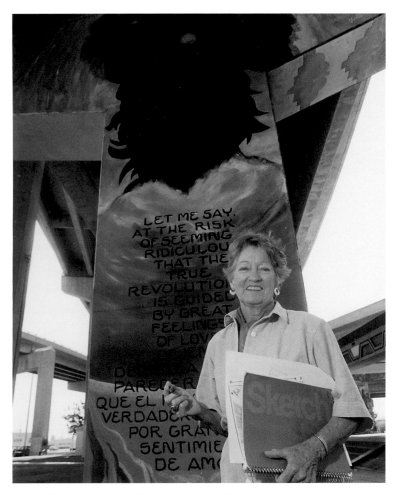

Eileen sketching in Chicano Park in San Diego, 1986.

shawl around her neck. That shawl – which was to become the subject of *Ancient Design* (p. 78), one of Eileen's most colorful, detailed, masterful paintings – was the start of a love affair with the country, its people, and its brilliant, multicolored textiles.

For Eileen, the timing of the Guatemala adventure and its stimulation was perfect. Well before, and for a few years after Fred's death in 1980, Eileen's palette had muted, the colors darkening. The stimulus of wanting to pour out her feelings in paint was not quite on hold, but no longer as spontaneous. At any time, she says, "I have to really be excited about something I see to get started on a new idea for a painting." More than twenty-five years earlier, on toasting the Whitakers on the occasion of his purchase of one of Eileen's paintings, Archer Milton Huntington had summed up their approaches to painting: "Frederic paints with his head; and Eileen, with her heart." After Fred died, nothing was all that exciting. Expression no longer just flowed, and her heart was definitely not in it.

Beginning in 1982, her book of paintings of San Diego for Copley Books had given her creativity a much-needed and appreciated boost. Her commission was defined in the broadest of terms – to paint her impressions of San Diego County. The

result was a portfolio of paintings that not only represent a scene or subject, but also flowed from an invigorated and stimulated heart. Eileen's palette brightened, the attention to detail in some works was modeled in realistic, eye-catching colors, impressions became lighter, more fanciful, and more in tune with the artist's nature, which is cheerful and optimistic.

With her excitement about painting revived, Guatemala inspired in her an explosion of color and brought the artist once again to her overriding interest, people. "I'm always fascinated by people, wherever I travel," Eileen says. "In Guatemala, I was thrilled by the natives, with their beautifully proportioned bodies, golden skin, and distinctive Mayan features. And everywhere you look in the marketplaces, there is boundless, stunning color, intricate designs, and a flurry of activity. It's almost too much of a good thing.

"Experiencing that first market day in Guatemala literally unleashed my palette. Nothing I had heard about Guatemala prepared me for the excitement I felt in being there. The warmth of the people, so friendly and gracious, and the gorgeous colors and wonderful, often ancient, woven designs of their garments are paradise for an artist – certainly, this artist. I've been thriving on this brilliant color ever since."

Eileen was constantly sketching the Guatemalan people, quick one-, two-, three-, five-minute sketches. When not sketching, she was chatting with them in their own tongue and bartering for their colorful textiles. "My Guatemalan people are not specific" individuals, Eileen says. "They are impressions I have from looking at people and sketching them quickly. Subconsciously, I'm studying people all the time. It's my instinct. I get so excited about people. When I draw or paint them, I'm re-creating them partly from imagination and partly through interpretation."

Interestingly, the initial creative spark in Guatemala resulted in a painting very different from most of Eileen's Guatemalan work. *Ancient Design* is simply a watercolor celebration of the colorful, intricate design of one hand-woven shawl.

"I am crazy about this design," Eileen says. "It took me a year to decide how to paint it. I wanted to represent the design, softened by folds. I didn't want people involved, because that would compete with the shawl's design."

During this time, Eileen also was shepherding two other projects. One was the Frederic Whitaker and Eileen Monaghan Whitaker Foundation, a nonprofit organization founded in 1988 to preserve and promote the work of both artists. Among the foundation's first activities was Eileen's second project, to introduce the idea of a retrospective exhibition of paintings by Frederic Whitaker to be presented in 1991, the centennial anniversary of his birth.

Syracuse University, the repository of the Frederic Whitaker Manuscript Collection and more than a hundred of his paintings, was the likely place to start. The exhibition, *Frederic Whitaker: Watercolor by Design*, which was organized by Alfred T. Collette, the director of Syracuse University Art Collections, Domenic J. Iacono, the associate director, and David Prince, the curator and registrar, was presented by Syracuse University Art Collections. The exhibition opened on November 10, 1991, in the Lowe Art Gallery at the university, and ran through February 10, 1992. The scope and depth of the presentation was limited (because of the charter within which the University Art Collections functions) to works from the Syracuse collection only. Nevertheless, twenty-seven significant paintings and other artworks, including Fred's early metalware design, were shown and offered a modest, but concise, glimpse at the productivity, variety, strength, and excellence of Fred's work.

Following the show and after reading a tribute to Fred in an AWS newsletter, the artist George Gibson, in a letter to Eileen dated February 14, 1992, wrote: "I am sitting here thinking about . . . how genuinely thoughtful and kind Fred was toward all these painters who were fortunate enough to have benefited from attributes which were typically his. Few of us have done so much and helped so many. His efforts for and on behalf of watercolor rightfully entitle him to bear the name 'Mr. Watercolor.'"

These years of travel and exhibitions restored Eileen's vivacity and marked her return to painting "with her heart." In addition to the exhibition at the Frye Art Museum in 1990, she had a one-person exhibition in 1988 at Founders Gallery at the University of San Diego, and, in 1989, a one-person show at the Riggs Gallery in La Jolla, where she began showing regularly.

Sadly for Eileen, her brother Kevin died on September 23, 1989, in Dublin, where he had been living for more than thirty years. He was the proprietor of a shop at 43 Dawson Street called Doona of Dublin (taking Doona after his mother's maiden name), where he sold Irish prints, antiques, souvenirs, portraits of houses, murals, and decorative items. Of the six Monaghan children, Eileen was the creative child who did become a professional artist, but Kevin, too, had been a creative child, a talented artist, and a member of the American Watercolor Society. He had studied at the Art Students League in New York, with Fernand Léger (1881–1955) in Paris, and at academies in Rome, Bologna, and Milan after service in World War II. Sketches he sent home to his parents and sisters during the war were clever, personal, observant works of art, many accented with wit and dry humor.

Kevin was known for paintings that he called "architectural moods" or "architectural portraiture," depicting historic homes in the United States and Europe. He exhibited these in one-person and competitive shows on the East Coast during the mid-1950s. Disillusioned by the commercialism of the United States, Kevin moved to Ireland in the late 1950s. "He was so talented," Eileen says. "He was a natural artist. He had such an eye for things. It's sad to me that he didn't pursue his talent."

Kevin stopped painting when he moved to Dublin. Eileen never knew why. She suspects it was because of practical reasons. For instance, in his compact apartment, which was combined with his shop and which he called his "subterranean penthouse," the entrance being below the sidewalk of Dawson Street, there was simply no room for a studio.

Though not a working painter, Kevin was highly regarded in Dublin's art community. In a tribute article in the *Dublin Evening Press* (November 8, 1989), Kevin is described as "an intrinsic member of the Dublin artistic set for more than two generations. Few Dublin artists were more recognizable . . . one of the city's most memorable characters."

Deirdre Kelly, who was well known in Dublin and a staunch crusader for controlled growth and the preservation of the neighborhoods, Georgian architecture, and the character of the city of Dublin, was a good friend of Kevin's. "Just sitting talking to him was my escape to unreality," she wrote to Eileen after Kevin's death. "He was lovable, stubborn, awkward, and delightful. He had a wonderful gift for telling a story."

"Kevin did exactly what he wanted to do, and he was happy," says Eileen. "He could be acerbic and outspoken, or he could be charming. But he had no sense of obligation – to himself or to anything. I feel obligated to myself every day of my life."

EMW: The Artist on Her Art

Eileen has been interested in painting as early as she can remember. Using watercolor as her medium, she offers her interpretations and impressions of people and the fascinating, colorful, exotic, and attractive materials, things, and places engendered by creative people wherever she finds them. Whatever she creates is done from her own, individual perspective, and in her painting she carries out her lifelong quest to be, do, perceive, interpret, and create in a way that expresses her distinctive personality. She strives for the unusual, the offbeat, and, always, the optimistic.

"Eileen is one of those spirited individuals who finds something wonderful in other people and places," observed M. Stephen Doherty, the editor-in-chief of *American Artist.* "She assumes there is something good and beautiful to discover, and she points her brush in the direction of those uplifting sights." Richard Reilly calls Eileen's work "a celebration of life."

Yet, however celebratory the creative outcome may be, that does not necessarily echo the process. Describing herself as an emotional artist, Eileen says that her paintings come into being from an emotional urge to create. "Being a creative painter," she says, "is long, hard work, although an artist is not forced to do it. We are driven by an urge so strong we can't resist it. For me, it is not fun to paint, as for some artists, but something akin to agony, but as I have often said, delicious agony."

She paints representational subjects in imaginative, abstract, or symbolic settings, often described, by reviewers and collectors, as Eileen's "wonderful backgrounds." "I've never thought about 'backgrounds,'" she says, with some surprise. "I don't feel that I paint 'backgrounds.' A background to me is as important as the foreground in a painting. It is all part of one painting. All part of the total design."

While she was living on the East Coast, Eileen's landscapes and cityscapes reflected the location. For the human figure, she was inspired by trips to Mexico. "Eastern landscape

hasn't thrilled me for a long time," Eileen says, comparing the landscapes of the East and West to two attractive women. The West is a nude woman with a beautiful body; the East is a well-groomed, well-dressed lady, quite refined, just not aesthetically stimulating. Eileen seldom paints only a landscape, but when she includes landscape in an overall design, she strives to evoke the "beautiful body."

"The Mexican people were the first foreign people I had come in contact with and I got carried away by the culture and the people – both personally and in my painting," Eileen says. "I love the color of the skin of the Latin Americans, their dark eyes, dark hair, native dress, and their bone structure. Many have very short foreheads, high cheekbones, and deep-set eyes. Beautiful to paint. And they are always doing something, carrying things on their heads, running thither and yon, always busy, so interesting to watch and sketch." After moving to the West Coast, and inspired by even more frequent trips to Mexico, Eileen continued to paint Mexican figures and also began painting the American Indian, a subject matter inspired by trips throughout the Southwest.

"I think my painting has changed gradually over the years," she says. "Years ago my paintings were maybe not as carefully worked out as they are now, and maybe they lacked finish and sometimes even accurate drawing, but there was a wonderful freshness to them. Guatemalan painting forced me into more detail. I was so taken by the textile designs and the symbolism. I was carried away by subject matter, and I had never given that much attention purely to subject matter. It was always the concept I concentrated on. And I thrived on being able to just follow my feelings, to go wherever they took me. Paintings used to be flights of fancy."

Her paintings of the late 1990s and early 2000s range in subject matter from a butternut squash, pears, and eggplant to nudes in unusual settings to richly colored birds in flight to flower portraits to figure studies to experiments with a flat dimensional composition to whatever else seduces her imagination. "I like to experiment with new subjects and to use new color schemes and new materials."

Whatever the subject matter, its major attribute must be that it excites in some way. To trigger the creative juices, something has to startle Eileen's attention. And if she does find a subject that elicits an immediate response, the type of subject matter is immaterial. "Whether it is a person, architecture with landscape, a bird, a pomegranate," she says, "you're working out the same principles: the impact of color and form, shapes, the way the light hits. The creative urge is to get out this wonderful feeling." By the same token, if she is drawn to somebody for a creative reason, that attraction has nothing to do with the person's identity, status, or even personality. "I'm not thinking about who this is, what a nice person this is, or what a grouch," says Eileen; she is simply responding to something about that person that has become a creative stimulus, a stimulus that elicits the same spark as does any other subject matter.

"An artist is observing constantly, thinking of things every minute you're awake," Eileen says. "Ideas, images, thoughts, inspirations flit in and out – along with everything else that's going on in life. Some of these fleeting ideas or inspirations stick long enough for you to grab hold and hang on. It's up to the artist what he does with them." In a letter written in 1994, Janice Lovoos, who had become increasingly close to Eileen over the years, said, of her painting and her passion: "Eileen, I cannot explain this but you are more of a true artist than most people alive today. You are a complete artist. You have a complete knowledge of what a really good painter needs to know and you utilize it."

When pressed to name artists whose work inspires her, Eileen lists three: Amedeo Modigliani (1884–1920), the Italian painter who lived and worked in France; Francisco de Goya (1746–1828), the Spanish painter; and Frederic Whitaker. Of them, she comments: "Modigliani's stylized, elongated portraits and nudes are so exciting! I love the way he used practically flat color – with minimal chiaroscuro – for skin tones, and then

The ladies of the Circle of Ten, 2003. Standing, from left, Jan Jennings, Yee Wah Jung, Eileen, and Barbara Madsen. Seated, Jackie Sowinski.

defines form with stunning, sensuous line. Goya's paintings are so bold, so dramatic, so passionate. Yet his palette is very low key. It's his values – of strong contrasts – that make the paintings sing. I wish I could paint watercolors like Goya's!" And, "I admire Fred's strong, rich watercolors. Whether it is an architectural subject or a tender Mexican man holding his firstborn, the distinctive quality of the work is achieved with bold, direct, spontaneous washes. Intimate detail is suggested in a few expressive strokes. I was fortunate to be able to watch Fred paint, and never tried to copy, but I naturally absorbed a tremendous amount just by observing. Whenever I would get discouraged and depressed about my work, Fred would try to help by suggesting certain procedures. I would rebel then, saying, 'That's your way – not mine! I don't want to do it that way!' I wonder how he ever put up with me!"

What is Eileen's way? What thoughts guide her in the creative process? "Well, . . ." Eileen hesitates only slightly, "to qualify as a creative work of art, a watercolor painting must have all the components required of any other major art form. It must have solid design or composition, values, harmony, color balance, sound drawing, and last in line, technique. More important than any of these are conception and inspiration. This is the individuality, the uniqueness, the artist offers – his personal observations, reflections, and his own message."

To Eileen, inspiration is the key to the painting, suggesting its mood and feeling and directing technique. Seeing something that excites her, she will do quick, small sketches and may scribble notes to herself on whatever conditions excited her

imagination: colors, mood, action, and so on. When detail is important, she will take stereoscopic or 35 mm photographs for reference. "The quick sketches are the most important," she says. "Really the lifeblood of my paintings. I make sketches constantly, on anything, bits of found paper, napkins, whatever is available at the time. I may go to these sketches immediately and create a small design or designs for a painting – or it may be years before I get back to them, yet they are every bit as exciting. I have tons of sketches to work from."

With sketches in hand, she changes and rearranges elements in small designs, feeling her way through to what she believes is an interesting composition for a painting, not overly detailed, but capturing the essence. These small layouts may measure only two by three inches or be as large as seven by nine inches. The composition must please her. "It must be successful, otherwise I'd just keep doodling forever," Eileen says. "I'd never get to do a painting."

On the full sheet, she lays out the composition quite loosely in pencil. When concentrating on figures, animals, birds, or architectural subjects, she does more detailed drawing. "When I start the actual painting, I begin with the elements which first inspired me, then continue building on those feelings." Concentrating on the center of interest, perhaps one figure, she works back and forth between it and the surrounding areas, establishing the key for the entire picture and marrying foreground with background. "Usually the thing I have before me suggests a rhythm, a swirl, or a direction, which I just naturally follow. It's following this rhythm and a building up of one feeling after another, just feeling my way through, that gradually leads to the final painting. I have no definite picture in my mind [of] how the painting will turn out, but I do have a direction and motivation from the person or thing that inspired me."

Writing to Janice Lovoos in June 1986, in response to Lovoos's queries for an article on Eileen that had been commissioned by *American Artist*, Eileen said: "I've never followed any rules in my work, never consciously thought about technique.

Jon Kery, a scholar of watercolor and collector of paintings by the Whitakers, and Eileen at Eileen's La Jolla home, 2001.

Each painting is merely a result of trying to put on paper, with pigment, water, and brushes, an image of the emotion that stirred within me the urge to create." Capturing this emotion on paper becomes a labor of love that frequently requires mopping out, painting over images and abstract patterns, scrubbing and scraping, and flooding washes. "Usually, I work with a brush in one hand and a sponge in the other, and the two hands seem to be equally busy," Eileen says. With considerable amusement, she adds that these and other treatments she uses in a painting emerge as a conglomeration of spots, lines, puddles, and the like that art reviewers have referred to as her "distinctive style." "I would label it an organized mess," Eileen says, "which I am somehow able to feel my way through to a degree of completion – some paintings more than others. Briefly, my practice is painting a fairly complete composition in watercolor, scrubbing it down to what might be called an overall texture, and then, after it is dry, painting the finishing effect directly onto the scrubbed-down surface. This gives a quality and background luster that can never be achieved by the application of finished washes directly upon pure white paper.'

Just as Eileen abhors the word *technique*, she is as repulsed by the word *formulae*. "Each painting should be as unique as the spark that inspired it," Eileen says. "I don't think a truly creative work of art can be achieved by relying on formulae for painting certain items or subjects, no matter how common they may seem, or by adhering to rigid technique. And I don't think a truly creative person could stomach such painting. Formulae annoy me. I approach each new painting like a newborn babe."

Standing up, Eileen paints at a large, adjustable drawing table in her home studio. All the finished paintings are done in the studio. The colors in her palette are lemon yellow, cadmium yellow deep, raw sienna, raw umber, sepia, Venetian red, brown madder, cadmium scarlet, cadmium red, French ultramarine blue, cerulean blue, cobalt green (yellow shade), viridian, terre verte, oxide of chromium, and olive green. All are Winsor and Newton Artists Watercolors. For brushes, she uses mostly flat,

ox-hair or sabline brushes, from half an inch to one and a half inches wide, a round, double-ended Japanese brush, and occasionally a few round, red sable brushes, sizes 8, 14, and 30. For paper, she uses Arches three-hundred-pound cold-press and hot-press papers, in sheets measuring twenty-two inches by thirty inches, and Winsor and Newton cold- and hot-press paper.

"I like to work on several paintings at the same time, leaving each for a while to concentrate on another,' Eileen says. In response to a letter from an art student at Western Washington State College, who asked, in January 1973, "Are you ever satisfied with your paintings or do you feel you should change or improve them?" Eileen wrote, "I am never satisfied with a painting. At a point, one must consider it finished, but if it remains with me, it will perhaps be changed." Over the years, that conditional response has expanded: Now, "I regularly take out my paintings and work over them." Years may go by, decades even, and she will discover a painting and itch to change it. Seeing one of her paintings framed and hanging in a gallery or private residence, she often wishes – but, fortunately, stifles the urge – to liberate it from its frame, and change it: swab out, add, delete, refine, define, re-create.

Distinguishing her work from other watercolor painters, Eileen observes: "My paintings are worked over a great deal more than [those done in] the traditional 'direct, spontaneous' approach. Many watercolorists would be appalled at how long it takes me to do – or more correctly – to be relatively satisfied with, a painting. The length of time a painting takes does not matter to me, weeks, months, years. It is the way I work. The

goal is to feel at the end that I have been able to complete the journey sparked by the initial inspiration. When that happens, what a feeling!"

A distinctive and individual ingredient to her work, Eileen adds, is anomaly. "I frequently combine abstract shapes – designs – with quite realistic figures or juxtapose realistic images of unrealistic size, color, or placement. I am always looking for something that gives me the opportunity to add a special twist, a different look, something that will jolt the imagination, but in both a surprising and pleasing way. Creative artists, without thinking, bring their own vision to their work. This is my goal."

Asked about what she feels makes a painting exceptional, Eileen replies: "I couldn't define it. If I start to analyze, I'm dead. I'm just stopped. I never really know. I get irritated when people feel they have to 'analyze' paintings. The works should speak for themselves." As for defining art, Eileen says: "Art encompasses all manifestations of life. Anything beautifully, creatively, and well done can be a work of art."

FW: The Artist on His Art

"Of course," Fred has said. "I enjoy painting watercolors. I'd be a fool to spend so much time at it if I didn't. Many people find their pleasure away from their 'job,' say at a ball game or playing cards. . . . By making a pleasure of our chosen work – by adjusting our point of view to the fact that work or the fulfillment of duty is a boon, we can achieve the greatest entertainment and pleasure. . . . Producing pictures is my pleasure."

In a professional career in fine art that spanned thirty-five years, from 1940 until he retired from painting because of failing eyesight in 1975, and the years before that when he was merely "practicing," Fred painted perhaps as many as two thousand watercolors, and observed that "people generally appear to like and to get some inspiration from my product."

He was largely self-taught and his path to success as a fine art painter in watercolor took many colorful turns. A champion of representational art, Fred was of the opinion that "if it inspires me in some way, I can paint anything." No subject matter is neglected. Architecture was of interest because of his experience in the details of metalwork design. He has depicted landscapes, seascapes, city scenes, steel towns, statues and statuettes, patios, flowers, bumblebees, bougainvillea, boats, ships, female nudes, fantasies, and the peoples and places in Mexico and Spain that he loved so well.

His ideas for paintings arose from what he saw around him. He was always looking for something unusual, something that he could delight in translating through his own perceptions, be it a beautiful or tranquil scene, some lavish religious ornamentation, an intriguing facade, an expressive person, a dramatic sky, a humorous moment, or perhaps a mundane, everyday scene, such as a trash can at a rear entrance, that he could elevate to a visual delight.

When inspired, he immediately made a small pencil sketch on the site, including notes to himself about the colors, shapes, mood, and the reason for his attraction. Sometimes he took

photographs as visual aids to memory when attention to detail was important, and he often used a stereoscopic camera. Sometimes he began work on the concept within a day or two; sometimes he left it for weeks or months.

The primary work for each painting was done in the studio, where he began by developing the pencil sketch into a small sketch in color. These sketches ranged in size from three by five inches to eight by ten inches and were the workhorses for the finished painting. Into these small sketches Fred poured his total concentration. He worked out the composition, design, colors, values, shapes, and the harmony of the various elements. If visual problems appeared, this is where he confronted and conquered them.

What he was always seeking was the perfect composition: a painting that was a "complete, self-sufficient entity. Within its borders are found everything that it requires and nothing that would fail to help it. The slightest change, addition or subtraction would sully its perfection." These small color sketches are meticulously thought out and so carefully rendered because, Fred says, "it is in this [preparatory work] that the artist injects himself." The charm of watercolor painting is its looseness, or the suggestion of fluidity. To achieve this liquidity, fluidity, luminosity, and looseness, however, Fred insisted, "you must know how to plan tightly."

Satisfied with the small sketch, Fred went to the full-sheet watercolor (he did use irregular sizes when the composition called for them), following his color sketch with tunnel vision. He penciled in the outlines, loosely or in detail depending upon the dictates of the subject and his color sketch. Then he began adding washes of color, and then the finishing touches. Describing the development of one painting, he said: "First I covered the paper with washes of local colors, the colors that eventually became more defined in the composition. When that was dry, I added the shadow color, in this case a mixture of brown and blue, to the areas of each part of the composition I wanted to accent. I used the same shadow color for the entire canvas. Then

Fred, 1979.

I went back and mingled the local color with the shadow color, and the units are interrelated. They hold together. Then, with a few quick, crisp finishing touches, the painting is completed, the shadow color giving it the solidity.

"I think perhaps my greatest discovery and contribution to watercolor painting is the use of shadow colors," which, he felt, gave his paintings substance. He was quick to point out that his overall process in painting a watercolor also usually entailed his manipulating the color washes, swabbing or sponging out, deleting spots or areas, and making other subtle changes deemed necessary before adding the finishing touches. The exact composition was achieved in the "think piece," the color sketch, but the technical aspects of painting the full-sheet rendering remained and often required varying amounts of tweaking or finessing. "Much of my watercolor work is far from direct," he said. "I change it about a good deal, for it is the only way I can achieve my ends. . . . No picture is finished as long as it can be improved."

Fred preferred to work on three-hundred-pound, cold-press, handmade, 100-percent rag paper, preferably Whatman or Arches paper. His square-ended, flat, ox-hair brushes ranged

in width from a quarter of an inch to one and a half inches. For line drawing or fine detail, he used an inexpensive double-ended Japanese brush in a bamboo handle. His palette included ivory black, sepia, burnt umber, yellow ochre, cadmium yellow light, cadmium orange, cadmium scarlet, cadmium red, Winsor red, cobalt violet, phthalo blue, Winsor green, oxide of chromium, viridian, phthalo green, raw umber, cerulean blue, and cobalt blue, all made by Winsor and Newton.

In Fred's earlier works, from the late 1920s and 1930s, there is a looser handling of the watercolor, more simplicity, less detail, and many of the paintings, though strongly depicting the subject matter (including street scenes, houses, and landscapes), are not as finely rendered as they were to become later. There is an almost primitive quality to many, although they are by no means primitive in the manner of a painting by Grandma Moses. In each painting there is the feeling that everything fits: a balance, harmony, solidity, repose, if somewhat less refined. The paintings made during the 1940s through the early 1970s, when Fred's eyesight was good, are strong, solid, bold, and detailed, painted with flair and refined in style. As his eyesight declined, Fred developed a different approach to painting. He could no longer see the points of his pencils or brushes, and straight lines would "appear to be meanders." Anything on paper a foot or two away was a blur. Detailed work was out, yet he continued to paint.

Writing an addendum to his autobiography, in September 1975, Fred observed: "Friends express wonderment that I am able to paint such successful pictures while still unable to read, write, or use the typewriter successfully. This fact also surprises me." He did it by placing even greater emphasis on preparation, and then, when painting, worked as a mural painter does, one section at a time, until he had arrived at the whole.

"Part of the success of my new and enforced method (and I feel that some of my latest paintings are the best that I have ever done) is due," Fred wrote, "to my exacting practice of choosing subjects," which included landscapes and similar ungeometric shapes that he could handle with relative ease.

Whatever his method and whenever he painted, Fred was true to his beliefs about his work. "The purpose of art – drawing, painting, sculpture – is to create a thing of beauty; to convey a thought or message of some kind; or to provide inspiration to someone," he said. The viewer, he believed, was of the utmost importance. Though all art need not be pleasant, it should have something to say and do so in an understandable manner. Fred saw nothing sacred about art and felt that – just like any other product: groceries, automobiles, books, movies – it should be created with the needs and tastes of the consumer or viewer in mind. "Lack of consideration for the wishes or opinions of others leads only to irresponsibility, and I see no excuse for artists, alone among all other workers, claiming the right to be irresponsible."

A practical, practicing artist, Fred was an established figure in the New York art world when abstract expressionism was born. To him, it was just another ism. He knew cubism, impressionism, fauvism, dadaism, minimalism, and so on, and the artists who could be categorized by these isms had, he said, "but one string to their bow." Cubists, for example, insist on geometric technique; impressionists specialize in light refraction. In the process, he felt, they discarded elements such as perspective, atmosphere, chiaroscuro that are important tools in the wide range available to the artist.

For his own part, he sought to use every tool at his disposal. "Would I not be dull indeed to throw away deliberately even one of the few faculties given me for making myself understood? That would be like trying to converse without using any words beginning, say, with *S* or *A*. Such conversation would surely set the speaker apart – which might satisfy some – but we must remember that the real purpose of speech, and art, is not merely to advertise oneself, but to convey thought," which Fred conveyed through representational paintings. "Representationalism," Fred believed, "is the only ism that has persisted through the ages, all others having petered out after about ten or fifteen years. It is the only style of picture making that has been accepted

by the people generally; and no art can achieve lasting success without popular approval and support. Painting realistically will continue long after the isms are forgotten."

Asked to sum up his career as an artist, Fred was likely to have said, modestly, that he did no more than to put one foot in front of the other in life, handle each task before him to the best of his ability, in spite of his limitations, and was fortunate to enjoy a degree of talent. Asked about the perception that his was a successful career, he was likely to have replied that success in any particular endeavor entails a simple formula. It comes from careful planning followed by appropriate action. It is accomplished through concentration, whether the endeavor be large, small, or one's overall goal in life. For personal success, Fred held concentration as but one of three components of the formula; the two others being "the habit of working toward the goal during all waking hours, and the enjoyment derived from work."

Using his own criteria, one might well conclude that Frederic Whitaker was a man who thoroughly enjoyed concentrating on painting – hence his success. To that formula, Fred added another element: the "really successful people," he said, "are those who produce for humanity in general something worth more than they receive." Fred considered it his duty to paint as many good pictures as he possibly could, "to give back to the world what has so generously been given to me."

Never a man to mince words, Fred believed that a person can be original only if he has something of his own to say and the fortitude to say it. From knowledge and experience gleaned over decades of learning, concentrating, planning, and doing, Fred spoke and wrote of his convictions with clarity and authority, wit and humor, style and panache. He painted his watercolors with directness and assurance, charisma and class.

"One of the appalling thoughts that comes to an old person is the enormous amount of time all of us have wasted in nonproductive activities." (It is surprising that Fred Whitaker even recognized the word *nonproductive*.) Writing in "I Marched in the Parade," Fred said, "Like Harry Truman, I would like my epitaph to read, but not too soon, 'He done his damnedest.'"

Notes

My principal sources for these biographies have been my numerous conversations (many of them recorded) with both Fred and Eileen since 1972. I have also relied on his three books, two on painting, *Whitaker on Watercolor* (New York: Rheinhold, 1963), and *Guide to Painting Better Pictures* (New York: Rheinhold, 1965), and *The Artist and the Real World* (Westport, Conn.: North Light Publishers, 1980) and two biographies, that by Janice Lovoos, *Frederic Whitaker* (Flagstaff, Ariz.: North Land Press, 1972), and the unpublished autobiography "I Marched in the Parade."

For Eileen Monaghan Whitaker, our conversations aside, details have been gleaned from her own handwritten biographical account, from numerous magazine articles by and about her and numerous newspaper articles, and from her correspondence with various people during her career in fine art.

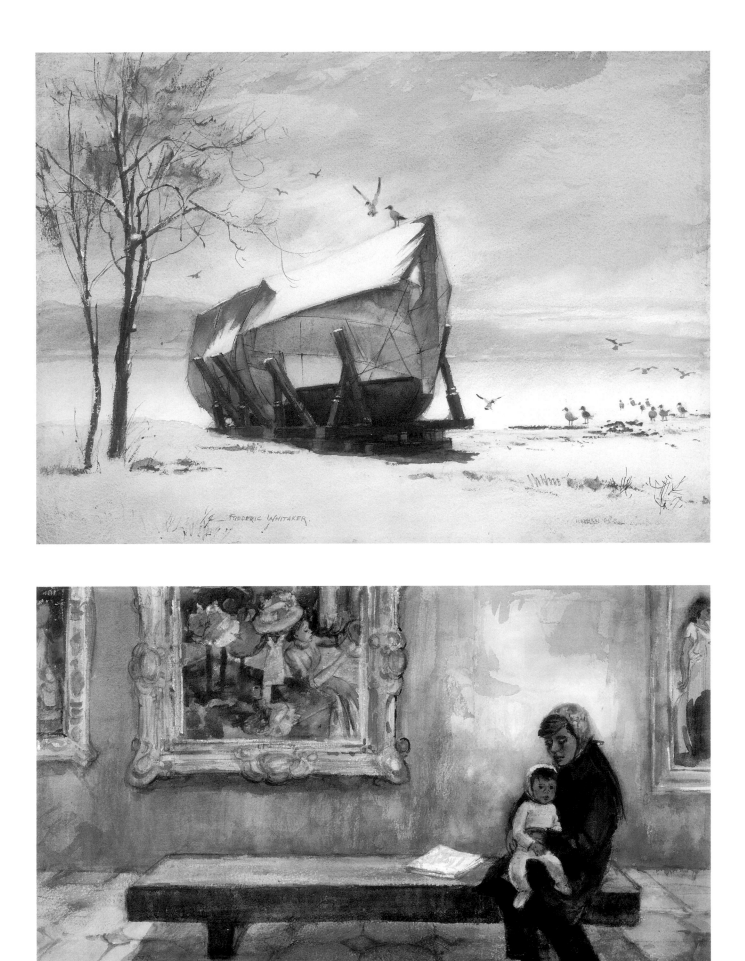

Frederic Whitaker and Eileen Monaghan Whitaker
Masters of the American Medium

For much of the twentieth century, the course of western art was marked by an ever-changing succession of styles that came upon one another with a rapidity and assertiveness not previously manifested so spectacularly in its history. As early as 1913 representational art tended to become eclipsed by the more avant-garde applications, such as abstraction and cubism. With the event of the landmark Armory Show in New York that year, modern art, as practiced in Europe, and revealed in depth here for the first time, was introduced to America. Despite this development, many American artists persisted in their allegiance to the native luminist-realist tradition, which had long dominated the nation's art. As one critic of twentieth-century American art, Clement Greenberg, saw it, "The visionary overtones [of major American painters of the realist persuasion] move us all the more because they echo *facts*. This is perhaps the most American note of all."

Out of this time-honored tradition, the art of Eileen Monaghan Whitaker and Frederic Whitaker has drawn its nourishment and special appeal. Monaghan's early background as a fashion illustrator and commercial art director was the impetus for her subsequent allegiance to a realist mode for conceptualizing the world in terms of art. She has said that from childhood she "always had a terrific urge to paint." In the 1940s, she finally turned from the commercial aspect of her career, devoting herself fully to easel painting. Not coincidentally, it was during this time that she met and married Frederic Whitaker. A designer, businessman, and entrepreneur, Whitaker was already an established artist, known for his mastery of watercolor. This was the medium in which he created elaborately detailed designs for ecclesiastical metalware for such prestigious enterprises as the Gorham Company and Tiffany, as well as for his own multiple business ventures. Watercolor was the natural medium of expression for Whitaker's easel paintings. His example proved to be a formative influence on Monaghan, herself an avid practitioner in the medium. To their credit, however, while carving out an intimate life together, Monaghan and Whitaker firmly retained their own individuality in terms of their styles of painting, each working in a distinctly personal manner.

In the New York art scene of the post–World War II era, perhaps no entity more resolutely defended conservative values in art than the National Academy of Design. Founded in

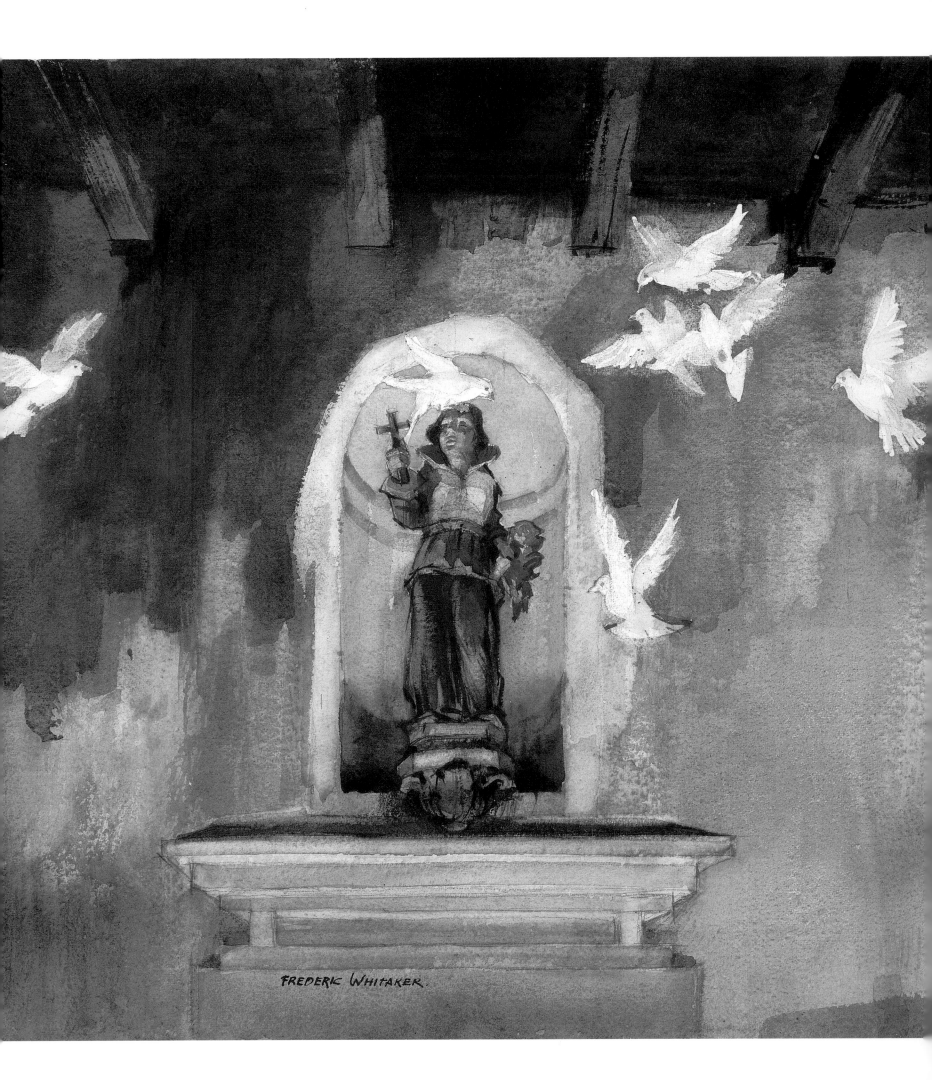

FREDERIC WHITAKER.

1825, the academy included on its roster of members almost every American artist of note since its inception. Whitaker was among their number; moreover, from 1949 through 1957, he served as president of the American Watercolor Society, which was closely identified with the academy. Monaghan also became a member of both these organizations during this period. Together they saw the tectonic shift that American art underwent in the late 1940s as traditional values rapidly gave way to radical change, especially in the form of abstract expressionism. Suddenly, the relevance of representational forms of art seemed to be called into question.

For Monaghan and Whitaker, however, this was never an issue. They continued steadfastly down the path they championed: painting fine, traditional, representational artworks. As Whitaker called it: "understandable art . . . art that is recognizable to the viewer." This, it seems, they were destined to do, whether working at the center of artistic innovation in New York City, or in the increasingly more receptive and open cultural milieu of Southern California.

In 1965 Monaghan and Whitaker departed the New York scene, relocating in La Jolla, California. For decades, California had sustained a thriving art tradition of landscape and figurative painting. Furthermore, many of the state's leading artists specialized in watercolor painting and were notably prominent in major national venues, such as the American Watercolor Society. Significantly, California was not the cultural desert that many Easterners envisioned.

Long before their resettlement in La Jolla, the Whitakers had traveled extensively in the American Southwest and Mexico, accruing inspiration for their paintings. With their move to California, they were afforded the luxury of proximity and could concentrate fully upon subjects associated with this new living environment. The result was an outpouring of work that reflected their fascination with Native American and Hispanic peoples and the street scenes they inhabited. As their art had been invigorated during earlier travels throughout Europe, particularly Spain, so it was stimulated by these exotic prospects of the Southwest.

A major statement in the art of both Monaghan and Whitaker is that they reject the commonly held notion that watercolor must be spontaneous, that brilliance of technique should be a primary ambition for the serious painter of watercolors. Not so, they aver, and most convincingly. A great achievement of their art is that it conceals the effort of creation; it seems immediately realized and instinctive. For both artists, in exceedingly different and individual ways, a great amount of thoughtful preparation and execution lies at the core of each picture.

In the nineteenth century, writers frequently referred to watercolor as "the American medium," largely because of the sheer number of artists who embraced the medium and the important place it had assumed in exhibitions and among an avid public. Although art in our time has shifted into a variety of expressive means that would have been unimaginable then, watercolor yet claims the allegiance of many important American artists working today. It is a tribute to Frederic Whitaker and Eileen Monaghan Whitaker that their formidable talent has enabled them to create watercolors of such unique and personal vision. Each is truly an exemplary advocate for "the American medium." 🖉

LEFT
Frederic Whitaker
The Little Statue #2, n.d. (detail)
Watercolor on paper, 22 × 27 in.
Private collection

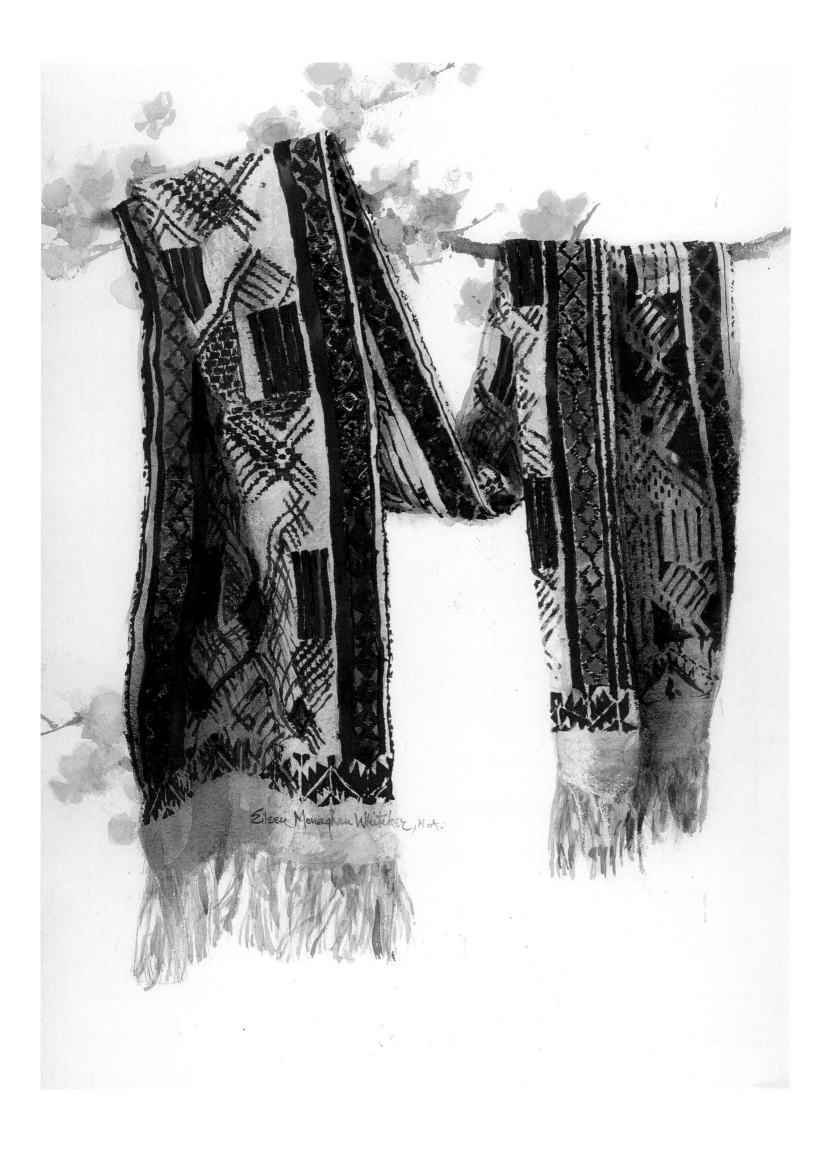

Precise Design and Deep Delight
The Art of Eileen Monaghan Whitaker

Precision and atmosphere – both are intrinsic to the art of Eileen Monaghan Whitaker. This has been the case stretching back for at least seven decades. Think of these qualities as polarities, between which her images edge closer to one or the other on a continuum, depending upon the nature of the subject. At one end of the spectrum is *Eggplant Study* (1977; p. 80), one of the few compositions that the self-critical artist openly praises; it's the stately meticulousness of the pair of forms named in the title that gives the composition such vitality and charm. At the other pole is *Chac Mool #3* (1968; p. 80) – one of a group of works made between the sixties and the nineties – in which the reclining sculptural icon is enveloped by a field of phantom flowers, birds, and purely atmospheric flourishes of color; the soft universe that surrounds the central icon infuses the work with a mood that elevates the mystical above the empirical.

Watercolor has been her major medium. She and her late husband Frederic Whitaker moved to California in 1965. By that time, he was already one of the most ardent champions of the medium in the United States – so much so that many admirers affectionately referred to him as "Mr. Watercolor."[1] The West Coast already possessed a climate favorable for the reception of such work. Accomplished contemporaries such as Dong Kingman and Millard Sheets had contributed to an efflorescence there of watercolors distinguished by sensitive interpretations of the landscape and its character.

Together, the Whitakers helped to further the climate for California as a lively center for watercolors. He applied his considerable gifts and range to figures, landscapes, and architecture; Frederic had a great affinity for Baroque-inspired architecture, for which he found excellent sources in San Diego as well as Mexico. She established her own considerable role with keen intuition for pictorial design, a sharp eye for color, and a poet's appreciation for the ordinary object, for nature, and for the human form.

Eileen was born in Holyoke, Massachusetts, in 1911. She trained at the Massachusetts College of Art. She had told her parents, "I want to be an artist." Their reply – like that of most parents concerned with practical matters – was "there is no future in that."[2] She met them halfway by devoting herself to a career in commercial illustration and fashion design.

LEFT
Eileen Monaghan Whitaker
Ancient Design, 1989
Acrylic on paper, 30 × 22 in.
Collection of the Frederic Whitaker
and Eileen Monaghan Whitaker
Foundation, San Diego, California

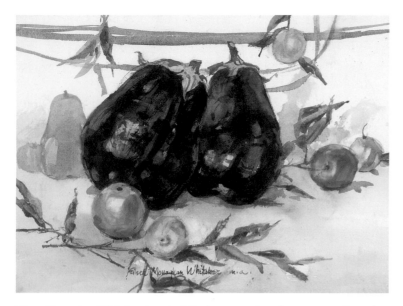

Eileen Monaghan Whitaker, *Eggplant Study*, 1977, watercolor on paper, 16 × 22 in. Collection of the Frederic Whitaker and Eileen Monaghan Whitaker Foundation San Diego, California

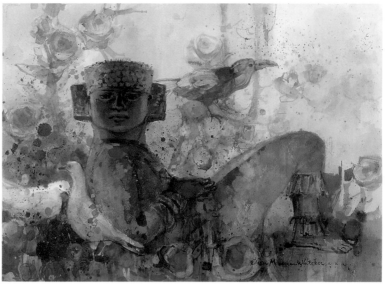

Eileen Monaghan Whitaker, *Chac Mool #3*, 1968, acrylic on paper, 22 × 30 in. Frye Art Museum, Seattle, Washington Gift of Ms. Minnette L. Frohlich

Much of that time was spent in Manhattan, which is where she met Frederic Whitaker in 1943 – on Valentine's Day, she is quick to mention. He was having an exhibition at Ferargil Galleries. Sketching trips together evolved gradually into a serious relationship.

They were ideally suited for each other, aesthetically and romantically. Although her art exudes a more Romantic sensibility, they shared an unwavering passion for design in painting. "Even when I do figures," she observes, "design is the first thing I pay attention to, consciously or unconsciously." He felt much the same way, as he was to say in an essay called "The Purpose of Painting": "Design, in a painting, means the contrived arrangement of masses, colors, values, directions, key, etc., which, added to the chosen theme, makes a perfect picture."[3] Her *Bird Watcher* (1989; p. 81), with its carefully structured layers of design, is a telling example of this shared philosophy. One's eye is inevitably drawn first to the lone female figure in the picture – the watcher – because she is distinctly rendered in relation to the rest of the picture, because the scarf on her head has an intricate pattern, and because the furled arrangement of the scarf is so gracefully rendered. Subtler, but no less compelling is the geometric pattern in her blouse: soft rectangles in reds, blues, and greens. The rest of the image is even softer: striped textiles rippling in the wind, a hovering butterfly, and a bird by the woman's shoulder. She is obviously enjoying a still moment observing nature, while also serving as a stand-in for the artist, who is conveying that same appreciation to us through the effective design and atmosphere of the picture.

When they moved to La Jolla, it was the first time the artists had lived on the West Coast. They had been New Yorkers during the previous fifteen years of their marriage, with a passion for frequent trips to Mexico. It is clear that they relished their new regional identity, traveling even more frequently to Mexico, whose people and architecture make abundant appearances in their art. Eileen ventured to Guatemala in the years after her husband's death, and *Bird Watcher* is one picture that is a result of those later trips.

Eileen would also pay affectionate homage to her Southern California hometown in a series of pictures published as *Eileen Monaghan Whitaker Paints San Diego* (1986). She recalls the project with great pleasure, saying that Richard Reilly, formerly the curator at the Copley Library, told her that she could paint whatever she wished for its pages.[4] Some of the book consists of the county's iconic sights, such as La Valencia Hotel and the Palomar Observatory. But there is her characteristically keen attention to small things, such as trees in a rural landscape and a pair of California quail. Few artists render birds with as much sensitivity as she does. To her, they are clearly a prime emblem of the beauty of nature – and finding a form to fit that beauty is clearly a bedrock passion for the artist.

She captures a reverence for nature that links her more to nineteenth- than to twentieth-century artists; they expressed a sense of wonder about flora and fauna that has mostly degenerated into formula with so-called wildlife painters. At the same time, the free use of space in and around figures and objects, presented as color-saturated atmosphere with soft traces of

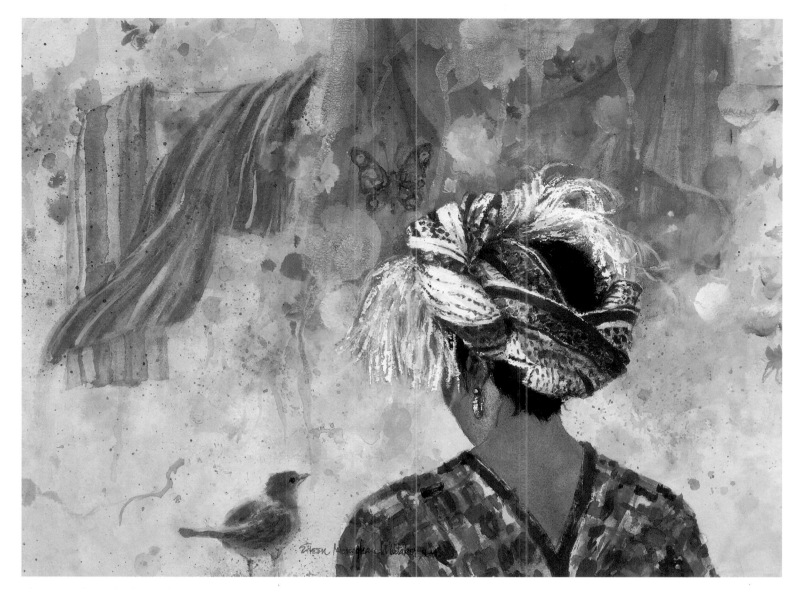

Eileen Monaghan Whitaker, *Bird Watcher*, 1989, acrylic on paper, 22 × 30 in.
Collection of the Frederic Whitaker and Eileen Monaghan Whitaker Foundation, San Diego, California

objects, subtly bonds her to the modernist tradition cultivated by the likes of Arthur Dove and John Marin.[5] Achieving such effects requires a mastery of one's medium, so it should surprise no one that she was chosen for the select category of Academician among watercolorists in the National Academy of Design.

Firmly grounded in traditions of draftsmanship with roots in the Renaissance, her art is tradition minded, but not academic in the pejorative sense of the word. It is a disciplined form of personal expression. "I am always trying to get something I feel on the paper," she explains. The American philosopher and educational theorist John Dewey was to observe that the universal could be found in the local. In the arena of Eileen's art, one may take this to mean that, through intimate observation of things, an artist may create pictures that communicate with a wide spectrum of viewers. This is precisely what she achieves, whether she is painting something close to home or in another country.

The delight that she takes in the natural landscape, fruit, vegetables, the human figure, textile designs, ancient statuary, and enduring architecture are all evident in her art. For her, only close observation will do and only an expressive translation of the world into art will suffice. Precision meets atmospheric poetry. The end result is a form of delight for the viewer, which runs parallel to the visual pleasures of the world itself. 🌼

Notes

1. See Janice Lovoos, *Frederic Whitaker* (Flagstaff, Ariz.: Northland Press, 1972), 30.

2. Eileen Whitaker, interview by author, February 10, 2003; all subsequent quotations from the artist are from that conversation, unless otherwise noted.

3. Lovoos, *Whitaker*, 31.

4. Eileen Whitaker, telephone conversation with the author, April 6, 2003.

5. For a broad discussion of stylistic trends in the nineteenth and twentieth centuries, see Donelson F. Hoopes, *American Watercolor Painting* (New York: Watson-Guptill, 1977).

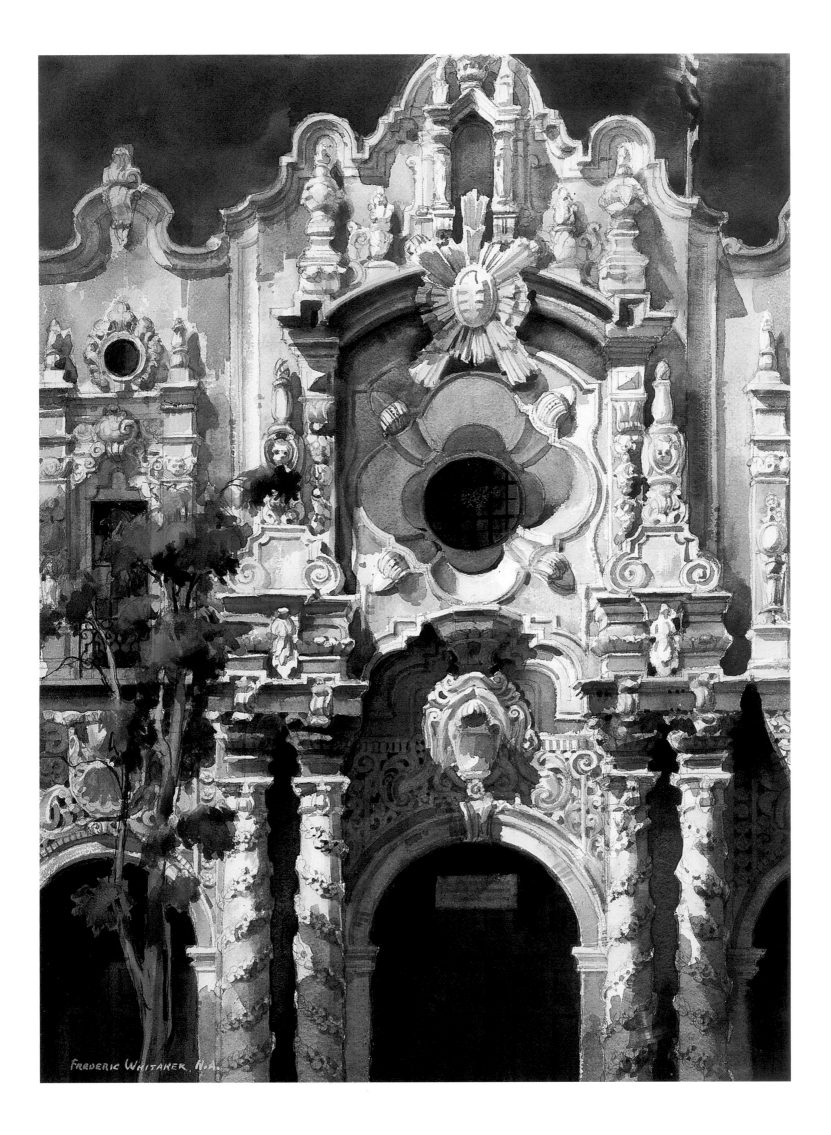

FREDERIC WHITAKER, N.A.

Discipline, Communication, and Creativity
The Art of Frederic Whitaker

When it came to painting, Frederic Whitaker knew exactly what he was doing. As a consummate master of the watercolor medium, he had no difficulty in producing the precise effects he wanted. But that was only the skilled craftsman's side of his creativity. Of much greater importance was what he could communicate to others through his art. After all, he had written: "The purpose of art is to create a thing of beauty, to convey a thought or message of some kind, or to provide inspiration to someone." Whitaker's wide, respectful, and affectionate acceptance as a creative individual of substance, not only by his fellow artists and art professionals, but also by the general public, proved conclusively that he practiced what he preached.

He was most emphatic in his insistence that art should not be dependent upon gimmickry or fashion. An artist, he believed, should always be himself and paint what he knew and felt. Modernism, with all its isms, did not impress him, especially when it required extensive explanations. "Art that cannot explain itself had better be left undone," was how he put it. At the same time, he was opposed to photographically exact renderings. Nature was the artist's raw material, the source from which he drew his inspiration. It was to be sensitively and intelligently interpreted and transformed into art, not mindlessly replicated. In short, he had a vision of art that was poetic and mildly romantic, one that demanded he look beyond the surface appearances of things to those deeper qualities and attributes of nature that help illuminate the meaning of life and give art its significance as well.

To realize this vision, especially in a medium as temperamental as watercolor, Whitaker had to be crystal clear about his objectives and totally in control of the steps necessary for their actualization. Proof that he succeeded on both counts can be found in the hundreds of impressive watercolors – thousands, if one counts his sketches and color studies – he produced during his highly productive career. Any painting leaving his studio was certain to be honest, direct, structurally sound, technically accomplished, and an effective argument for how seriously watercolor deserved to be taken.

His range of subjects was remarkable. Nothing was too humble or too difficult for him to tackle. He was as interested in the minutiae of nature – insects and flowers, for instance – as he was in windswept seascapes, complex urban vistas, and depictions of human character.

LEFT
Frederic Whitaker
Baroque Facade, 1968
Watercolor on paper, 30 × 22 in.
Collection of James and Jerel West

83

Animals, architectural details, and foreign people and places – to say nothing of female nudes – also received his careful attention.

For someone who spent the early years of his working life as a successful silversmith, Whitaker was wonderfully free and spontaneous in his watercolors. Or so it seemed. In actuality, the path from initial sketch and color study through detailed preparatory drawing to final application of paint was as carefully planned and executed as a military campaign – except that Whitaker did not want it to appear that way. As he said, "My aim in watercolor is to make something that looks absolutely effortless, as if I had left it wet and it had accidentally dried into a perfect picture."

To Whitaker's perception of art, nothing was more important than good design and composition. If achieved, they helped fulfill an artist's grandest intentions. If not, the work produced remained a weak reflection of nature or shapelessly incomplete. His approach to composition was simplicity itself. He first looked for a design pattern in his chosen subject. Once that had been found, he broke down what lay before him into strategically placed spots, shapes, and directional indicators that conformed to his perceived pattern but minimized the realistic aspects of his subject. The placement of these formal elements, while suggested by the scene, was dictated primarily by the need to establish the broad outline and structure of the painting he was about to commence. Once these elements were in place – but not before – the more detailed business of shaping a work of art could begin.

Careful, concentrated effort still lay ahead in the studio. The original small pencil sketch with notations of color, mood, and details made in the field had to be translated into a color study showing exactly the colors, values, and relationship of parts as they would appear in the finished work. After that would come the drawing on a full-sheet, three-hundred-pound, cold-press, handmade, 100-percent rag paper. Following that, the actual painting would begin. Slowly, his subject would come to life. A blob of green would become foliage, a wash of brown, a

bridge, and a narrow vertical daub, a man walking in the distance. Total time from start to finish: anywhere from five hours to three days.

Once completed, the painting would find its way into one of Whitaker's East or West Coast galleries or into any one of the numerous exhibitions, competitive and otherwise, that he entered or to which he was invited. He was about as far from being an ivory-tower artist as one can be, not only because he saw himself as an active participant in the practical world of creating art for an appreciative audience, but also because he wanted to give back to the world "something more than it has so generously given me."

Whitaker fulfilled the responsibility he felt toward the world, not only as a watercolorist who gave pleasure to the many who bought his paintings or saw them in museums or galleries, but also as a writer who contributed articles on other artists to various art magazines. He was the author of a number of books on art, most notably *The Artist and the Real World*, in which he discussed his working methods and gave his frank, unvarnished opinions on art, the art world, and what it meant to be an artist. As if that were not enough, he held prominent positions in a number of America's most prestigious art organizations.

But it was as a watercolor painter that he was best known and for which he most deserves to be celebrated. Despite such outstanding advocates as Winslow Homer, John Singer Sargent, John Marin, and Charles Burchfield, watercolor painting has never been regarded as highly in American art circles as works on canvas have. Perhaps this is because of its smaller size and greater informality, or possibly because watercolor is generally executed on paper. Whatever the reason, it was an

RIGHT
Frederic Whitaker
Special Guest, late 1940s
Watercolor on paper, 22 × 16 in.
Collection of the Frederic Whitaker and
Eileen Monaghan Whitaker Foundation
San Diego, California

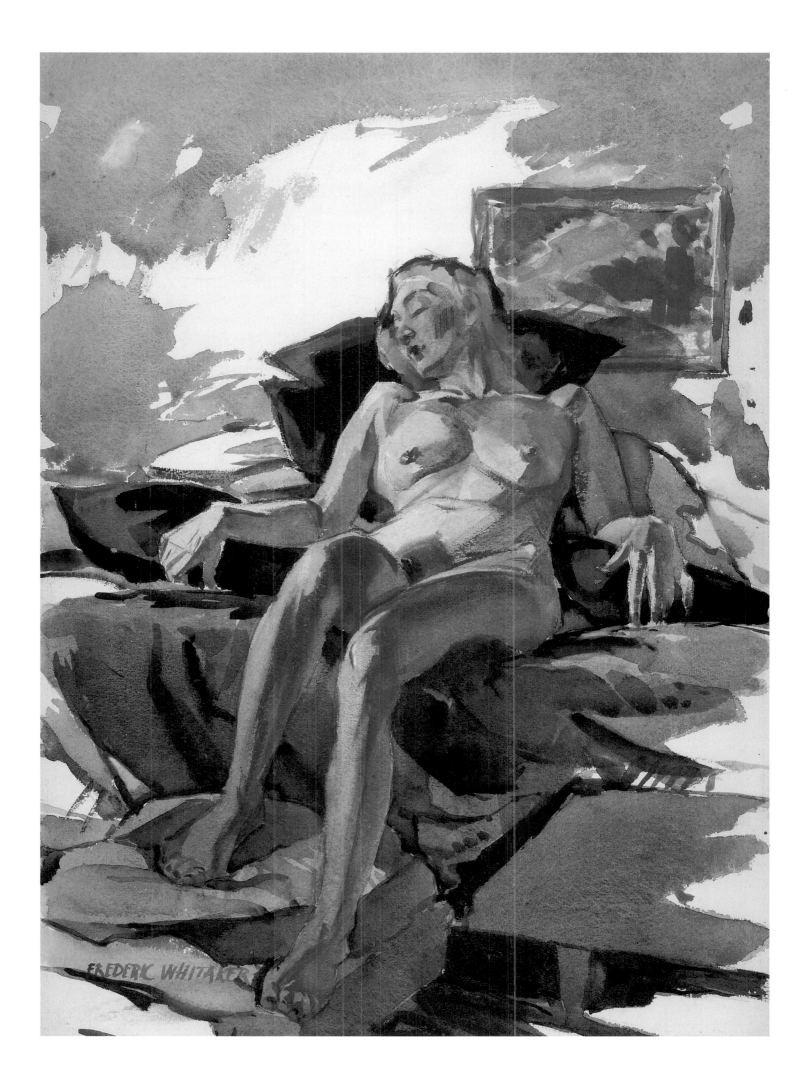

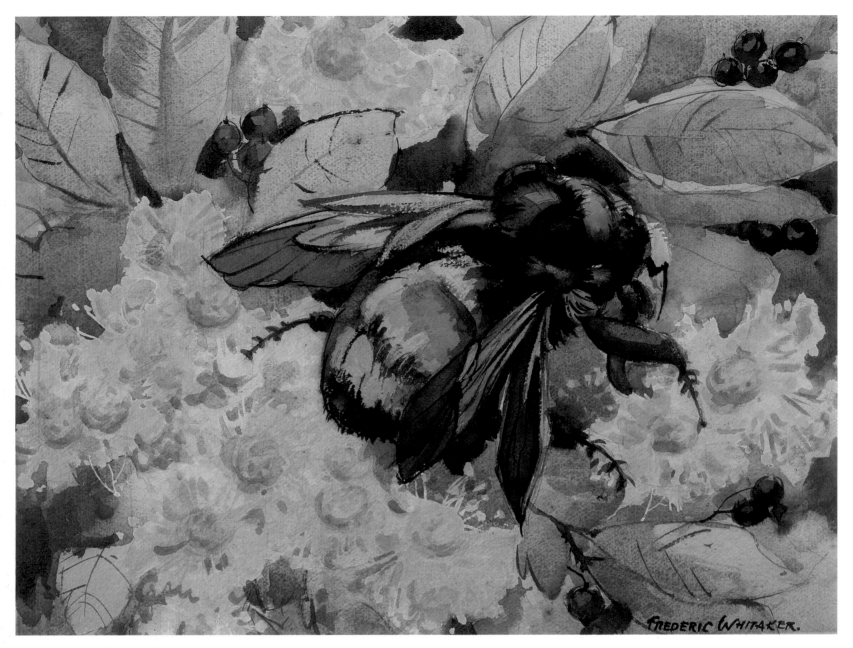

Frederic Whitaker, *Mr. Bumble*, 1965, watercolor on paper, 14 × 18 in.
Private collection

unfortunate prejudice that Whitaker did his best to counter by demonstrating repeatedly that watercolor was capable of depth and monumentality as well as brilliant virtuoso effects.

Of course, he did not set out to raise the art world's opinion of his chosen medium. His objectives were more purely aesthetic and communicative. He wanted to produce handsome, well-designed, easily understood paintings that conveyed a feeling or an idea in a pleasurable, no-nonsense, and occasionally mildly inspirational manner. As an artist he stood firm. Nothing, neither the desire to impress nor the need for a quick sale, would ever be permitted to divert him from expressing himself as clearly, fully, and honestly as possible.

Seen in this light and from the perspective of modernist theory, his goals, while worthy, may appear unduly modest. But that fails to take the works themselves into account. Even a brief survey of his paintings will reveal not only that he remained true to his intentions but also that he produced an impressive number of watercolors that do honor to the medium by fulfilling its highest standards and ideals. No more can be expected of any artist.

RIGHT
Frederic Whitaker
Bougainvilleas, n.d. (detail)
Watercolor on paper, 10¼ × 11 in.
Collection of the Frederic Whitaker and
Eileen Monaghan Whitaker Foundation
San Diego, California

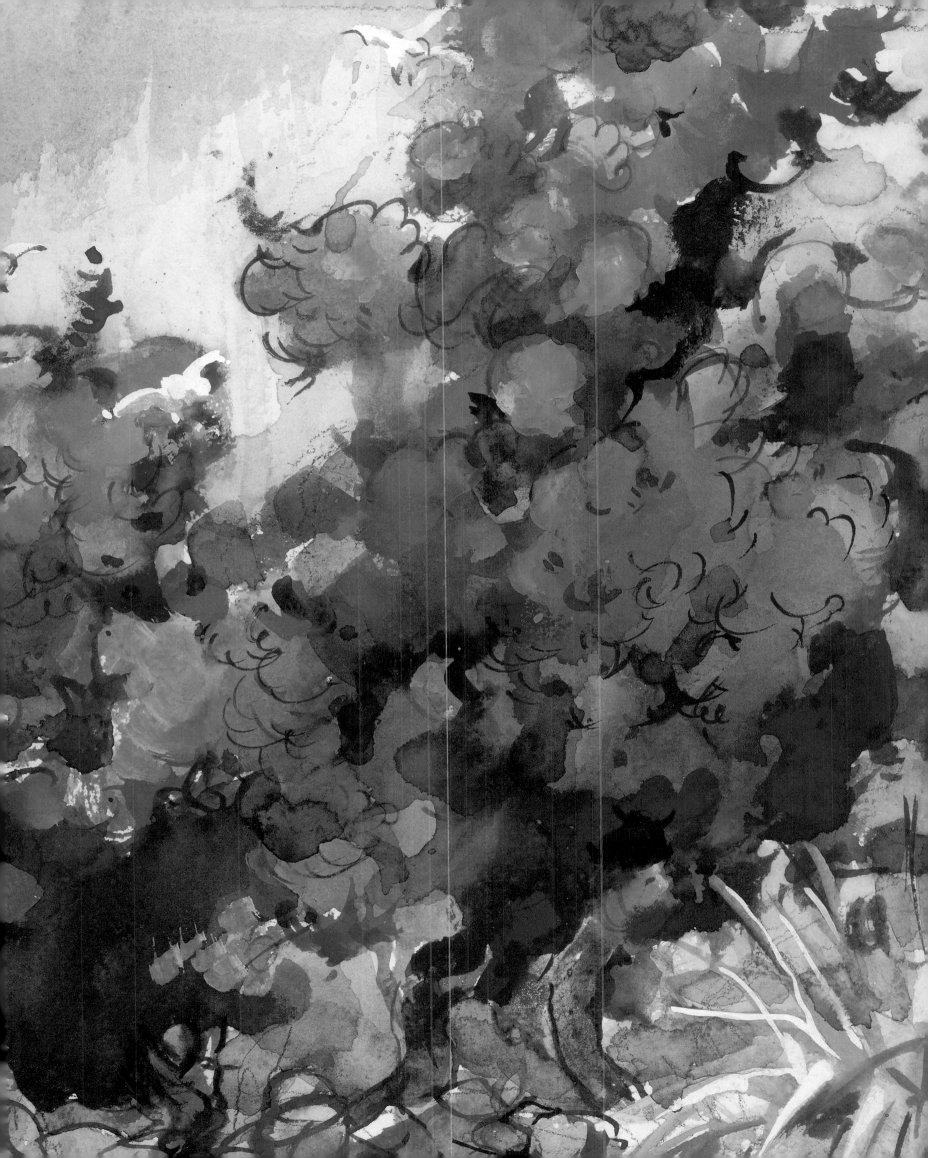

Plates

Eileen Monaghan Whitaker
In My Studio, 1997
Watercolor on paper, 22 × 30 in.
Collection of the Frederic Whitaker and
Eileen Monaghan Whitaker Foundation
San Diego, California

Eileen Monaghan Whitaker
The Inlet (The Cove), mid-1940s
Watercolor on paper, 16 × 22 in.
Collection of the Frederic Whitaker and
Eileen Monaghan Whitaker Foundation
San Diego, California

Frederic Whitaker
Day Is Done, 1971
Watercolor on paper, 22 × 30 in.
Private collection

Frederic Whitaker
Las Lavanderas, c. 1952
Watercolor on paper, 22 × 30 in.
Frye Art Museum, Seattle, Washington
Gift of Eileen Monaghan Whitaker

Frederic Whitaker
Mexican Memorial, 1946
Watercolor on paper, 22 × 30 in.
Private collection

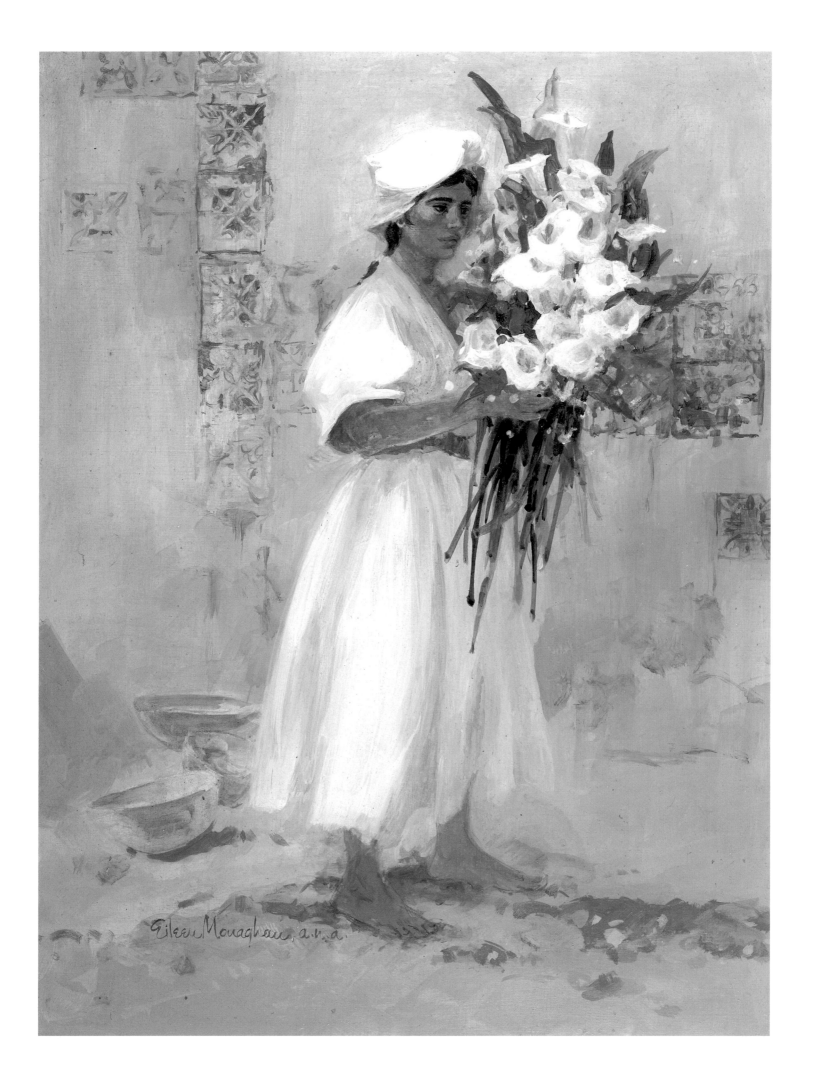

Eileen Monaghan, a.u.d.

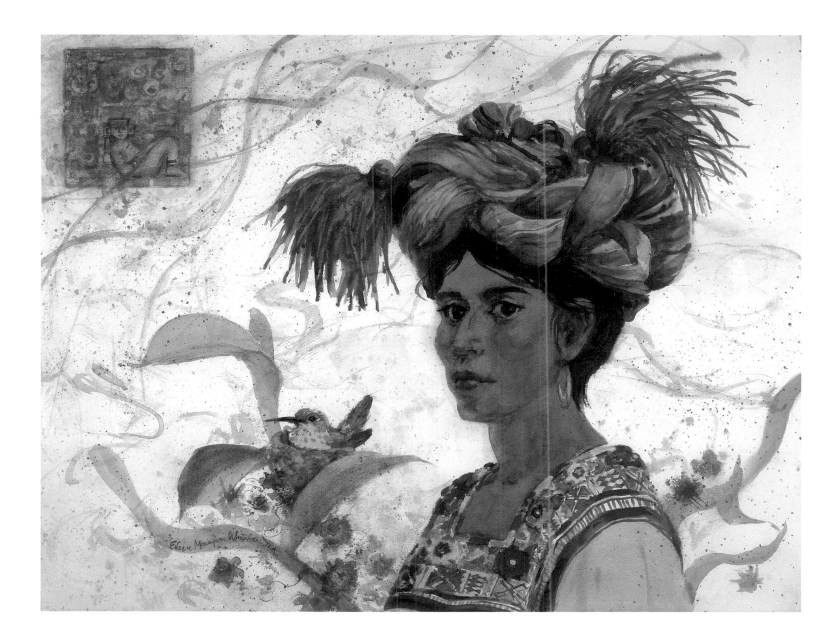

Eileen Monaghan Whitaker
Study in Whites, 1964
Acrylic on Masonite board, 24 × 18 in.
Collection of the Frederic Whitaker and
Eileen Monaghan Whitaker Foundation
San Diego, California

Eileen Monaghan Whitaker
Maya, 1991
Watercolor on paper, 22 × 30 in.
Collection of the Frederic Whitaker and
Eileen Monaghan Whitaker Foundation
San Diego, California

TOP
Eileen Monaghan Whitaker
Where's Dinner? 1981
Watercolor on paper, 22 × 30 in.
Collection of Steve and Beverly
Berg-Hansen

BOTTOM
Eileen Monaghan Whitaker
Tender Message, 1964
Acrylic on paper, 21 × 29 in.
Collection of the Frederic Whitaker and
Eileen Monaghan Whitaker Foundation
San Diego, California

RIGHT
Eileen Monaghan Whitaker
Toucan, 1988
Watercolor on paper, 30 × 22 in.
Michael Johnson Fine Arts
Fallbrook, California

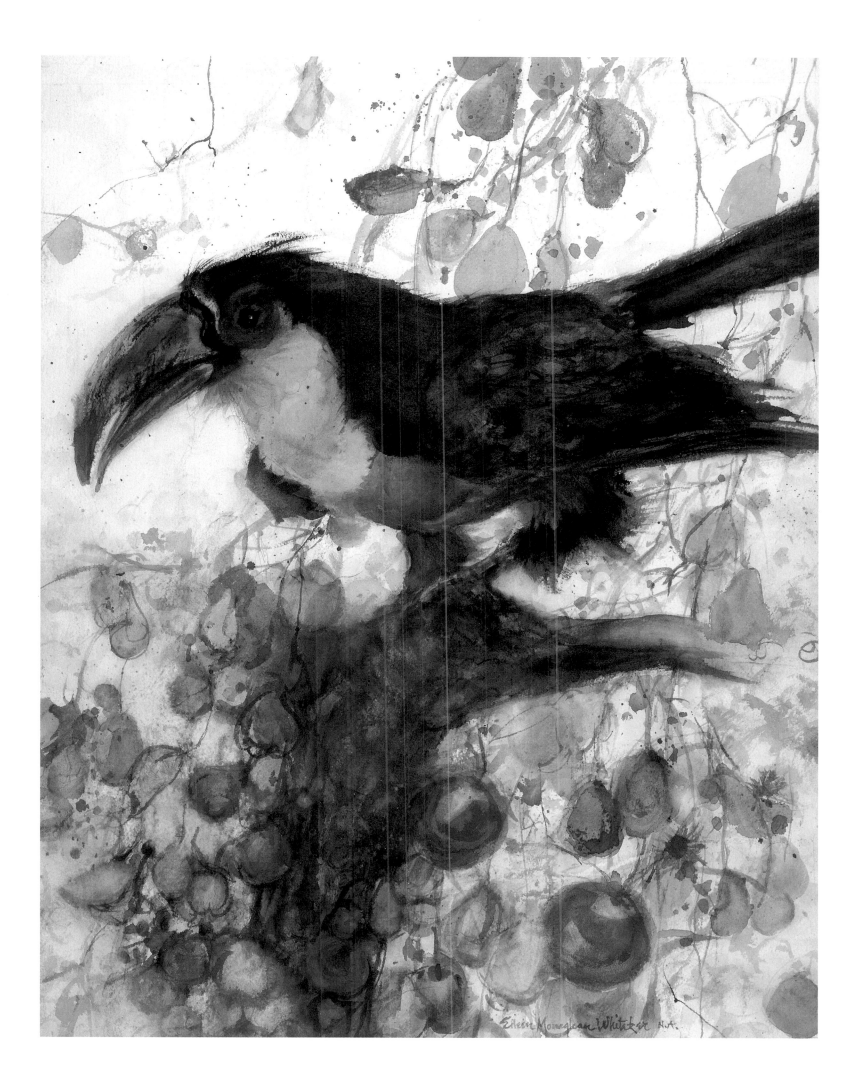

Eileen Monaghan Whitaker
Piscis Faustinius, 1982
Watercolor on paper, 16 × 22 in.
Collection of the Frederic Whitaker and
Eileen Monaghan Whitaker Foundation
San Diego, California

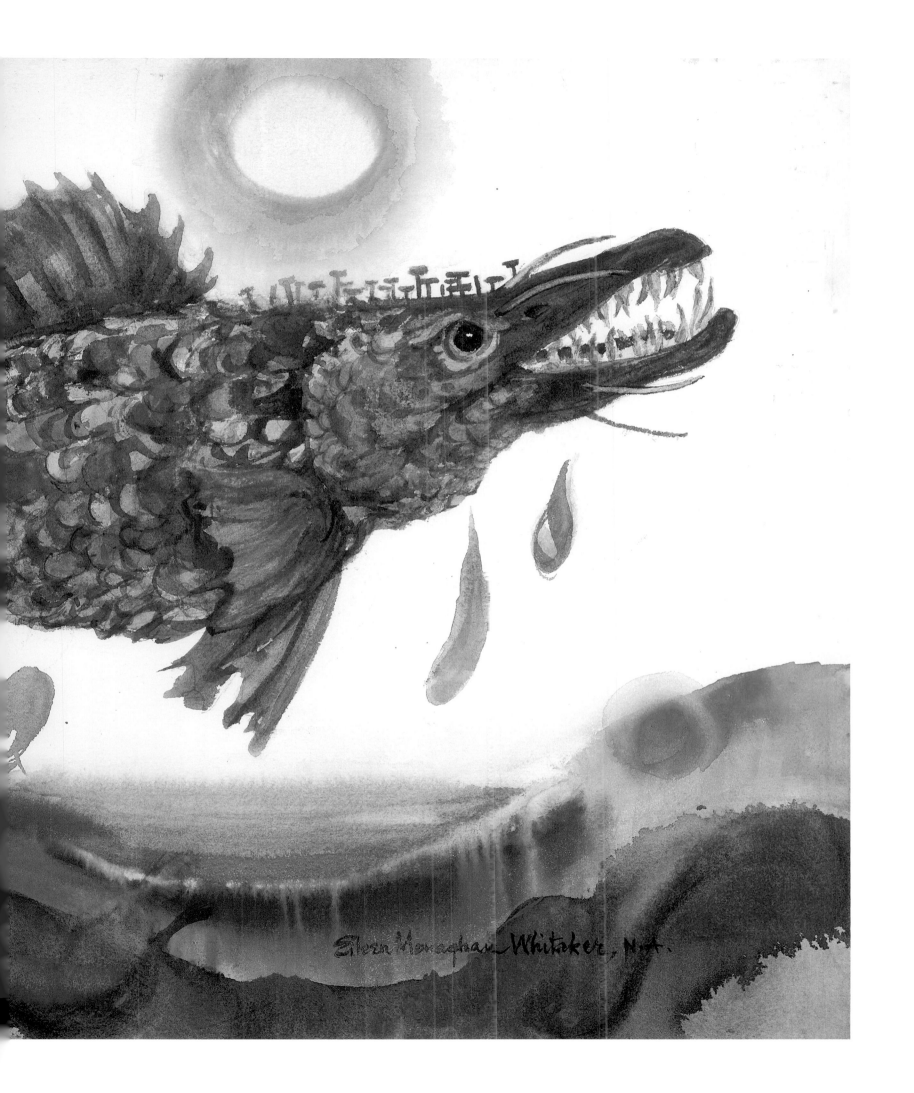

Eileen Monaghan Whitaker, N.A.

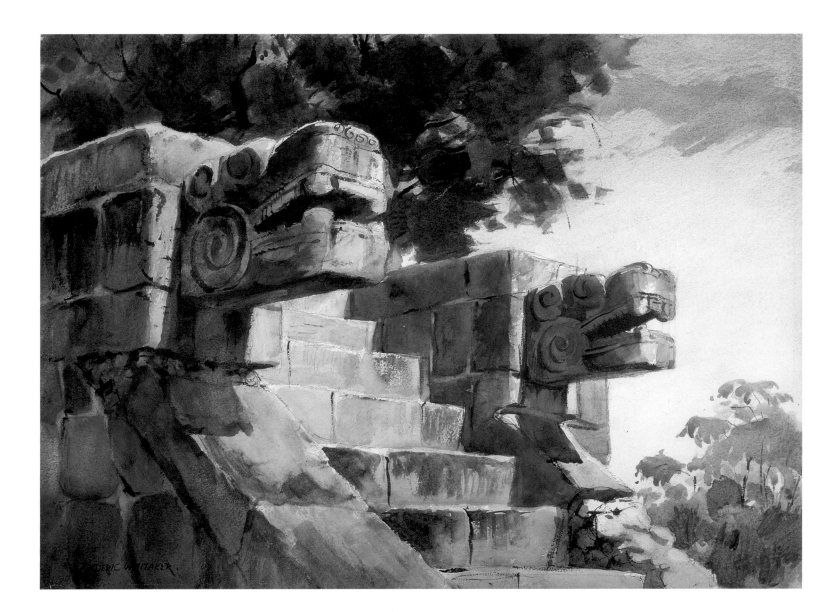

ABOVE
Frederic Whitaker
Altar Guardians, 1953
Watercolor on paper, 22 × 30 in.
Collection of the Frederic Whitaker and
Eileen Monaghan Whitaker Foundation
San Diego, California

RIGHT
Frederic Whitaker
Hail Mary, Full of Grace, 1973
Watercolor on paper, 30 × 22 in.
The Buck Collection
Laguna Hills, California

ABOVE
Eileen Monaghan Whitaker
White Rose #3, 1982
Watercolor on paper, 11 × 15 in.
Collection of the Frederic Whitaker and
Eileen Monaghan Whitaker Foundation
San Diego, California

RIGHT
Eileen Monaghan Whitaker
A Blue Mood, 1962
Acrylic on paper, 30 × 22 in.
Collection of the Frederic Whitaker and
Eileen Monaghan Whitaker Foundation
San Diego, California

FREDERIC WHITTAKER

LEFT
Frederic Whitaker
Wharfside Pasture, 1946
Watercolor on paper, 22 × 16 in.
Collection of the Frederic Whitaker and
Eileen Monaghan Whitaker Foundation
San Diego, California

ABOVE
Frederic Whitaker
Union Square #2, n.d.
Watercolor on paper, 21 × 22 in.
Collection of the Frederic Whitaker and
Eileen Monaghan Whitaker Foundation
San Diego, California

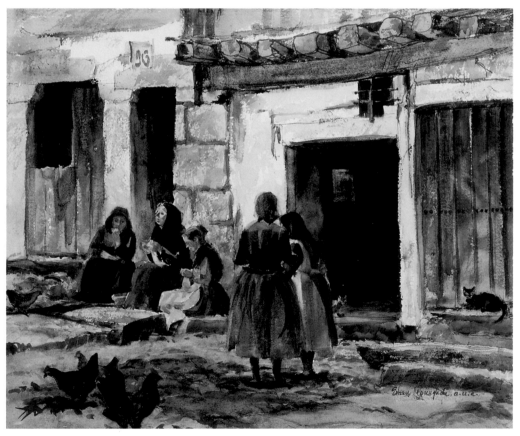

TOP
Eileen Monaghan Whitaker
Cuenca Cathedral, 1965
Acrylic on paper, 22 × 30 in.
Collection of the Frederic Whitaker and
Eileen Monaghan Whitaker Foundation
San Diego, California

BOTTOM
Eileen Monaghan Whitaker
Gossip Hour, n.d.
Watercolor on paper, 22 × 27½ in.
Museum of Fine Arts
Springfield, Massachusetts
Gift of the artist

RIGHT
Eileen Monaghan Whitaker
Chirmia Music, 1990
Watercolor on paper, 30 × 22 in.
Collection of the Frederic Whitaker and
Eileen Monaghan Whitaker Foundation
San Diego, California

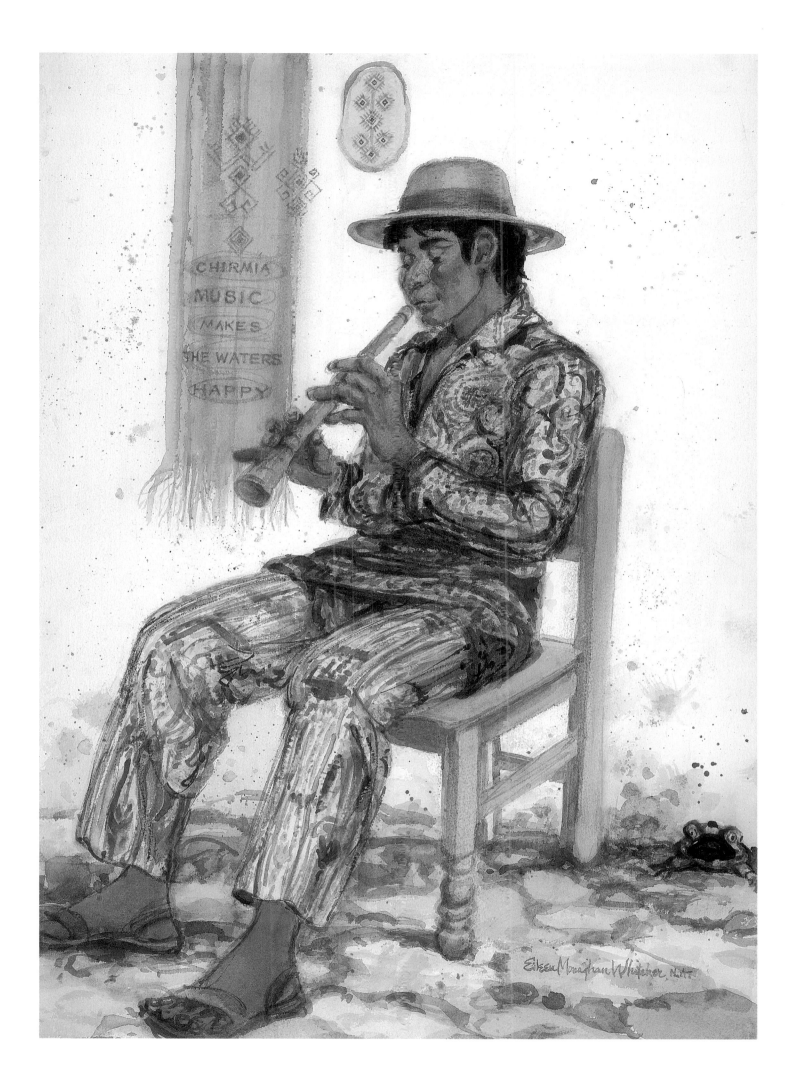

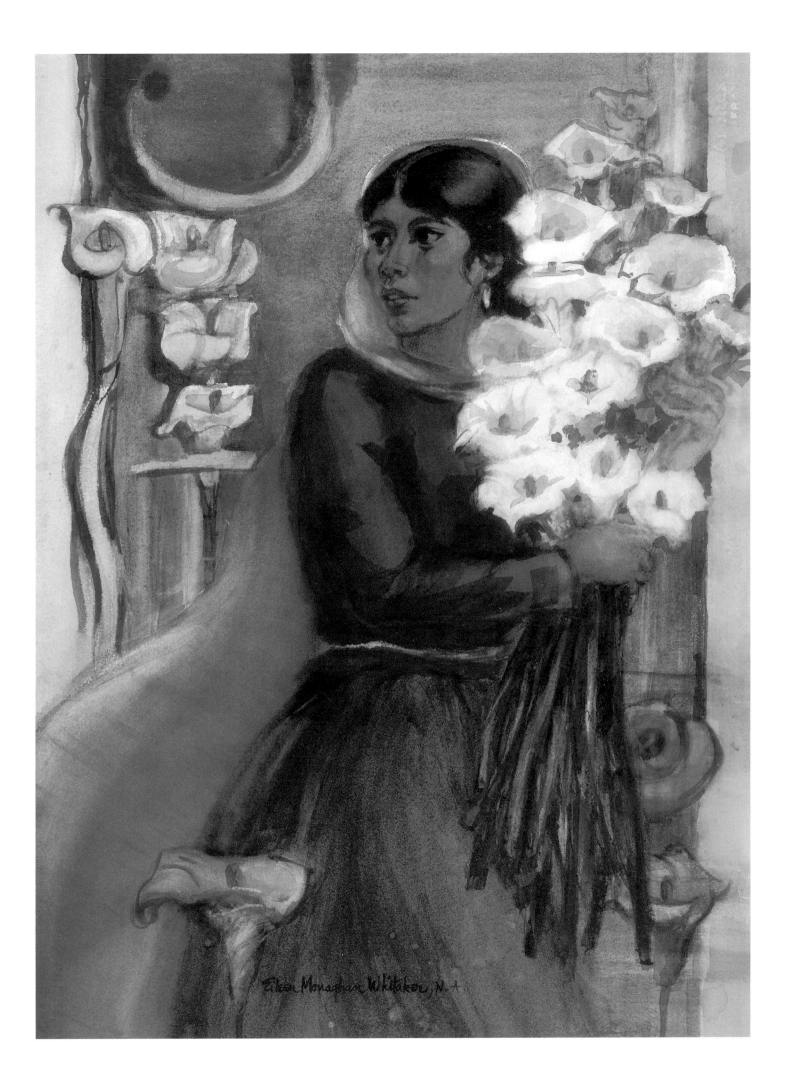

Eileen Monaghan Whitaker, N.A.

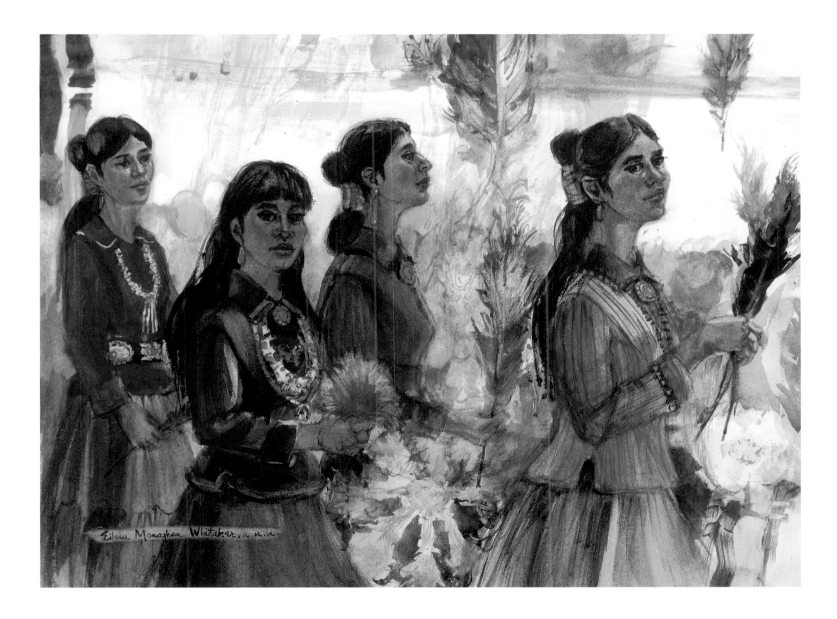

Eileen Monaghan Whitaker
Lilies from the Market, 1981
Watercolor on paper, 30 × 22 in.
Collection of the Frederic Whitaker and
Eileen Monaghan Whitaker Foundation
San Diego, California

Eileen Monaghan Whitaker
Feather Procession, 1974
Watercolor on paper, 22 × 30 in.
Private collection

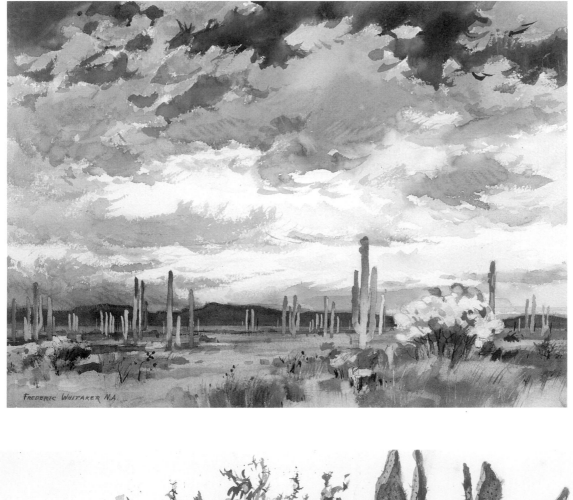

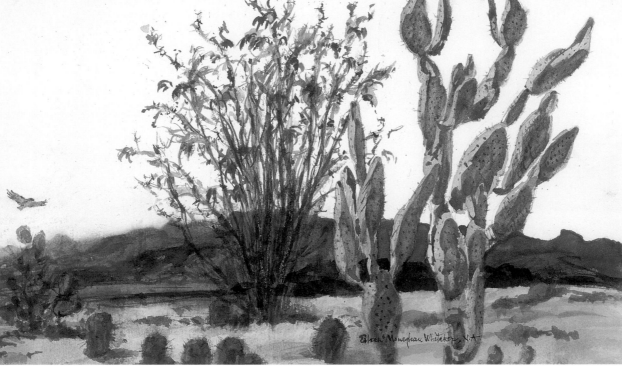

TOP
Frederic Whitaker
Saguaro Country, 1966
Watercolor on paper, 22 × 30 in.
Collection of James and Jerel West

BOTTOM
Eileen Monaghan Whitaker
Borrego Cactus, 1983
Watercolor on paper, 14 × 22 in.
Private collection

RIGHT
Eileen Monaghan Whitaker
Charlie Eagle Bird, 1975
Watercolor on paper, 30 × 22 in.
Private collection

112

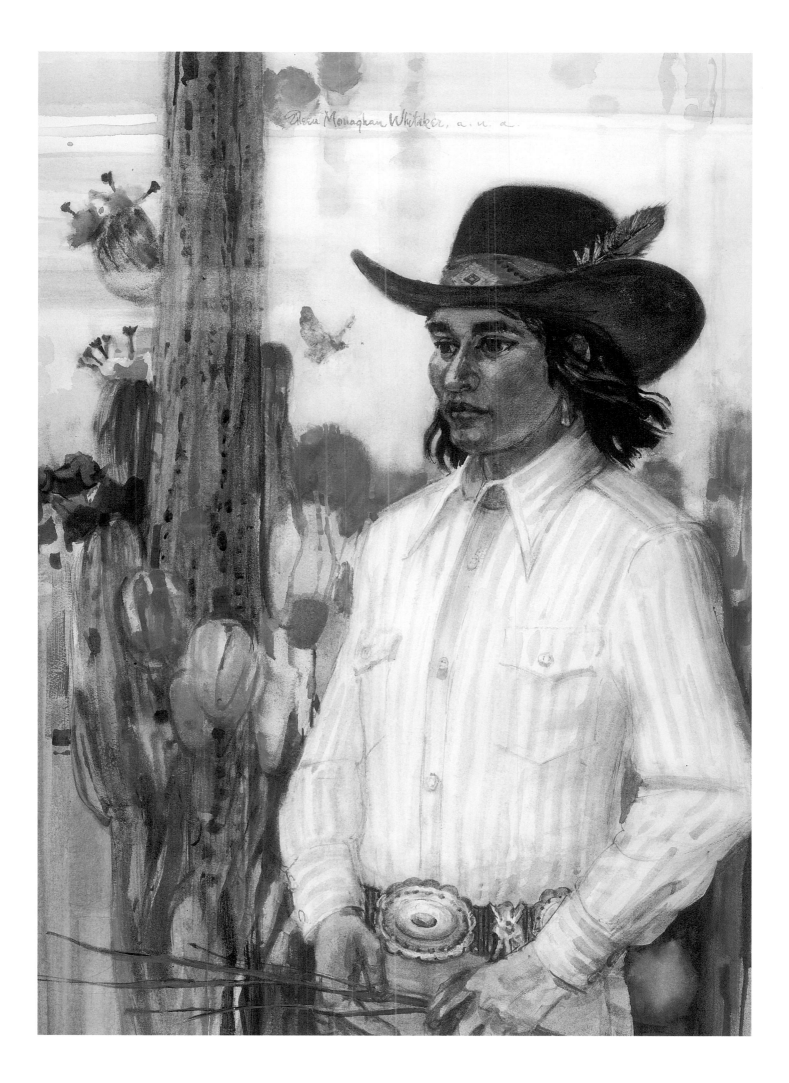

Gloria Monaghan Whitaker, a. w. a.

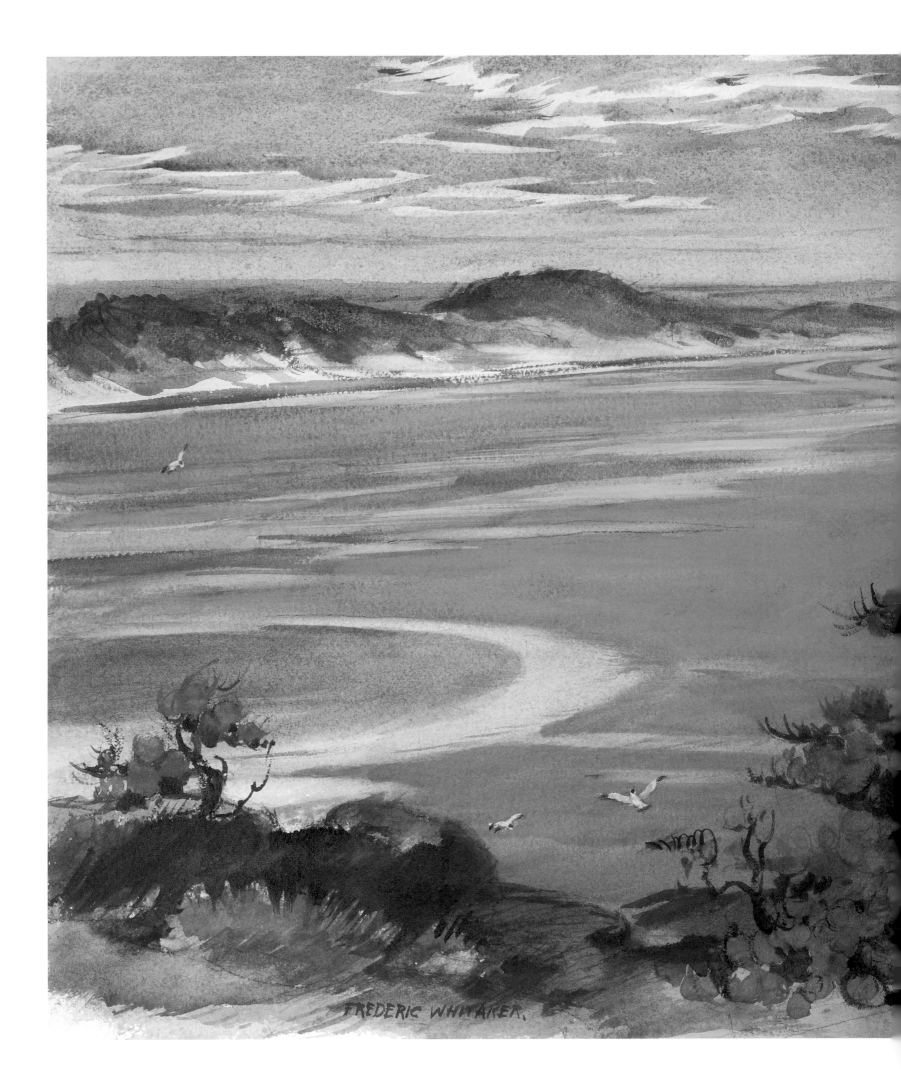

Frederic Whitaker
Fundy, Low Tide, 1951
Watercolor on paper, 16⅛ × 22 in.
Museum of Fine Arts, Boston
Abraham Shuman Provisional Fund

FREDERIC WHITAKER, N.A.

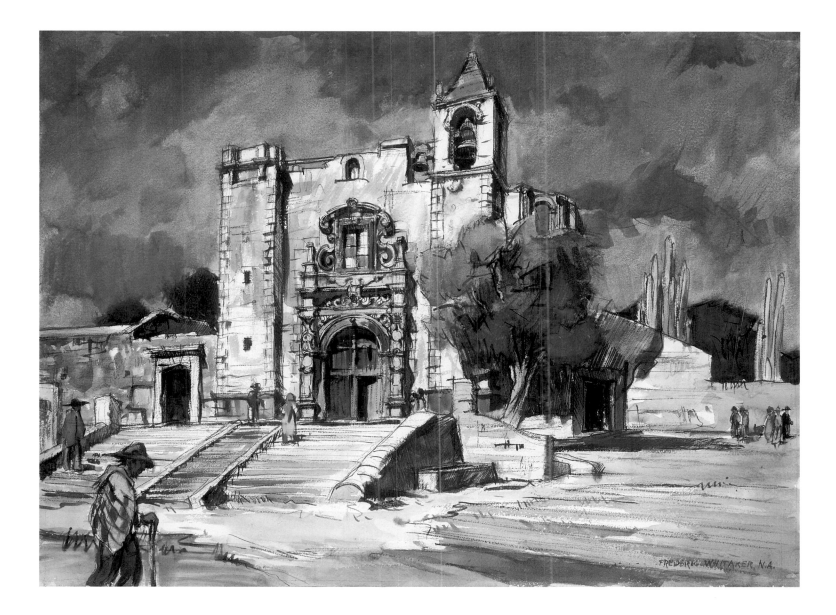

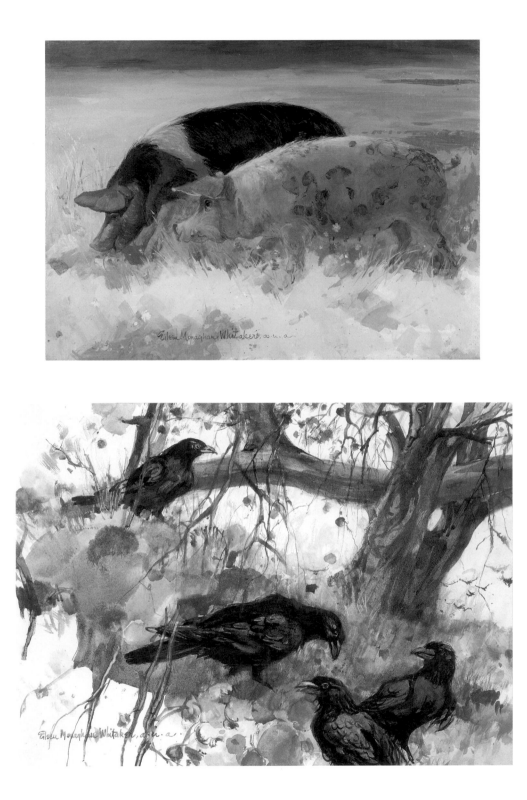

Eileen Monaghan Whitaker
Treasure Hunt, 1964
Acrylic on Masonite board, 18 × 24 in.
Collection of the Frederic Whitaker and
Eileen Monaghan Whitaker Foundation
San Diego, California

Eileen Monaghan Whitaker
Composition in Black & Gold, 1975
Watercolor on paper, 22 × 30 in.
Private collection

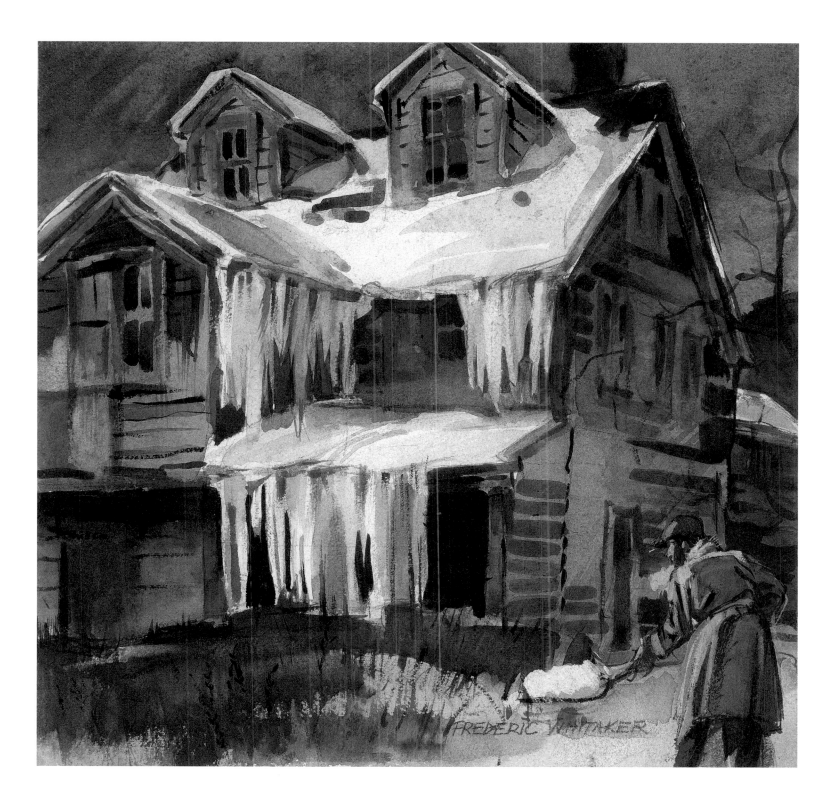

Frederic Whitaker
Snow Shoveler, late 1940s
Watercolor on paper, 10 × 11 in.
Collection of the Frederic Whitaker and
Eileen Monaghan Whitaker Foundation
San Diego, California

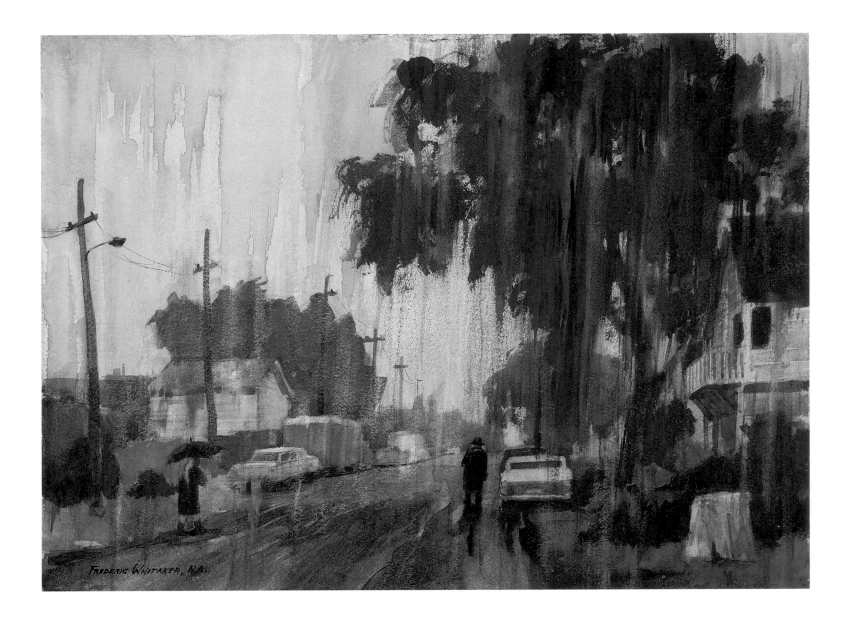

Frederic Whitaker
Vertical Rain, 1967
Watercolor on paper, 22 × 30 in.
Collection of the Frederic Whitaker and
Eileen Monaghan Whitaker Foundation
San Diego, California

Frederic Whitaker
Winter Fog #1, 1961
Watercolor on paper, 22 × 30 in.
Collection of the Frederic Whitaker and
Eileen Monaghan Whitaker Foundation
San Diego, California

TOP
Frederic Whitaker
Historic Ground, n.d.
Watercolor on paper, 11 × 15 in.
Collection of J. K. Kery

BOTTOM
Frederic Whitaker
House in Las Truchas, New Mexico, 1963–1964
Watercolor on paper, 19½ × 21½ in.
San Diego Museum of Art, California
Gift of Eileen Monaghan Whitaker, 1982:93

Frederic Whitaker
Habitual Smoker, n.d.
Watercolor on paper, 22 × 24½ in.
Collection of the Frederic Whitaker and
Eileen Monaghan Whitaker Foundation
San Diego, California

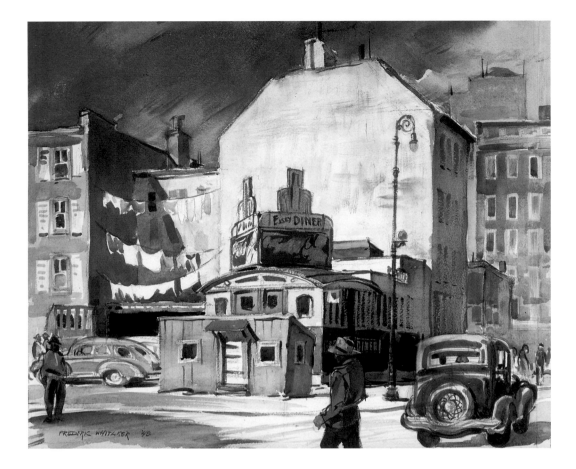

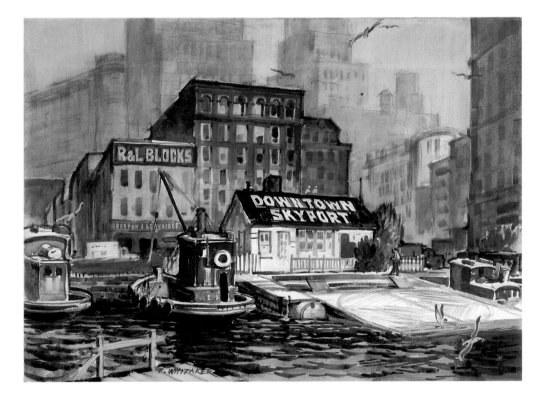

TOP
Frederic Whitaker
Easy Diner, 1948
Watercolor on paper, 16½ × 20 in.
Private collection

BOTTOM
Frederic Whitaker
Downtown Skyport, 1947
Watercolor on paper, 16 × 22 in.
Collection of the Frederic Whitaker and
Eileen Monaghan Whitaker Foundation
San Diego, California

RIGHT
Eileen Monaghan Whitaker
Marao Kachina, 1983
Watercolor on paper, 22 × 14 in.
Collection of the Frederic Whitaker and
Eileen Monaghan Whitaker Foundation
San Diego, California

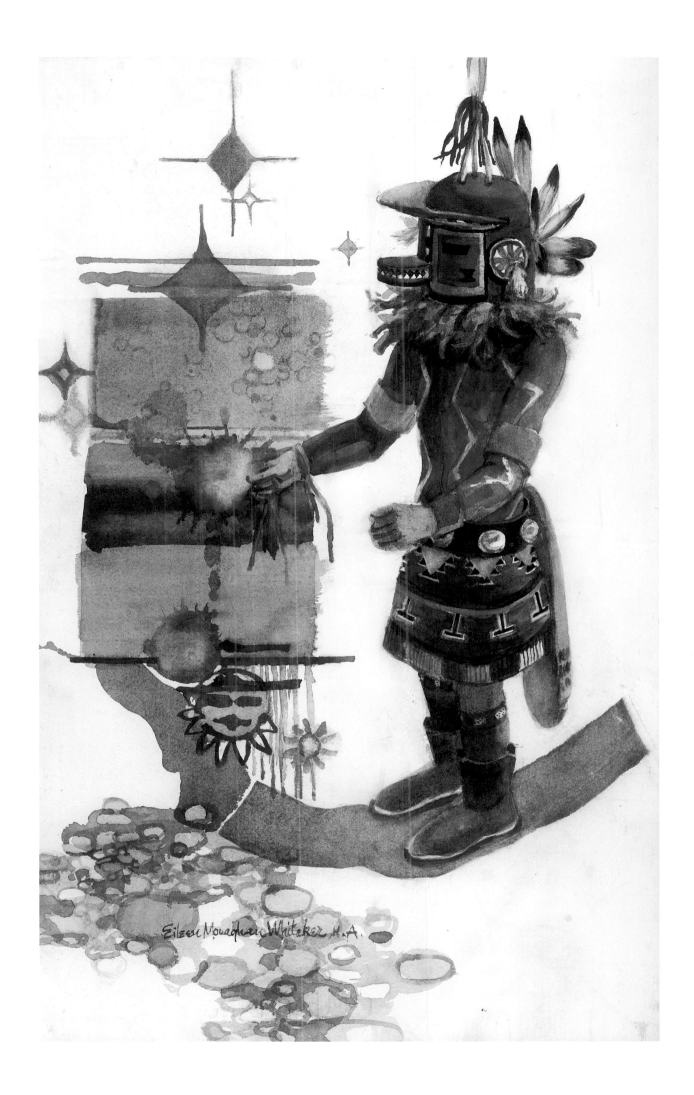

Eileen Monaghan Whitaker N.A.

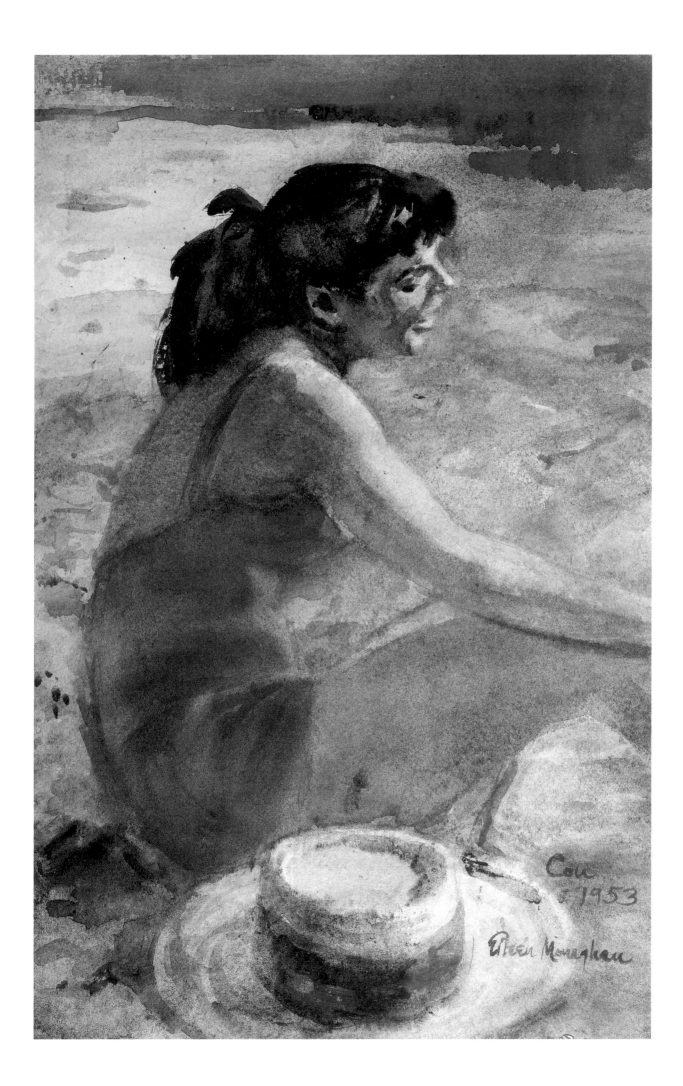

Con
1953

Eileen Monaghan

ABOVE
Frederic Whitaker
The Street of San Ildefonso, 1953
Watercolor on paper, 22 × 30 in.
Collection of the Frederic Whitaker and
Eileen Monaghan Whitaker Foundation
San Diego, California

RIGHT
Eileen Monaghan Whitaker
Geranium #6, n.d.
Watercolor on paper, 8 × 6 in.
Collection of the Frederic Whitaker and
Eileen Monaghan Whitaker Foundation
San Diego, California

130

Eileen Monaghan

Frederic Whitaker
Sunset on the Plains, n.d.
Watercolor on paper, 22 × 30 in.
Collection of the Frederic Whitaker and
Eileen Monaghan Whitaker Foundation
San Diego, California

Eileen Monaghan Whitaker
Fireworks over San Diego, 1979
Watercolor on paper, 22 × 30 in.
Collection of the Frederic Whitaker and
Eileen Monaghan Whitaker Foundation
San Diego, California

Frederic Whitaker
Tools of Trade, 1969
Watercolor on paper, 22 × 27 in.
Collection of the Frederic Whitaker and
Eileen Monaghan Whitaker Foundation
San Diego, California

TOP
Eileen Monaghan Whitaker
Lock and Bolts, 1969
Watercolor on paper, 16 × 22 in.
Collection of the Frederic Whitaker and
Eileen Monaghan Whitaker Foundation
San Diego, California

BOTTOM
Eileen Monaghan Whitaker
Quebec Dormers, n.d.
Watercolor on paper, 14¾ × 21¼ in.
Collection of the Frederic Whitaker and
Eileen Monaghan Whitaker Foundation
San Diego, California

Frederic Whitaker
The Little Statue #2, n.d.
Watercolor on paper, 22 × 27 in.
Private collection

Eileen Monaghan Whitaker
Legacy of Spain, 1992
Watercolor on paper, 22 × 30 in.
Michael Johnson Fine Arts
Fallbrook, California

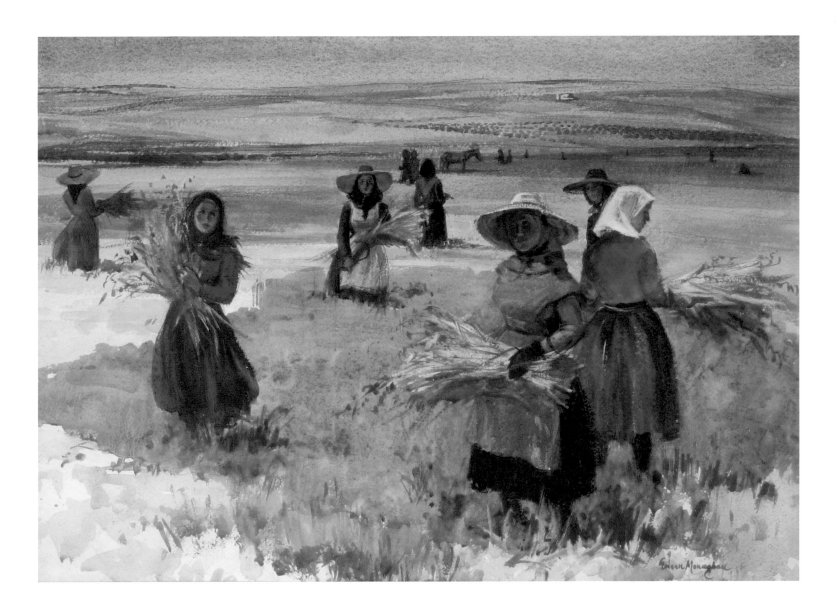

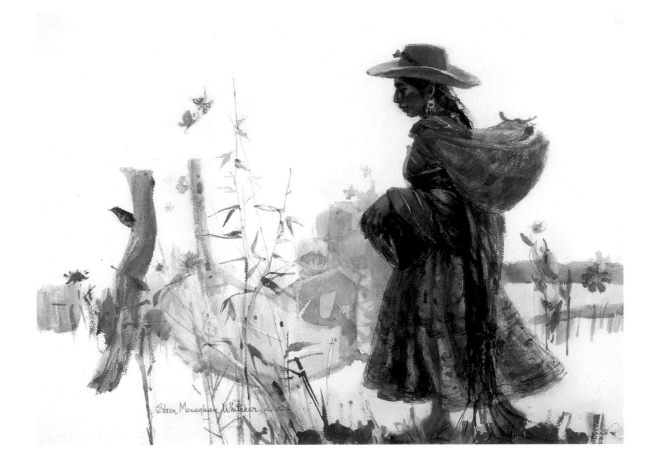

TOP
Eileen Monaghan Whitaker
Nahualá Family, 1992
Watercolor on paper, 22 × 30 in.
Collection of the Frederic Whitaker and
Eileen Monaghan Whitaker Foundation
San Diego, California

BOTTOM
Eileen Monaghan Whitaker
On the Road to Jocotepec, 1969
Watercolor on paper, 22 × 30 in.
Collection of the Frederic Whitaker and
Eileen Monaghan Whitaker Foundation
San Diego, California

RIGHT
Frederic Whitaker
Distraught Mother #2, 1971
Watercolor on paper, 30 × 20 in.
Frye Art Museum, Seattle, Washington
Gift of Mr. and Mrs. Bryon Saneholtz, Jr.
In memory of Andrew Casteel Saneholtz

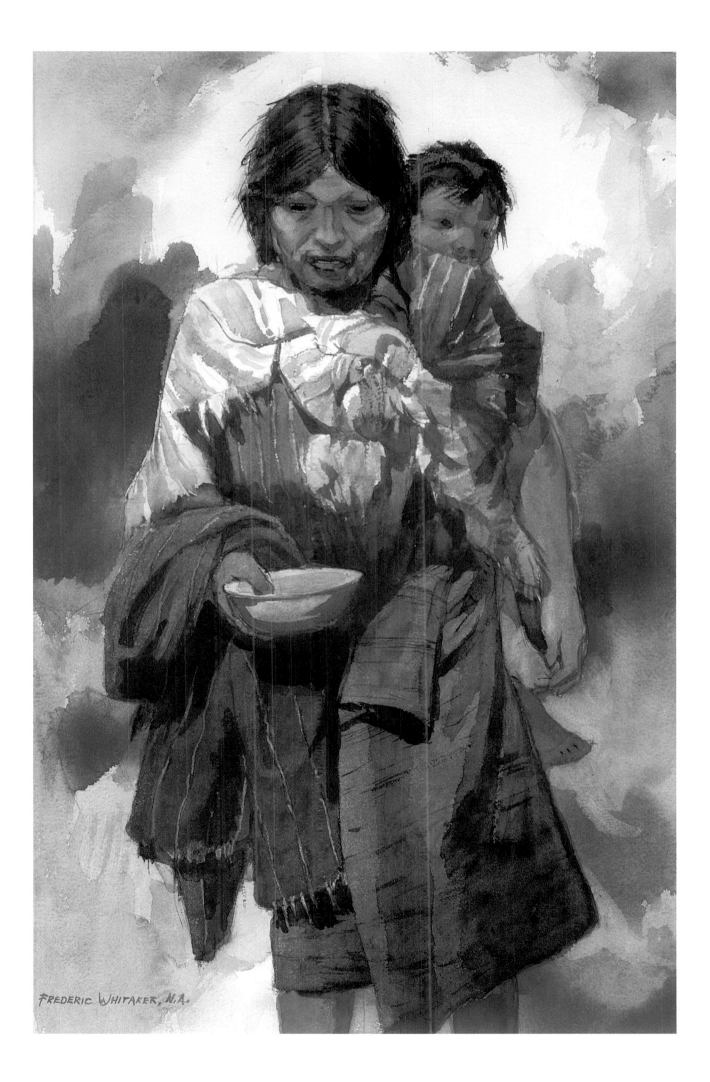

FREDERIC WHITAKER, N.A.

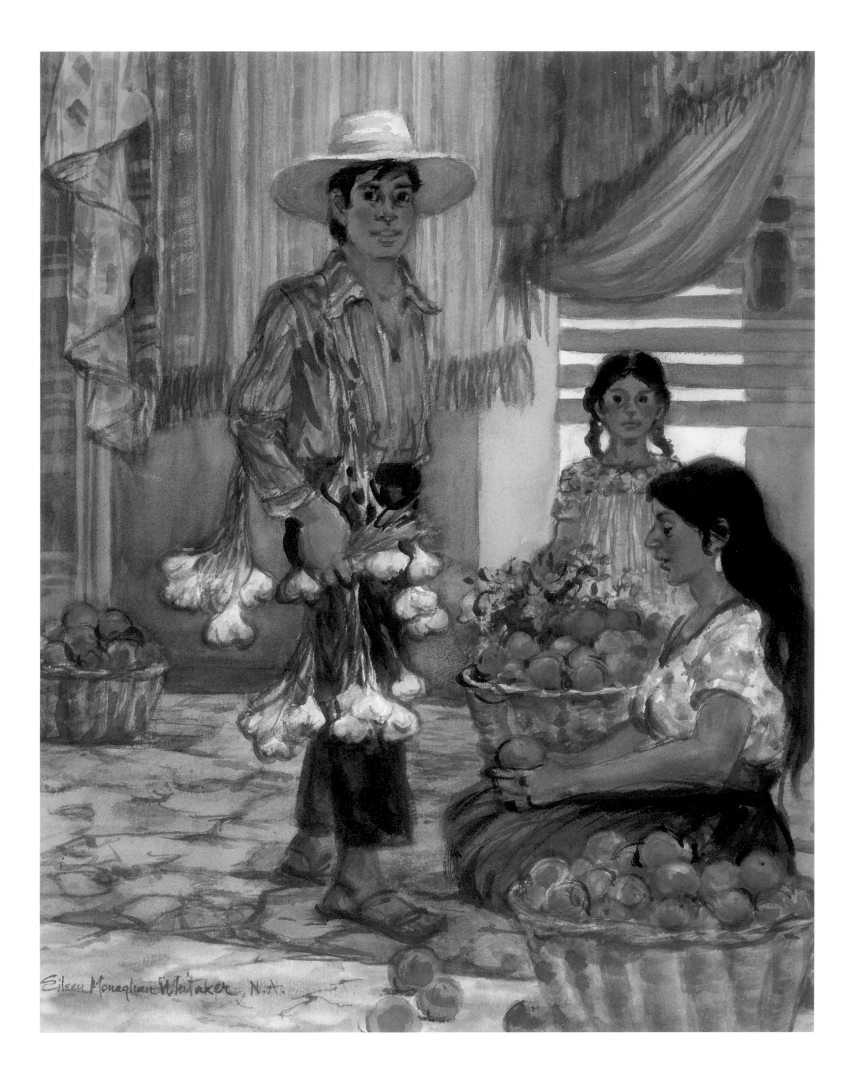

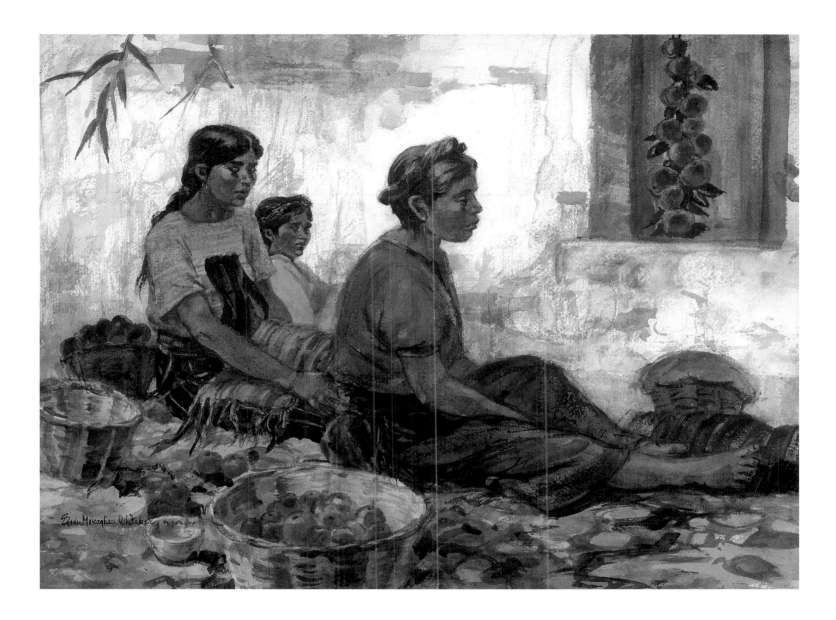

LEFT
Eileen Monaghan Whitaker
Se Venden Ajos, 1990
Watercolor on paper, 27½ × 22 in.
Collection of the Frederic Whitaker and
Eileen Monaghan Whitaker Foundation
San Diego, California

ABOVE
Eileen Monaghan Whitaker
Se Venden Naranjas, 1975
Watercolor on paper, 22 × 30 in.
San Diego Museum of Art, California
Gift of the artist, 2003:65

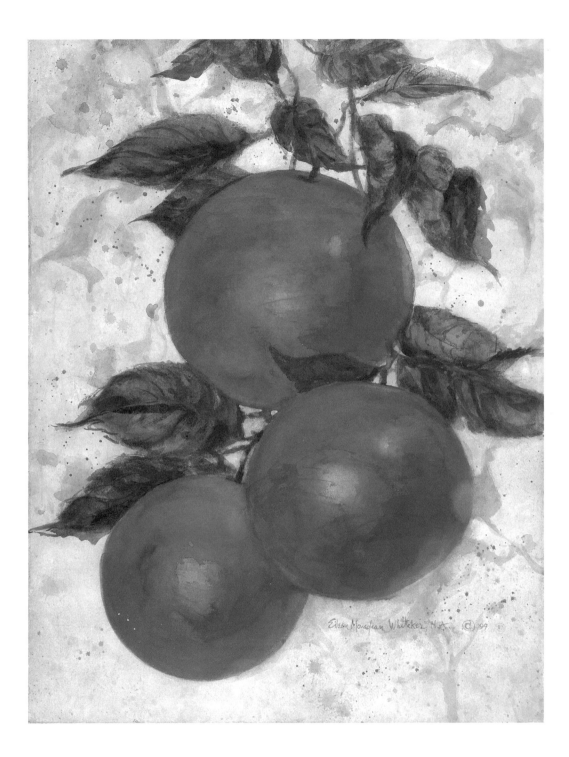

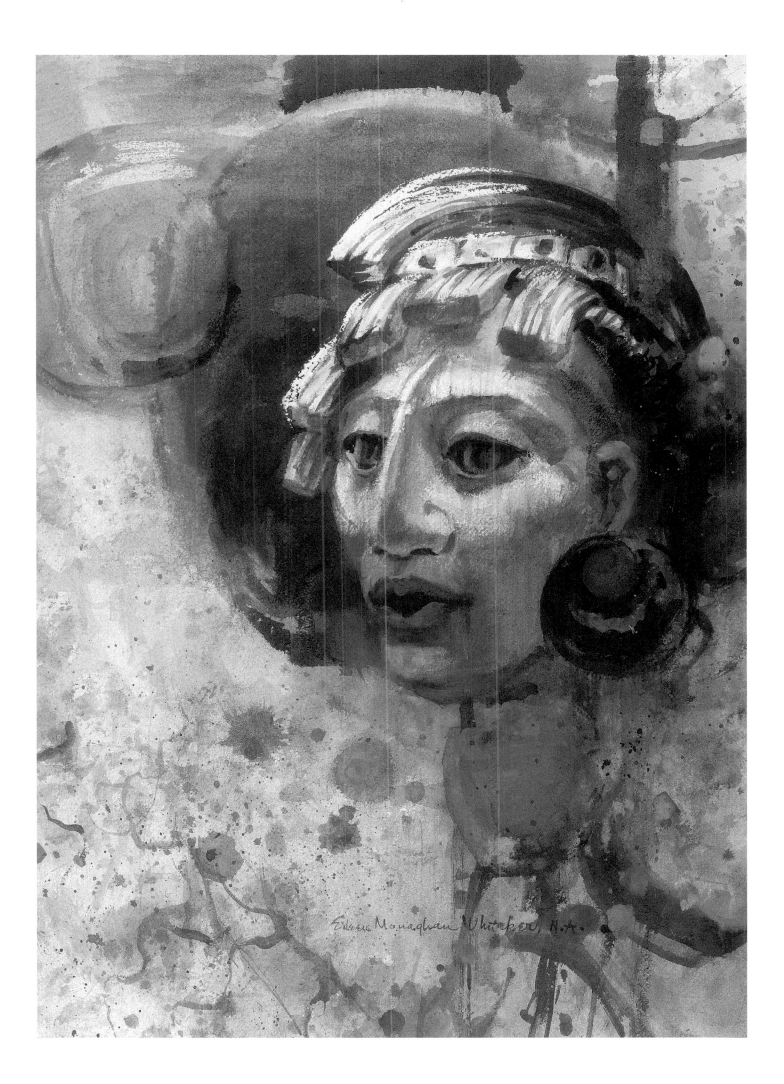

Eileen Monaghan Whitaker, N.A.

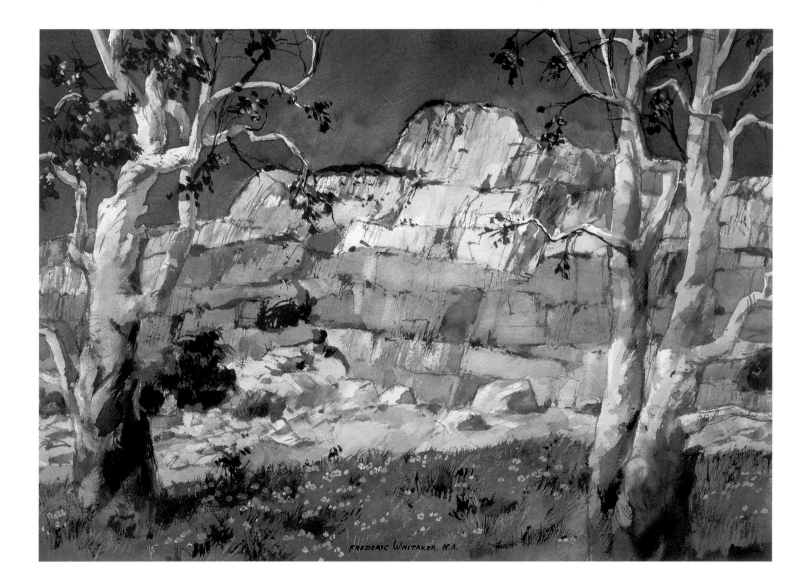

Frederic Whitaker
Sundown at Big Bend, 1964
Watercolor on paper, 14 × 19 in.
University of San Diego, California

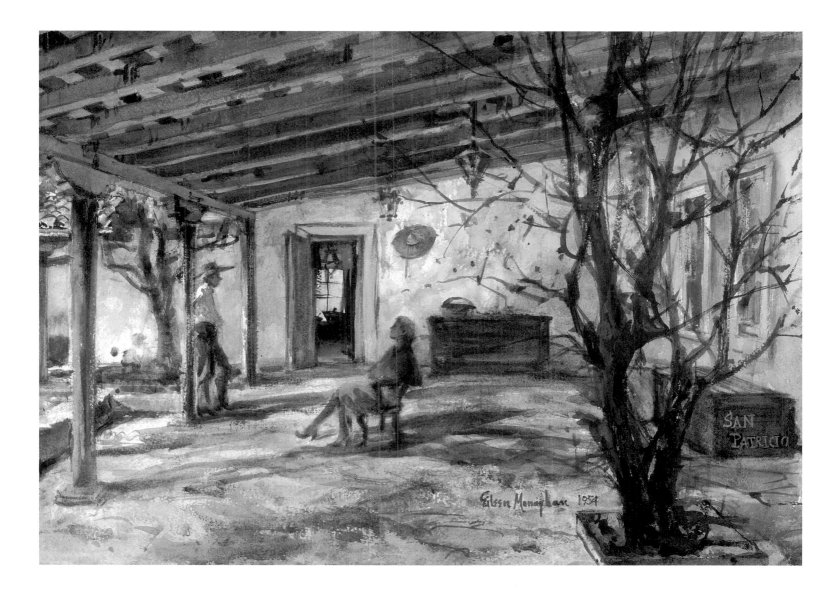

Eileen Monaghan Whitaker
Peter Hurd's Place, 1950s
Watercolor on paper, 14 × 20 in.
Collection of the Frederic Whitaker and
Eileen Monaghan Whitaker Foundation
San Diego, California

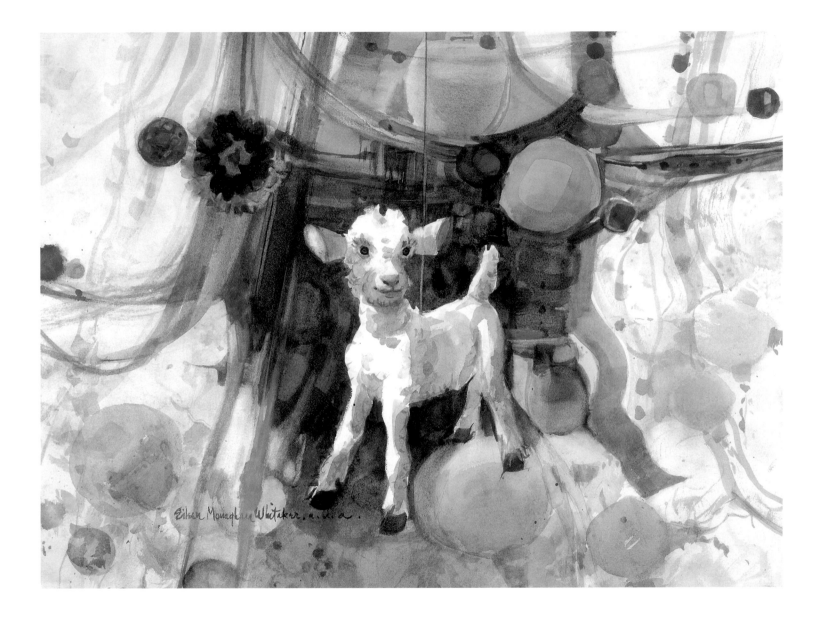

Eileen Monaghan Whitaker
Piñata #4, n.d.
Watercolor on paper, 22 × 30 in.
Collection of Joan Schlossman

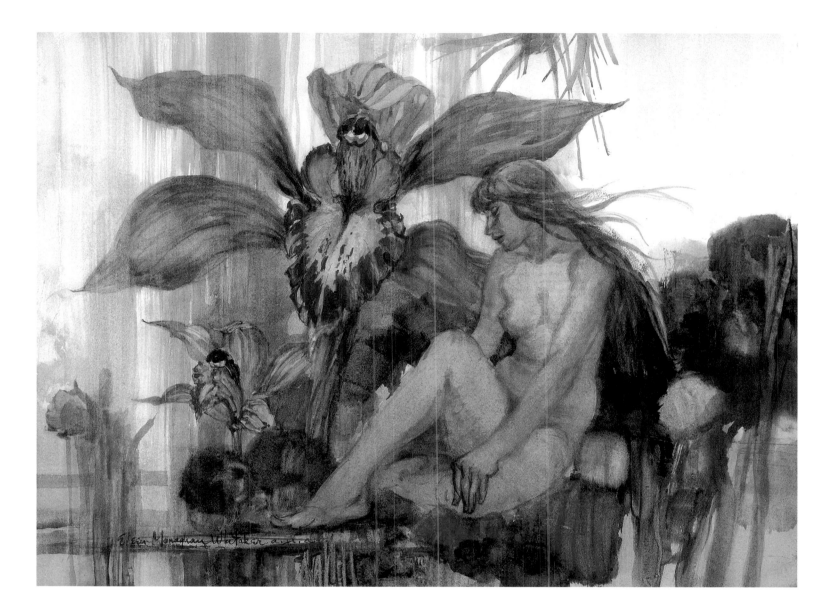

Eileen Monaghan Whitaker
Orchid, 1975
Watercolor on paper, 22 × 30 in.
Collection of the Frederic Whitaker and
Eileen Monaghan Whitaker Foundation
San Diego, California

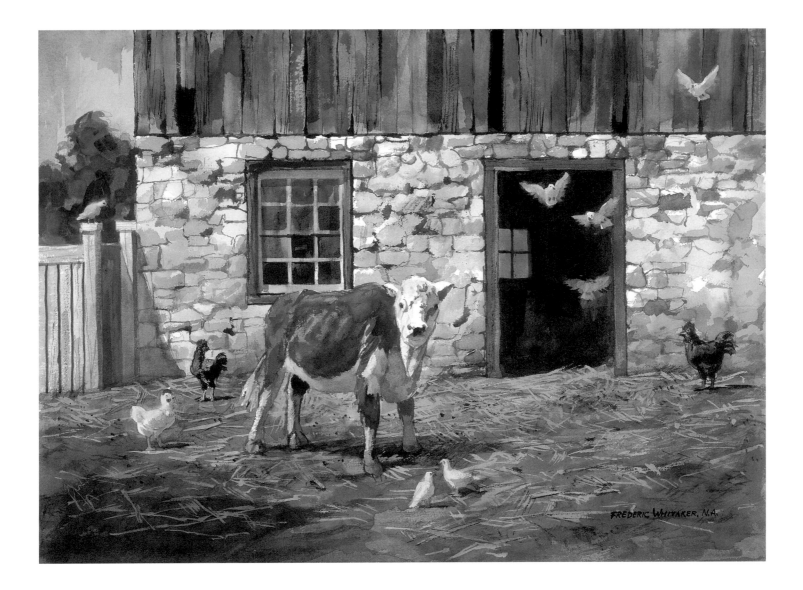

Frederic Whitaker
Whitey & His Friends, 1974
Watercolor on paper, 22 × 30 in.
Michael Johnson Fine Arts
Fallbrook, California

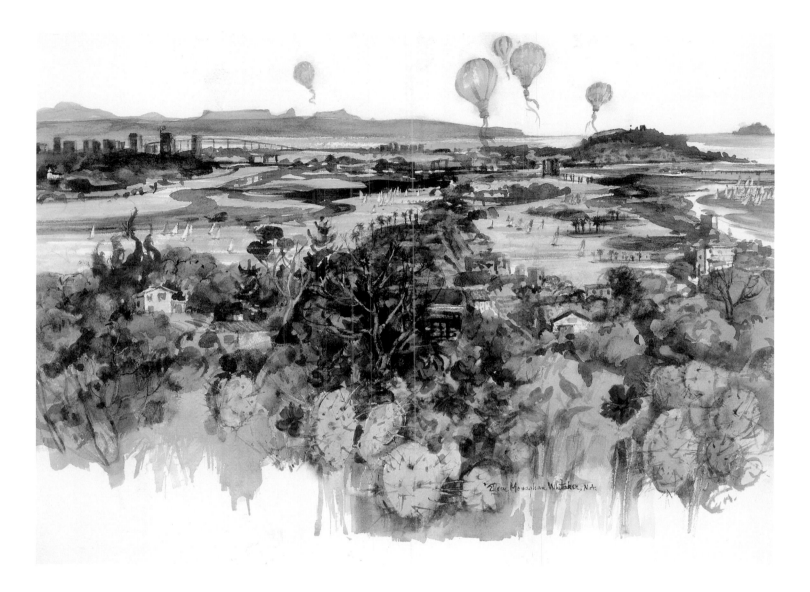

Eileen Monaghan Whitaker
Mission Bay from La Jolla, 1982
Watercolor on paper, 22 × 30 in.
Private collection

Eileen Monaghan Whitaker
Pair of Pheasants, 1982
Watercolor on paper, 16 × 22 in.
Michael Johnson Fine Arts
Fallbrook, California

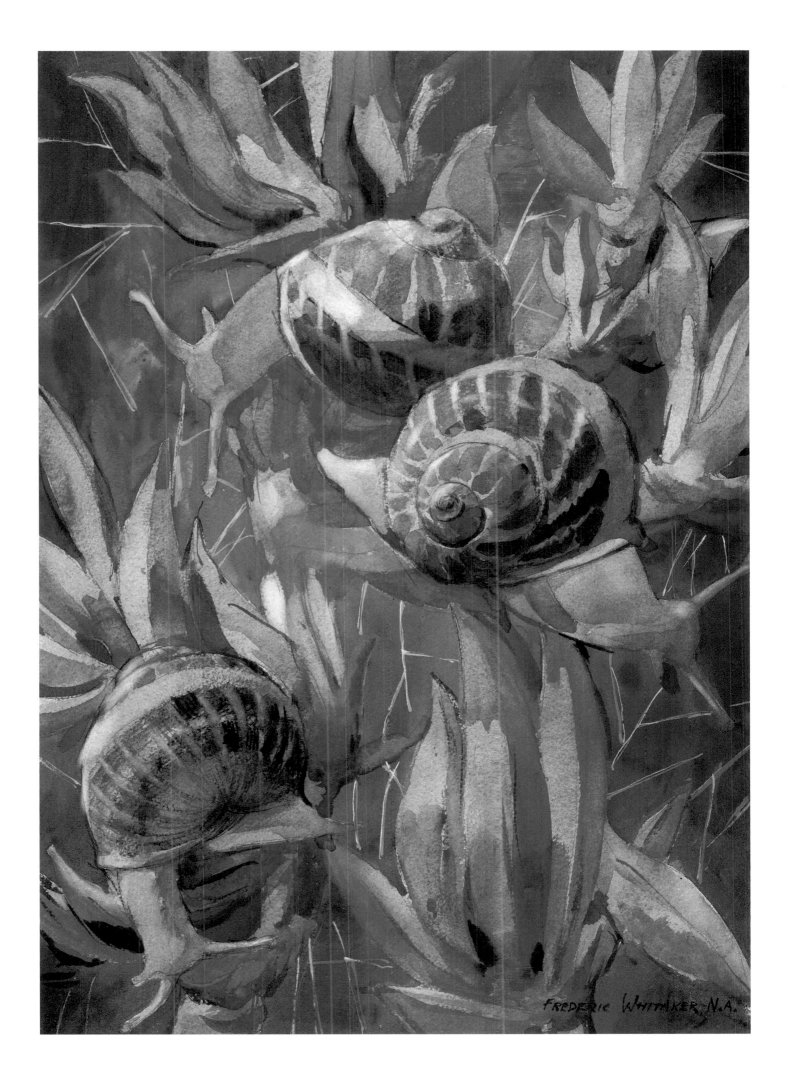

FREDERIC WHITAKER, N.A.

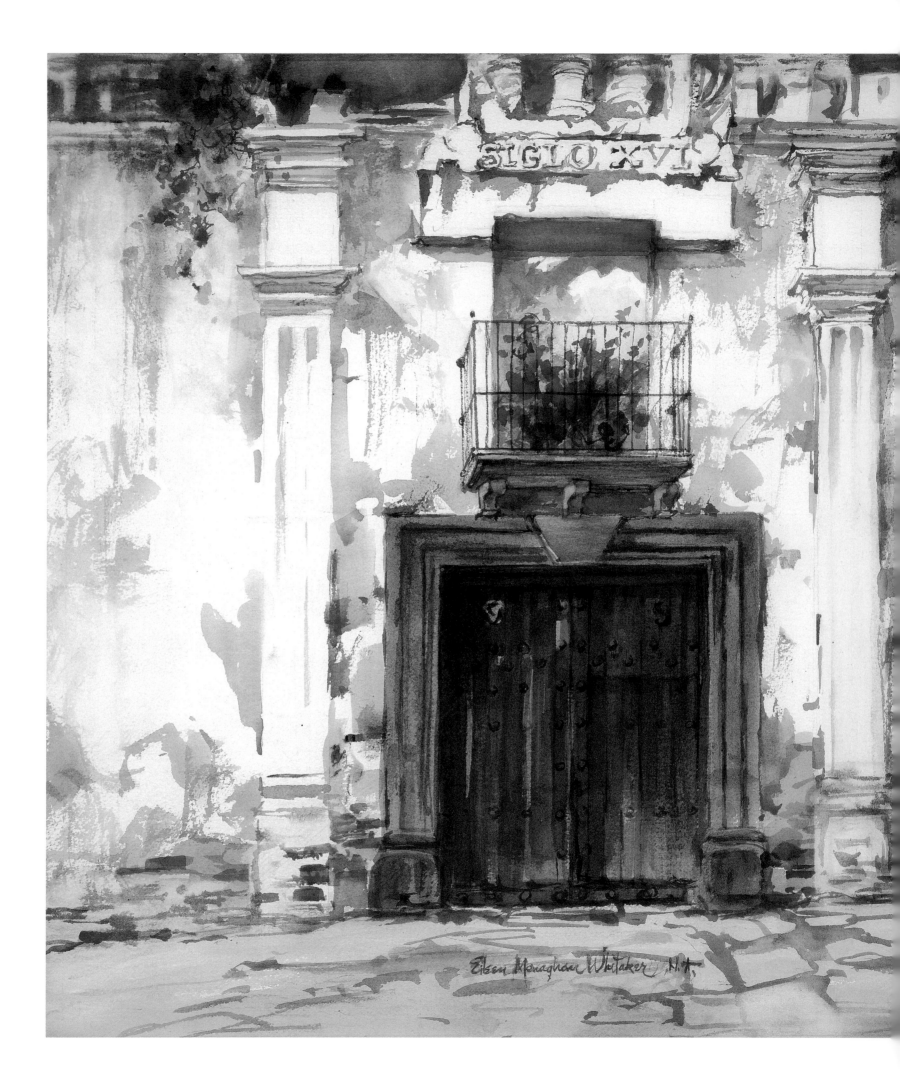

SIGLO XVI

Eileen Monaghan Whitaker N.A.

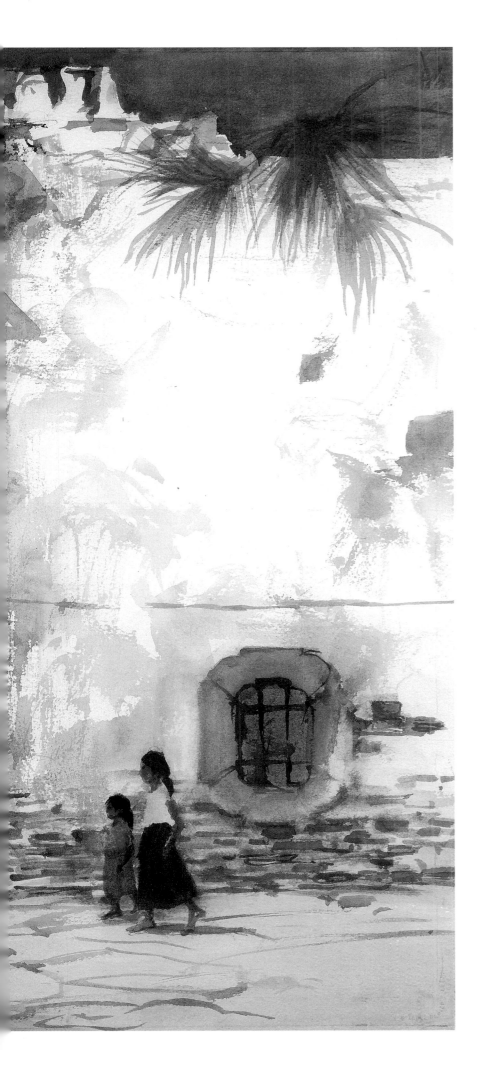

Eileen Monaghan Whitaker
Sixteenth Century Survivor, 1991
Watercolor on paper, 22 × 30 in.
Collection of the Frederic Whitaker and
Eileen Monaghan Whitaker Foundation
San Diego, California

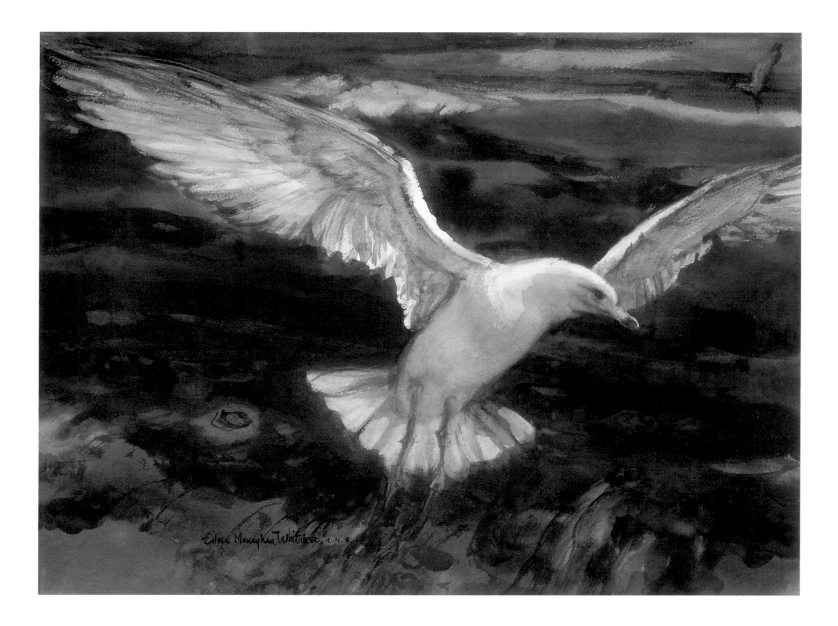

Eileen Monaghan Whitaker
Soaring, early 1970s
Watercolor on paper, 22 × 30 in.
Private collection

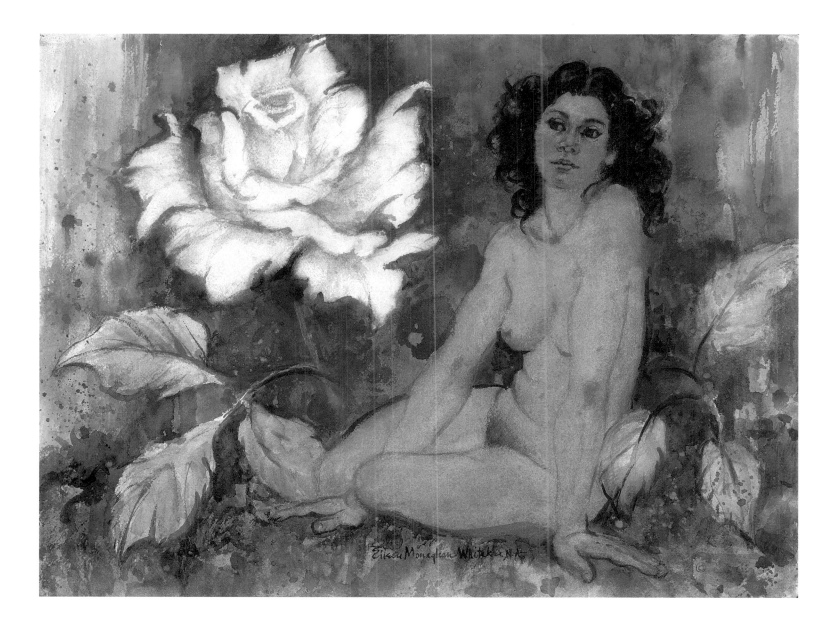

Eileen Monaghan Whitaker
Sweet Days & Roses, 1994
Watercolor on paper, 22 × 30 in.
Michael Johnson Fine Arts
Fallbrook, California

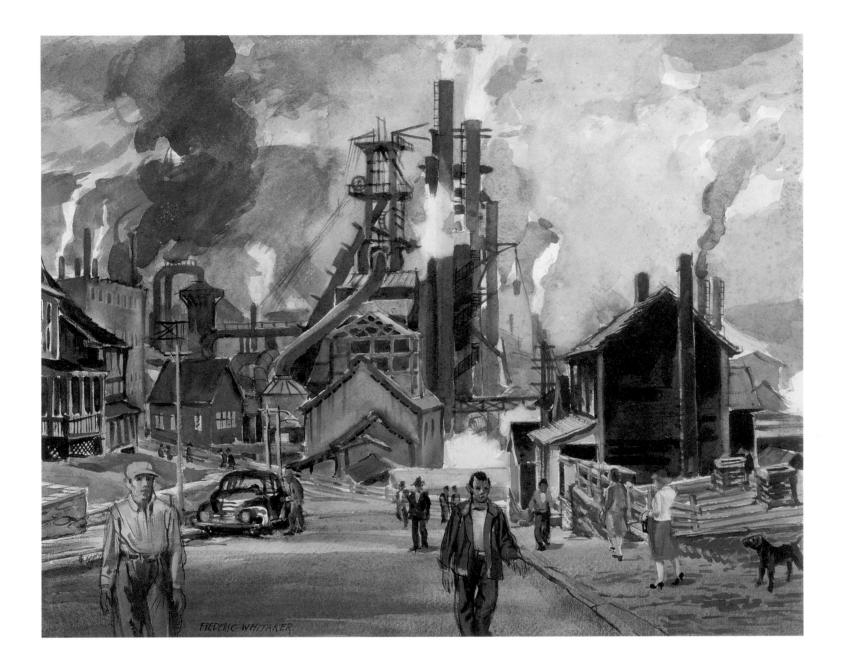

ABOVE
Frederic Whitaker
Basic Industry, 1941
Watercolor on paper, 16 × 20 in.
Collection of the Frederic Whitaker and
Eileen Monaghan Whitaker Foundation
San Diego, California

RIGHT
Frederic Whitaker
Belém Tower, Lisbon, 1956
Watercolor on paper, 27¾ × 22 in.
The Metropolitan Museum of Art, New York
Gift of Carmen Guabello, 64.313

162

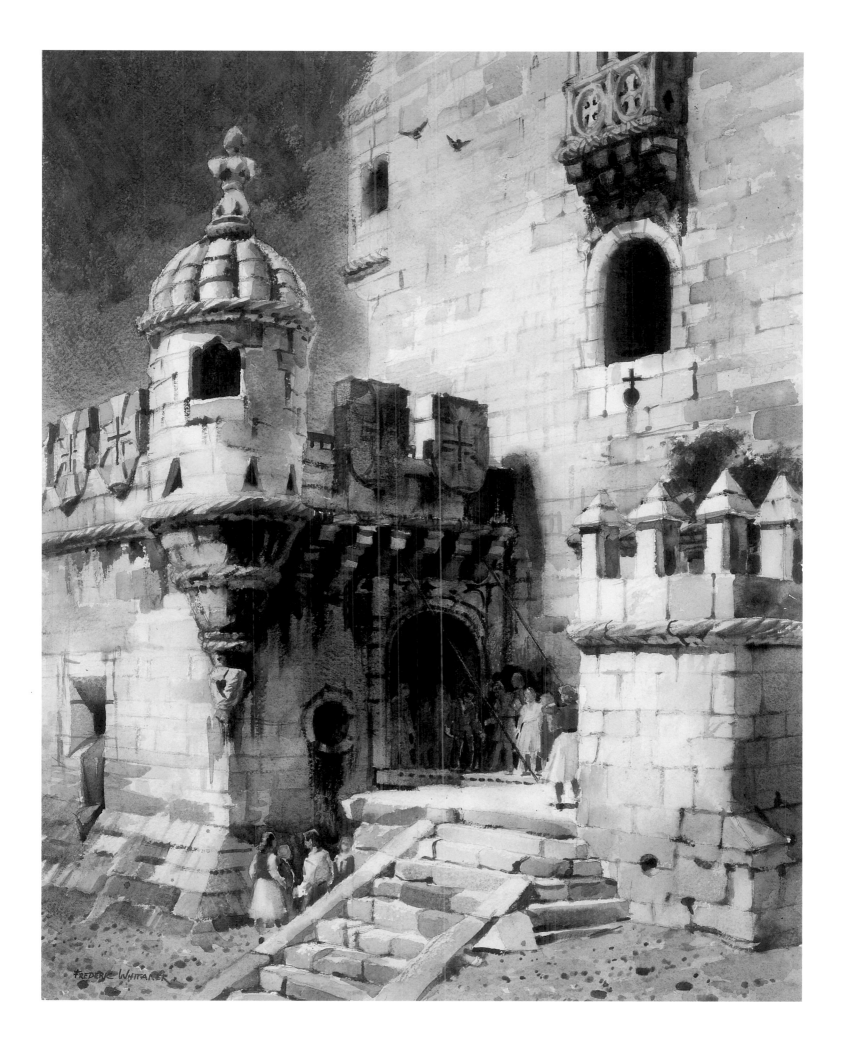

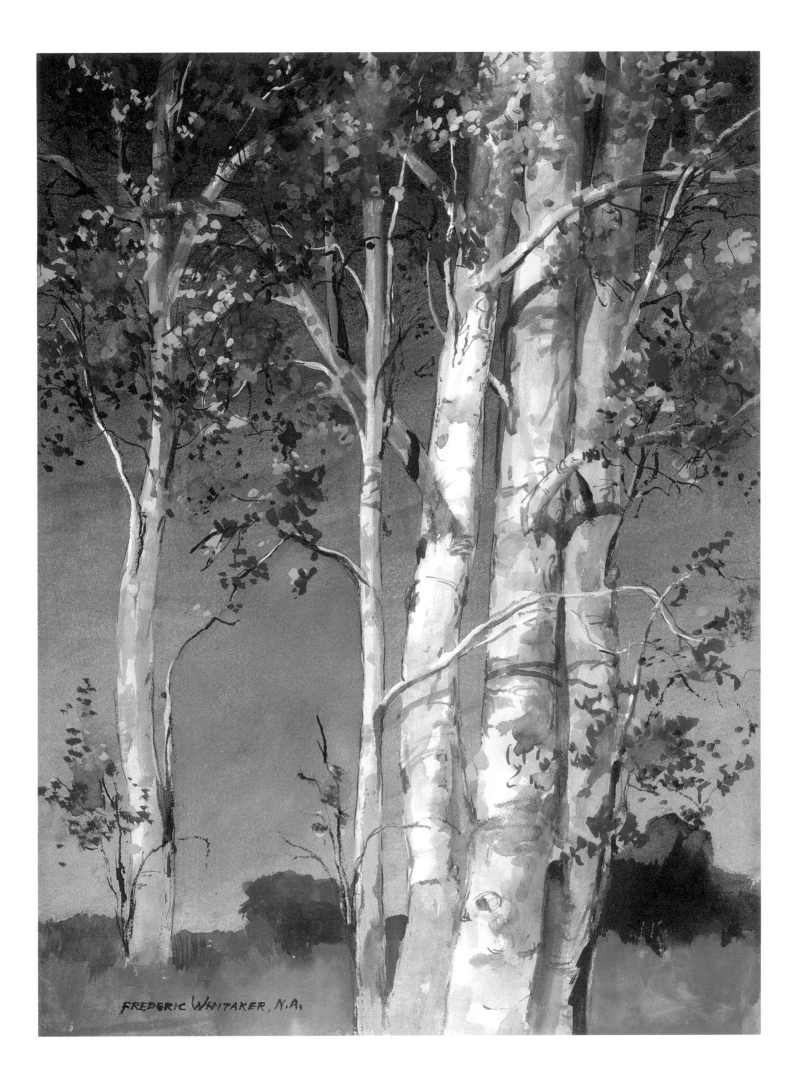

FREDERIC WHITAKER, N.A.

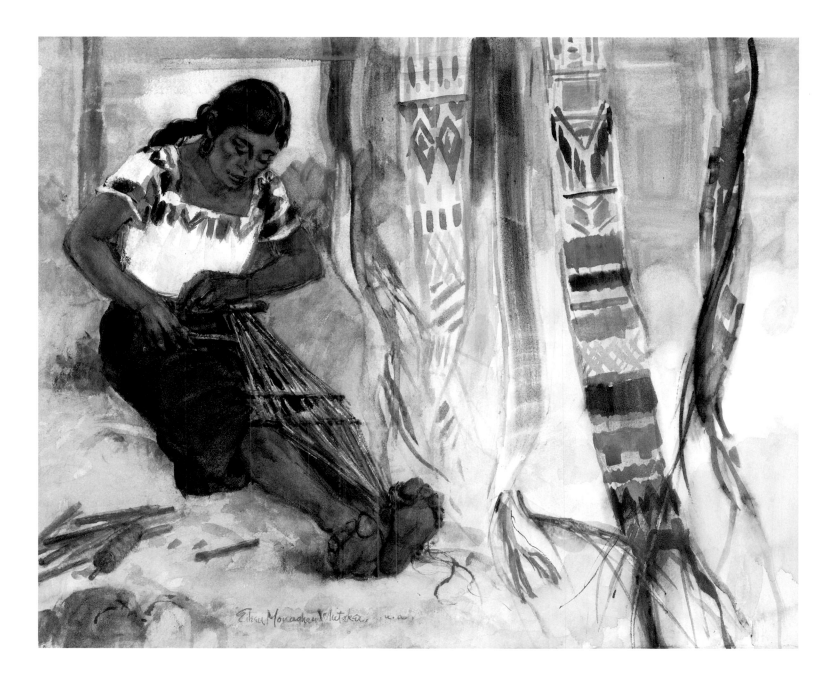

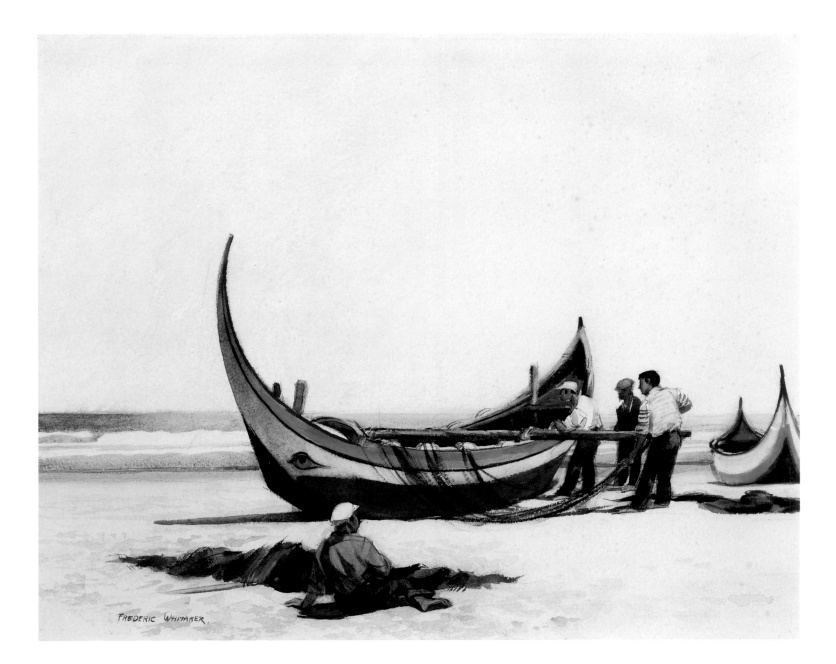

Frederic Whitaker
Beach at Caparica, Portugal, 1968
Watercolor on paper, 22 × 27 in.
Gift of Frederic Whitaker, courtesy of
The Syracuse University Art Collection
Syracuse, New York

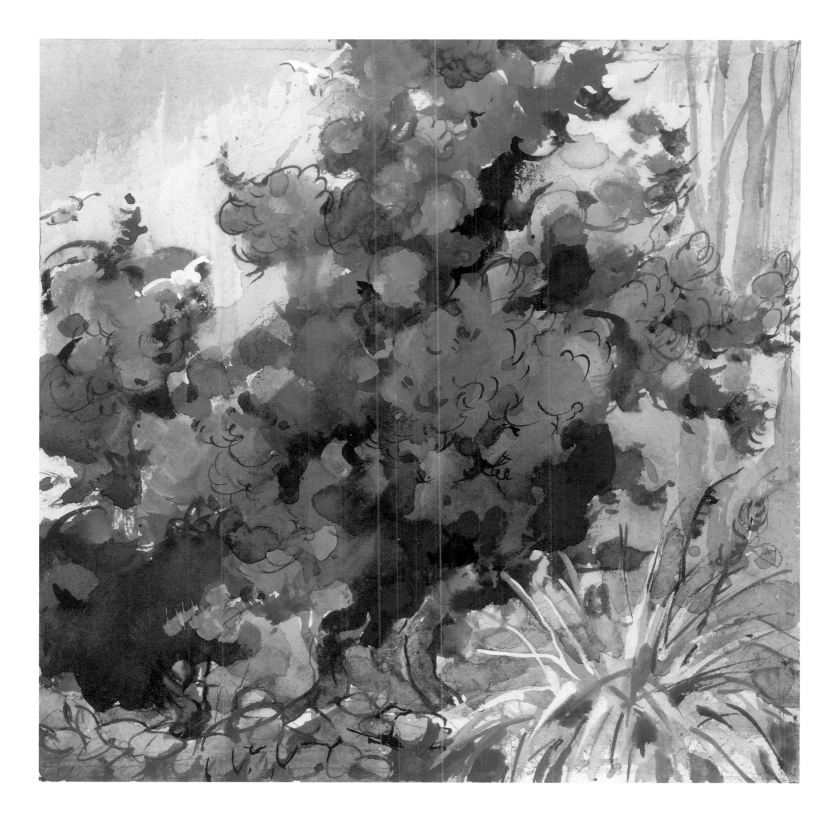

Frederic Whitaker
Bougainvilleas, n.d.
Watercolor on paper, 10¼ × 11 in.
Collection of the Frederic Whitaker and
Eileen Monaghan Whitaker Foundation
San Diego, California

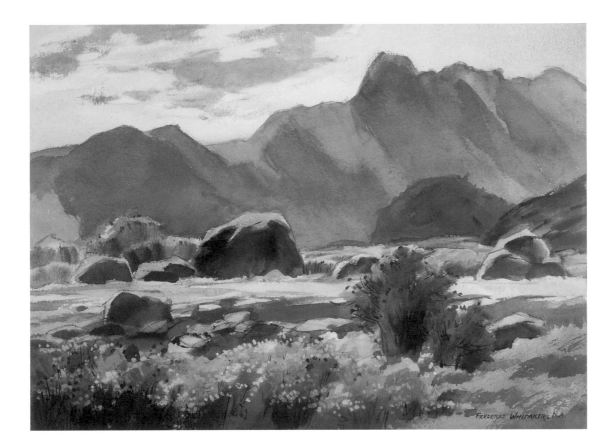

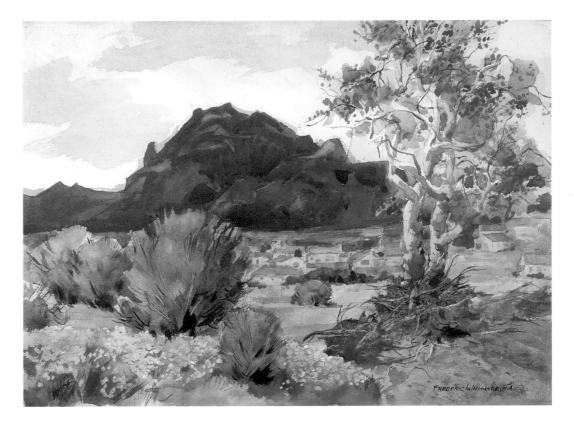

BOTTOM
Frederic Whitaker
A Village in the Valley, 1973
Watercolor on paper, 22 × 30 in.
Collection of the Frederic Whitaker and
Eileen Monaghan Whitaker Foundation
San Diego, California

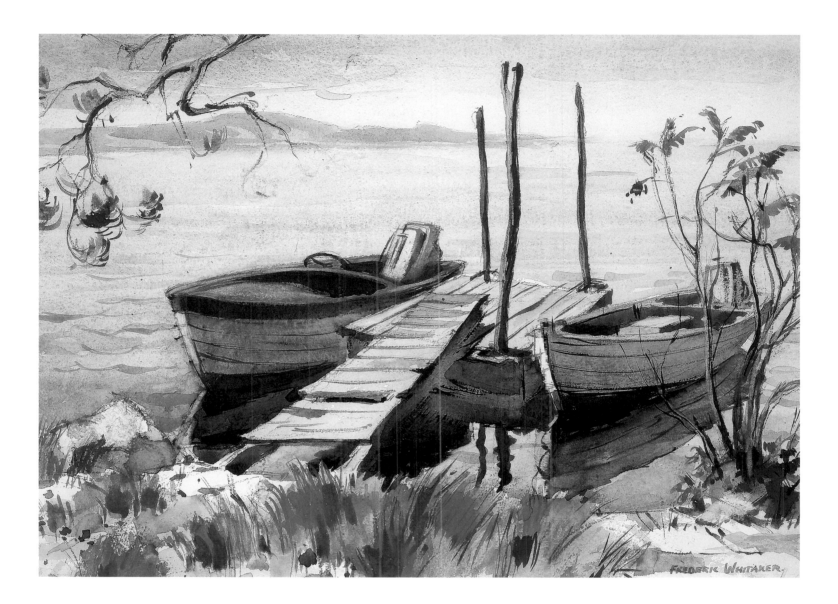

Frederic Whitaker
They Also Serve Who Stand and Wait, 1964
Watercolor on paper, 14 × 20 in.
Collection of Tom and Bruni Bush

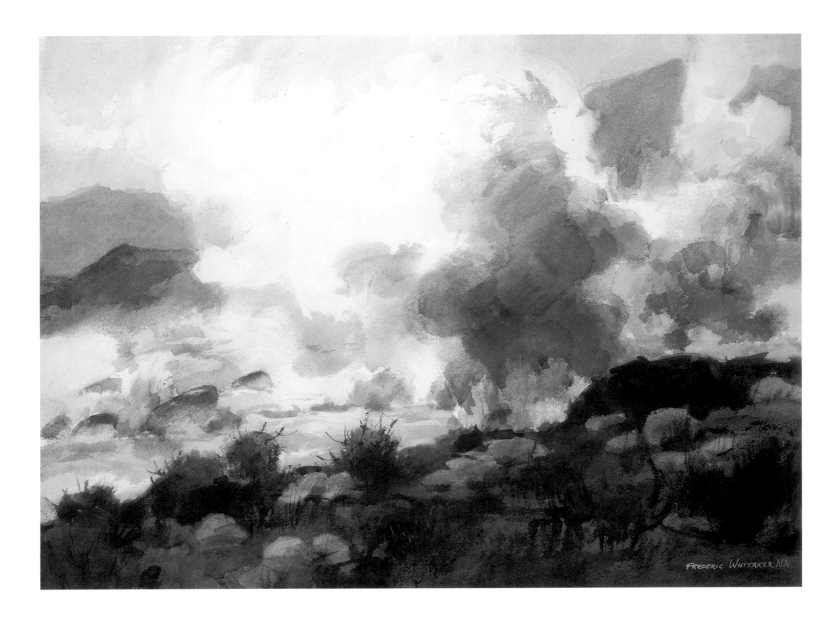

ABOVE
Frederic Whitaker
Fire in the Mountains, 1966
Watercolor on paper, 22 × 30 in.
Private collection

RIGHT
Frederic Whitaker
Fuchsias #3, 1974
Watercolor on paper, 22 × 16 in.
Frye Art Museum, Seattle, Washington
Gift of Eileen Monaghan Whitaker

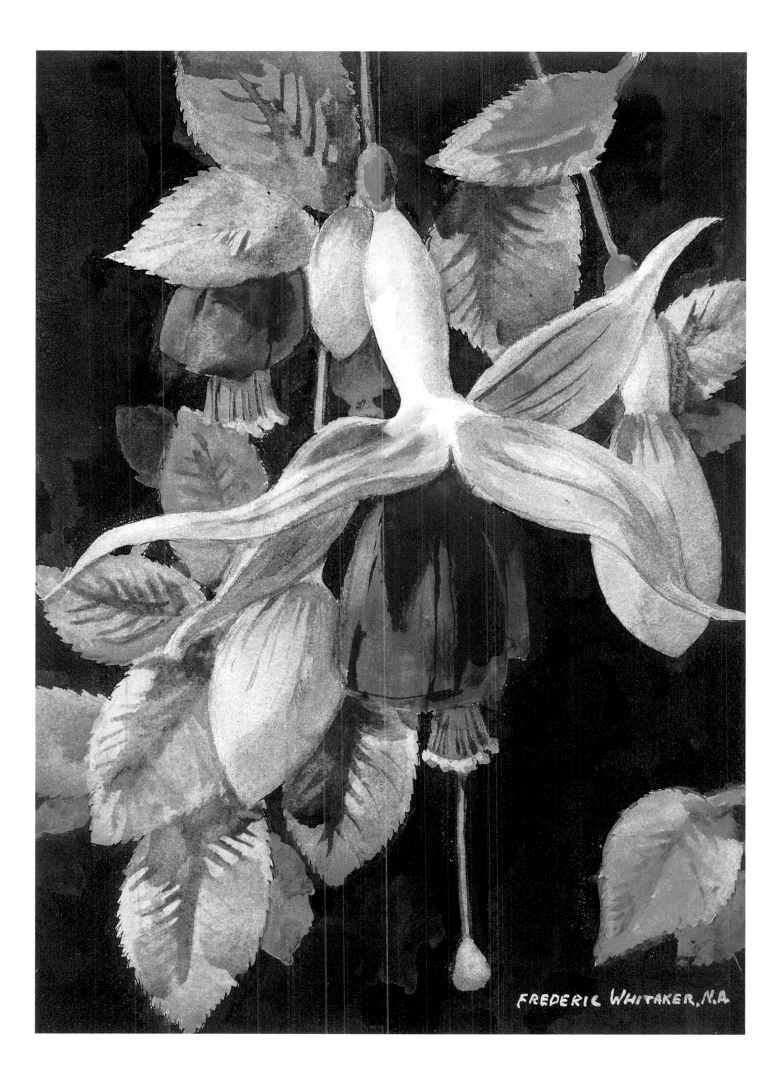

FREDERIC WHITAKER, N.A.

Frederic Whitaker
Cement Plant, 1947
Watercolor on paper, 17 × 23 in.
Hickory Museum of Art
Hickory, North Carolina

Frederic Whitaker
Waterboy, 1967
Watercolor on paper, 22 × 30 in.
Collection of J. K. Kery

Frederic Whitaker
Houses on a Hillside, 1958
Watercolor on paper, 22 × 30 in.
Collection of the Frederic Whitaker and
Eileen Monaghan Whitaker Foundation
San Diego, California

Frederic Whitaker
Humble Home, 1945
Watercolor on paper, 22 × 30 in.
Collection of the Frederic Whitaker and
Eileen Monaghan Whitaker Foundation
San Diego, California

Eileen Monaghan Whitaker
Baby Bird, late 1980s
Watercolor on paper, 7⅞ × 10 in.
Collection of the Frederic Whitaker and
Eileen Monaghan Whitaker Foundation
San Diego, California

Eileen Monaghan Whitaker
The Pear Theme, 1988
Watercolor on paper, 22 × 16 in.
Collection of the Frederic Whitaker and
Eileen Monaghan Whitaker Foundation
San Diego, California

Frederic Whitaker
Maine Monument, 1944
Watercolor on paper, 10 × 10½ in.
Private collection

Frederic Whitaker
Market Day, 1948
Watercolor on paper, 22$\frac{1}{16}$ × 30 in.
National Academy of Design
New York, 35-W

LEFT
Frederic Whitaker
Harlem Sunshine, 1949
Watercolor on paper, 22 × 16 in.
Collection of Charles, Jennifer, and
John Usher Sands

ABOVE
Eileen Monaghan Whitaker
Ranunculus Fields, Carlsbad, 1984
Watercolor on paper, 18 × 30 in.
Private collection

181

Frederic Whitaker
La Zinacanteca, 1965
Watercolor on paper, 22 × 16 in.
San Diego Museum of Art, California
Gift of the Frederic Whitaker and
Eileen Monaghan Whitaker Foundation
San Diego, California, 2002:33

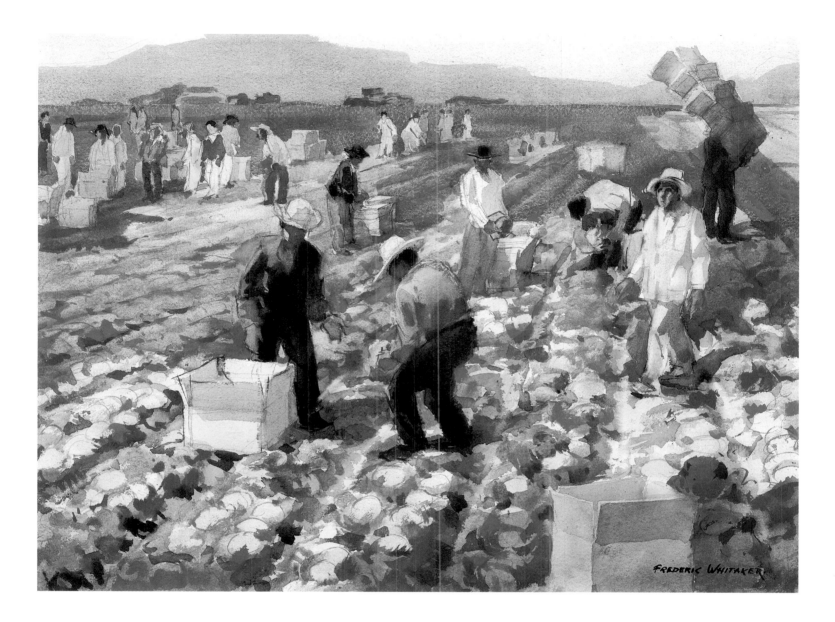

Frederic Whitaker
Lettuce Pickers, 1966
Watercolor on paper, 22 × 30 in.
Private collection

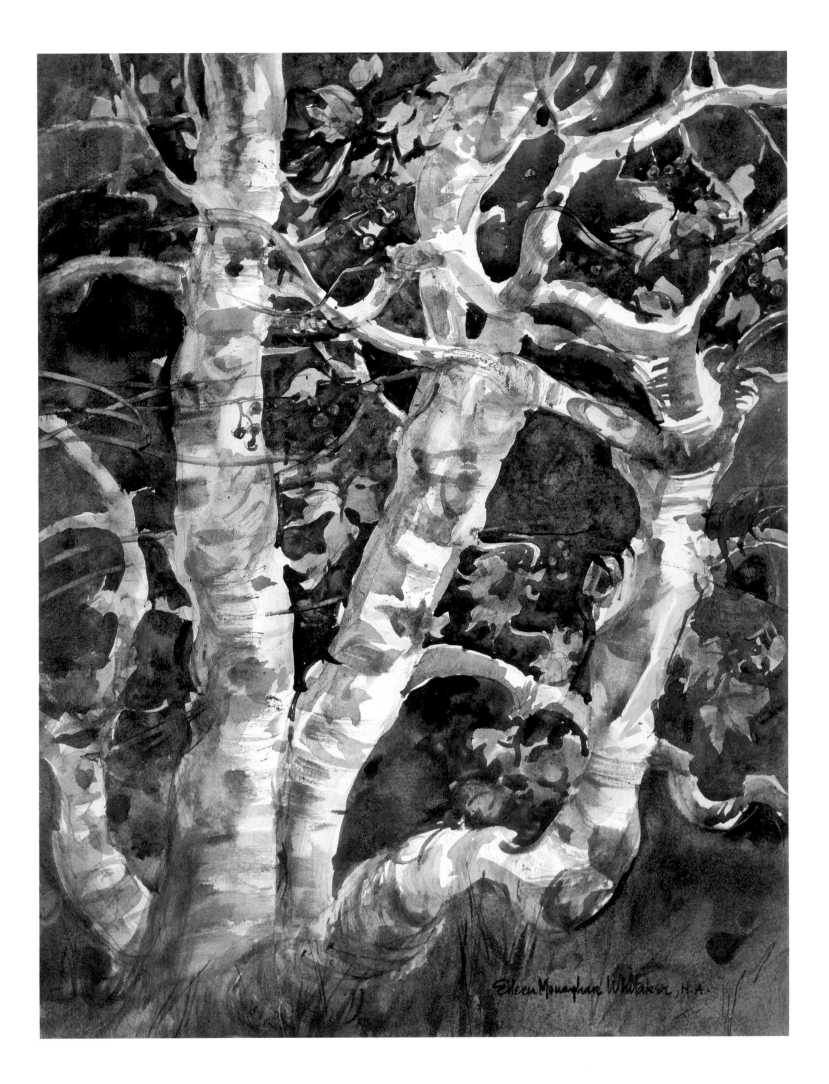

Eileen Monaghan Whitaker, N.A.

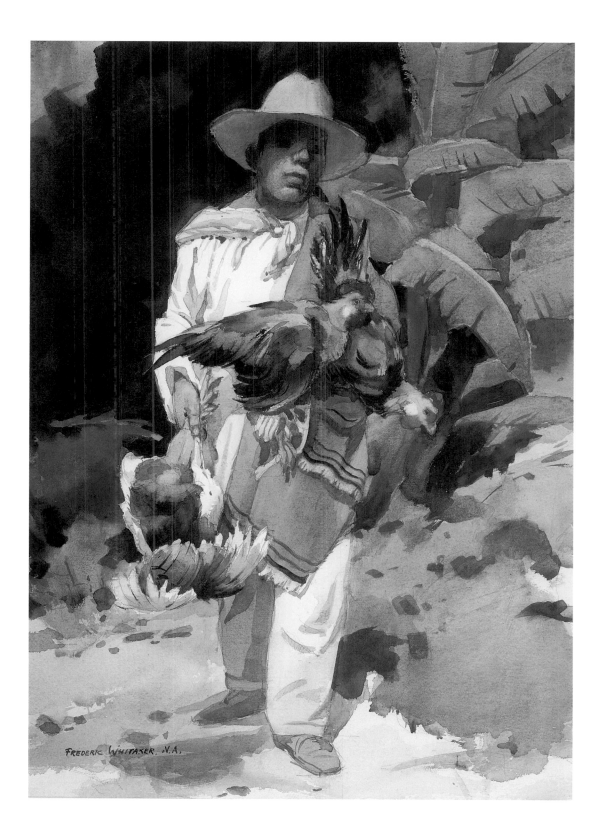

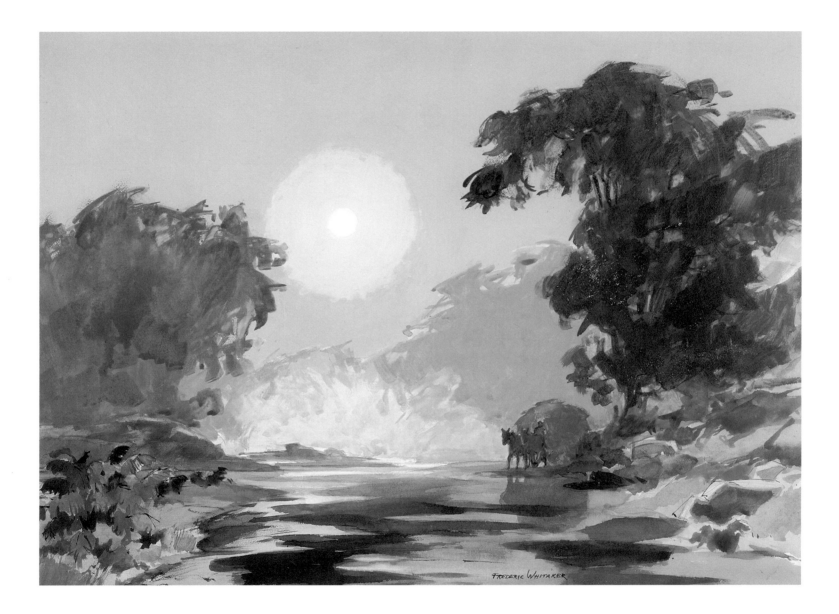

Frederic Whitaker
Morning Mist, 1966
Watercolor on paper, 22 × 30 in.
Frye Art Museum, Seattle, Washington
Gift of Eileen Monaghan Whitaker

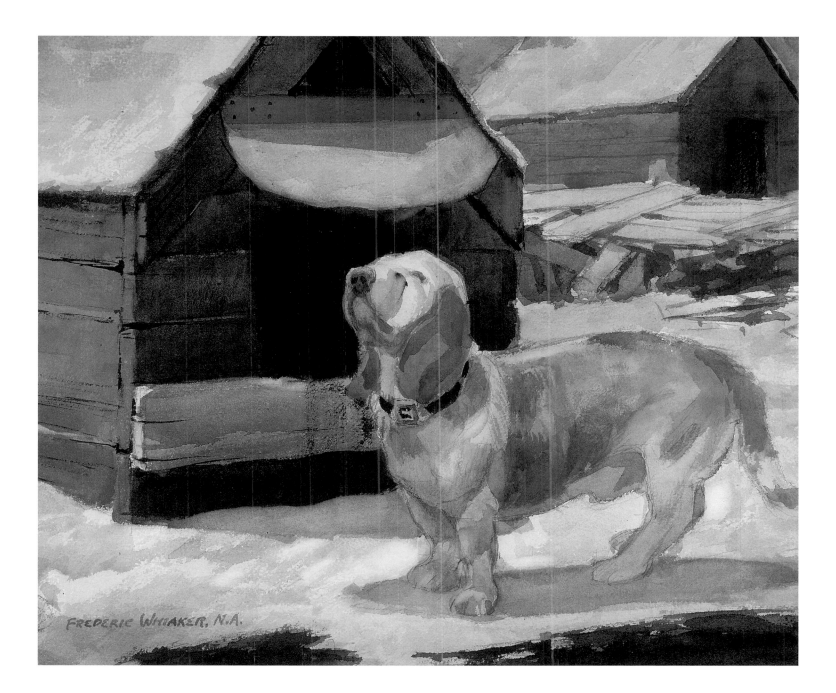

Frederic Whitaker
Old Man Bassett's House, n.d.
Watercolor on paper, 11 × 15 in.
Michael Johnson Fine Arts
Fallbrook, California

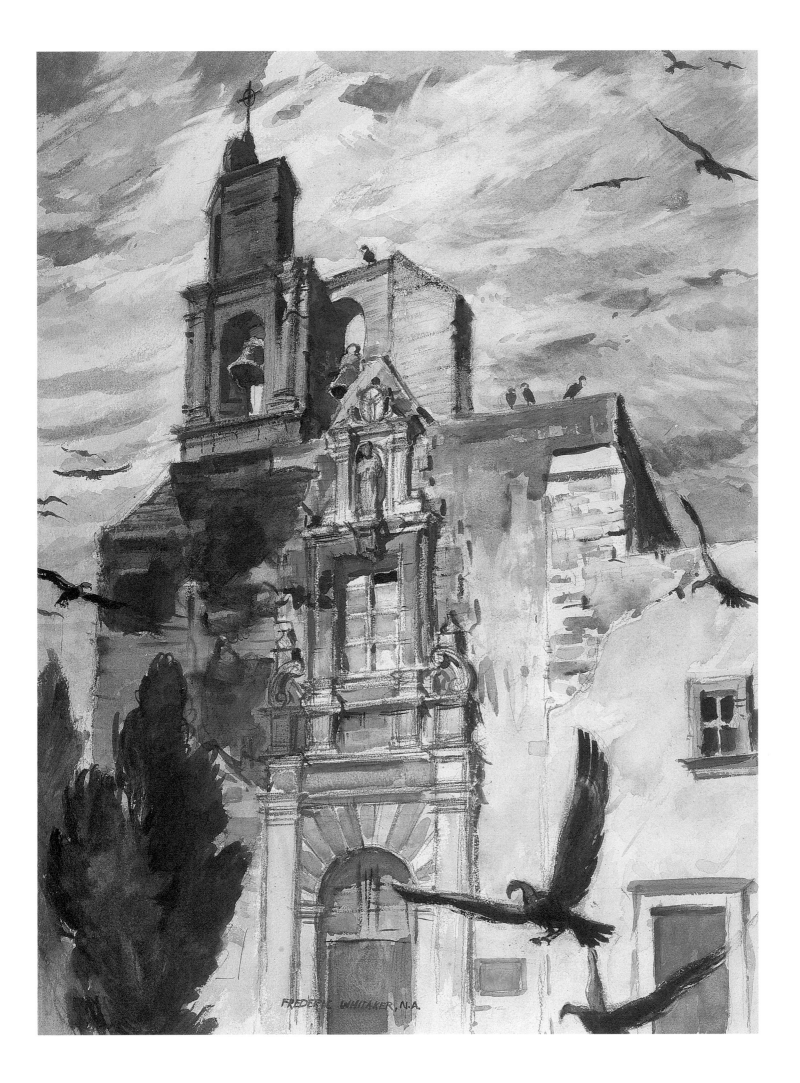

FREDERIC WHITAKER, N.A.

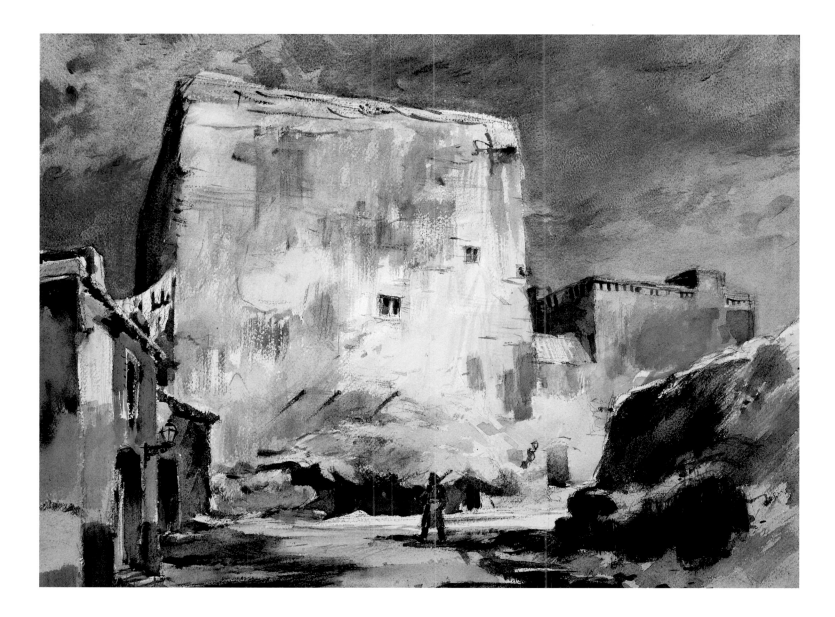

LEFT
Frederic Whitaker
Mexican Motif, 1940s
Watercolor on paper, 29½ × 21½ in.
Private collection

ABOVE
Frederic Whitaker
Military Prison, 1952
Watercolor on paper, 22 × 30 in.
Hickory Museum of Art
Hickory, North Carolina

189

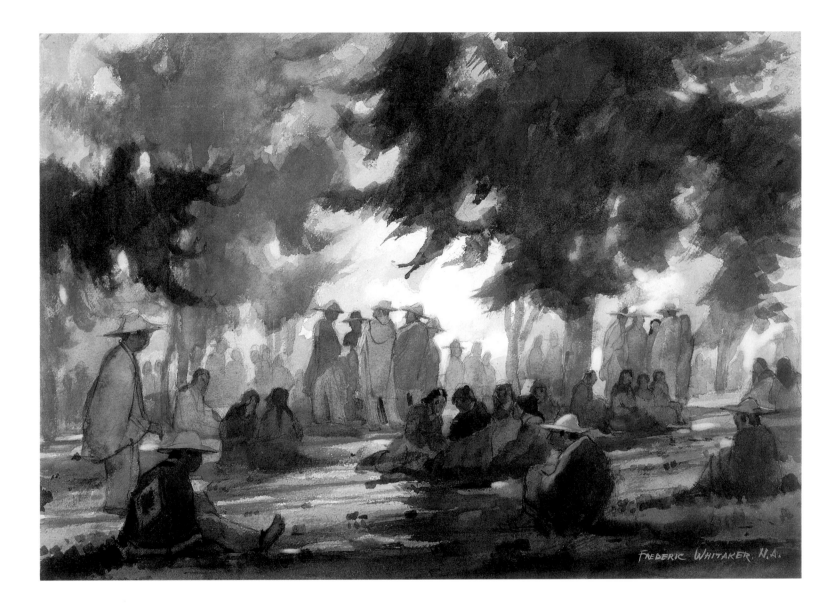

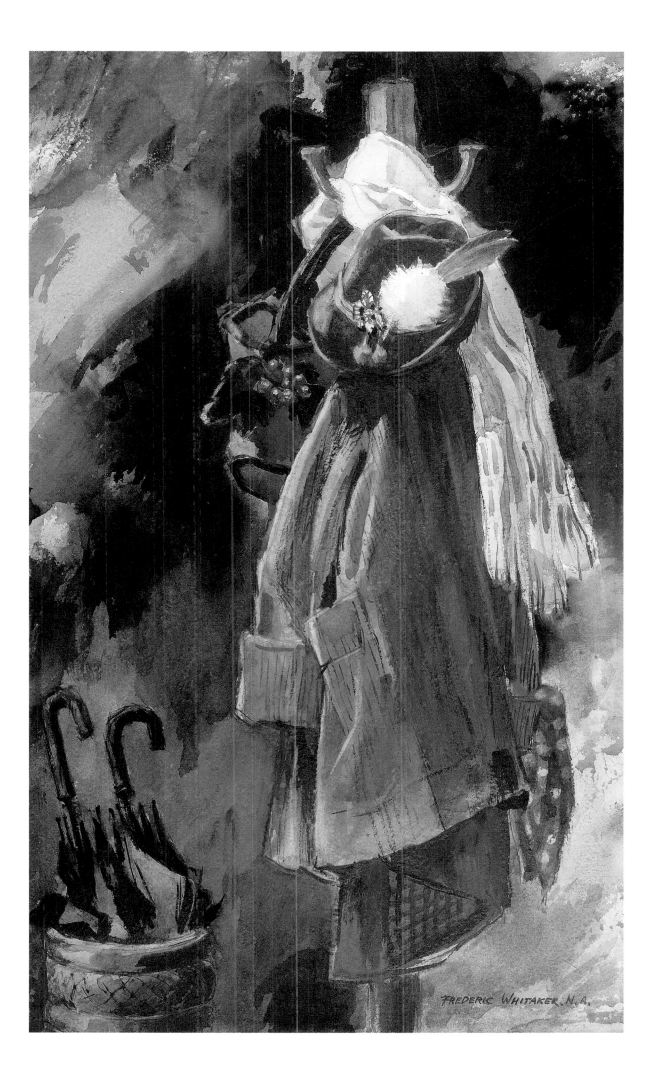

FREDERIC WHITAKER. N.A.

Exhibitions and Awards

These lists comprise selected exhibitions and awards, with dates where available.

Frederic Whitaker

SOLO EXHIBITIONS

1939	American Salon, New York City
1940, 1942, 1943	Ferargil Galleries, New York City
1951, 1963	Grand Central Galleries, New York City
1971	Jones Gallery, La Jolla, California
1972	Old Town Galleries, San Diego, California
1977	A. Huney Gallery, San Diego, California
	The Art Centre, Rancho Santa Fe, California

GROUP EXHIBITIONS

Academic Artists, Springfield, Massachusetts
Allied Artists of America, New York City
American Artists Professional League, New York City
American Institute of Architects, New York City
American Watercolor Society, New York City
Audubon Artists, Inc., New York City
Australian Water Colour Institute
Canadian Society of Painters in Water Colour
National Academy of Design, New York City
National Society of Painters in Casein, New York City
Philadelphia Watercolor Club, Pennsylvania
Royal Water Colour Society, London
San Diego Watercolor Society, California
Society of Western Artists, San Francisco, California
Springville Museum of Art, Utah
Watercolor West, Redlands, California

Eileen Monaghan Whitaker

SOLO EXHIBITIONS

1979	A. Huney Gallery, San Diego, California
1982	Rosequist Galleries, Tucson, Arizona
	Trailside Galleries, Scottsdale, Arizona
	United States International University, San Diego, California
1986	Old Town Circle Galleries, San Diego, California
1988	Founders Gallery, The University of San Diego, California
1989	Riggs Gallery, La Jolla, California
1990	The Frye Art Museum, Seattle, Washington

GROUP EXHIBITIONS

Invitational Exhibitions

American Academy of Arts and Letters (Childe Hassam show), New York City
Australian Water Colour Institute
Canadian Society of Painters in Water Colour
Festival of Arts, Mexico City (Museo de la Acuarela)
Founders Gallery, University of San Diego, California
National Academy of Design (Ranger Fund show), New York City
Royal Water Colour Society, London
Sangre de Cristo Retrospective, Pueblo, Colorado

Juried Exhibitions

Academic Artists, Springfield, Massachusetts

Allied Artists of America, New York City

American Watercolor Society, New York City

Audubon Artists, Inc., New York City

California Watercolor Society (now the National Watercolor
 Society), San Pedro, California

Philadelphia Watercolor Club, Pennsylvania

Providence Watercolor Club, Rhode Island

San Diego Watercolor Society, California

Society of Western Artists, San Francisco, California

Springville Museum of Art, Utah

Watercolor West, Redlands, California

Frederic Whitaker and
Eileen Monaghan Whitaker

TWO-PERSON EXHIBITIONS

1957 Grand Central Galleries, New York City
 Providence Art Club, Rhode Island

1965 Grand Central Galleries, New York City

1966 Jones Gallery, La Jolla, California

1967 Galerie du Jonelle, Palm Springs, California
 Jones Gallery, La Jolla, California

1968 Blair Gallery, Santa Fe, New Mexico

1969 Desert Southwest Art Gallery, Palm Desert, California

1970 Northland Press Gallery, Flagstaff, Arizona

1973 O'Brien's Art Emporium, Scottsdale, Arizona
 Old Town Galleries, San Diego, California

1974 Frye Art Museum, Seattle, Washington

1975 Wollheims' Rosequist Galleries, Tucson, Arizona

1976 A. Huney Gallery, San Diego, California
 The Art Centre, Rancho Santa Fe, California

SELECTED AWARDS

Frederic Whitaker

Allied Artists of America, New York City

American Artists Professional League, New York City

American Watercolor Society, New York City

Audubon Artists, Inc., New York City

Baltimore Watercolor Society, Maryland

Boston Watercolor Society, Massachusetts

National Academy of Design, New York City

National Arts Club, New York City

Pennsylvania Academy of Fine Arts, Philadelphia

Society of Western Artists, San Francisco, California

Springville Museum of Art, Utah

Washington Watercolor Society, Washington, D.C.

Watercolor West, Redlands, California

Watercolor, U.S.A., Springfield, Missouri
 A total of 159 awards

Eileen Monaghan Whitaker

Allied Artists of America, New York City

American Watercolor Society, New York City

California Watercolor Society (now the National Watercolor
 Society), San Pedro, California

National Academy of Design, New York City

Providence Watercolor Club, Rhode Island

San Diego Watercolor Society, California

Society of Western Artists, San Francisco, California

Springville Museum of Art, Utah

Watercolor West, Redlands, California
 A total of 87 awards

List of Paintings Illustrated

Biographies of the Authors

DONELSON HOOPES

Donelson Hoopes began his museum career in 1960, as director of the Portland Museum of Art in Maine. Until 1997, when he retired from the museum field, he served as curator of the Corcoran Gallery of Art, Washington, D.C.; curator of paintings and sculpture at the Brooklyn Museum; curator of American Art at the Los Angeles County Museum of Art; adjunct curator of American Art at the M. H. de Young Memorial Museum, San Francisco; and director of the Thomas Cole Foundation, New York.

Hoopes has published extensively on American art, especially in the field of watercolor painting: *Winslow Homer Watercolors* (1968), *Sargent Watercolors* (1969), *Eakins Watercolors* (1971), *American Watercolor Painting* (1977), and *David Armstrong Watercolors* (1985). His other books include *The American Impressionists* (1973) and *Childe Hassam* (1978).

Hoopes now resides in Maine, where he continues to write and lecture on the subject of nineteenth- and twentieth-century American art.

JAN NOREUS JENNINGS

Jan Jennings has known Eileen Monaghan Whitaker professionally and personally for more than thirty years. She knew Frederic Whitaker from 1972 until his death in 1980. She has written numerous newspaper and magazine articles about the Whitakers, including profiles and reviews.

Jennings was a feature writer and an art writer for the *San Diego Tribune* for more than twenty years, has written feature articles for magazines including *American Artist*, *Southwest Art*, *Art of California*, *Art of San Diego*, *Ranch & Coast*, and *West Art*, and served as the assistant to the director of Mingei International Museum. Concentrating, since the mid-1990s, on Whitaker research, Jennings is currently the Art Director/Writer for the Frederic Whitaker and Eileen Monaghan Whitaker Foundation and a senior writer in University Communications at the University of California, San Diego.

ROBERT L. PINCUS

The art critic for the *San Diego Union-Tribune*, Robert L. Pincus also writes reviews and features for a number of leading art magazines, including *Art in America* (for which he serves as a corresponding editor), *Art News*, *Artforum*, and *Sculpture*. He is an adjunct professor at the University of San Diego, where he teaches a seminar in critical thinking about art.

Pincus is the author of *On a Scale That Competes with the World*, a groundbreaking book on the postwar sculptor Edward Kienholz and his collaborator Nancy Reddin Kienholz. He has contributed to several other books, including *West Coast Duchamp*, *But Is It Art?: The Spirit of Art as Activism* and *Manuel Neri: Early Work*, and he has written essays for exhibition catalogues, including *L.A. Pop in the Sixties* and *Liza Lou: The Kitchen*.

Before coming to San Diego, he served as an art critic for the *Los Angeles Times*. He has received awards from the San Diego Press Club, the Society of Professional Journalists, and Copley Newspapers and is the recipient of the Chemical Bank Award for Distinguished Newspaper Art Criticism.

THEODORE F. WOLFF

As artist, designer, art critic, writer on artists and the arts, juror, appraiser, consultant, teacher, and lecturer, Theodore F. Wolff's professional career in the arts spans five decades. A former art critic for the *Christian Science Monitor*, he is the author of *The Many Masks of Modern Art*, a collection of essays culled from his articles for the *Monitor*, and has contributed full or partial texts for twenty books on art and artists including Morris Graves, Enrico Donati, James Turrell, Joyce Treiman, John Steuart Curry, and John Wilde. Wolff lectures on art at museums, colleges and universities, and at conferences on the arts. He has received the National Headliners Award for Consistently Outstanding Column on Art, the Art World/Manufacturers Hanover Trust Award for Distinguished Newspaper Art Criticism, and the principal award in arts criticism from the American Association of Sunday and Feature Editors.

Index

Copyright © 2004 The Frederic Whitaker and Eileen Monaghan Whitaker Foundation, San Diego, California
www.whitakerwatercolors.org

Library of Congress Cataloging-in-Publication Data
Jennings, Jan Noreus
 Contrasts that complement : Eileen Monaghan Whitaker & Frederic Whitaker / by Jan Noreus Jennings ; essays by Donelson Hoopes, Robert L. Pincus, Theodore F. Wolff.
 p. cm.
 Includes index.
 ISBN 0-9744202-2-0 (hardcover : alk. paper)
 1. Whitaker, Eileen Monaghan, 1911– . 2. Whitaker, Frederic. 3. Watercolorists—United States—Biography. I. Whitaker, Eileen Monaghan, 1911– . II. Whitaker, Frederic. III. Title.
 ND1839.W47J46 2004
 759.13—dc22 2004019838

Published by Marquand Books, Inc., Seattle
www.marquand.com

Distributed by
University of Washington Press
P.O. Box 50096
Seattle, WA 98145-5096
www.washington.edu/uwpress

Frontispiece: Eileen Monaghan Whitaker, *Lagarterana*, 1971. Watercolor on paper, 30 × 22 in. Collection of Wayne and Lauralee Bennett

Title page: Frederic Whitaker, *Beach at Caparica, Portugal*, 1968 (detail, see p. 166)

Endpapers: Eileen Monaghan Whitaker

The principal photographer for this book, Michael Campos, of Campos Photography in San Diego, provided all of the photographs except the following:

Campus Center Art Collection, University of Massachusetts, p. 140

Aaron Lee Fineman, p. 179

Ric Helstrom/Helstrom Studios, pp. 137, 169

Ken Howie Photography, pp. 165, 180

James Labrenz, Fanjoy-Labrenz Photographers, pp. 172, 189

The Metropolitan Museum of Art, New York, © 2003, p. 163

David Revette Photography, pp. 104, 105, 166

Edited and indexed by Frances Bowles
Proofread by Laura Iwasaki
Designed by John Hubbard
Separations by iocolor, Seattle
Printed and bound by CS Graphics Pte., Ltd., Singapore